NIKON

THE EXPANDEL

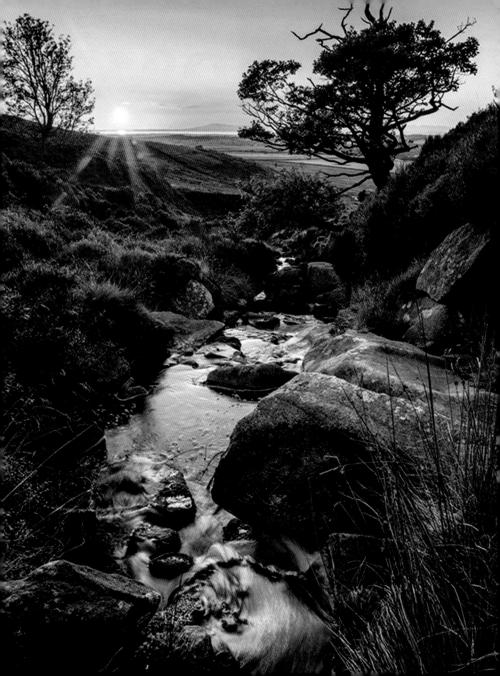

NIKON D810

THE EXPANDED GUIDE

Jon Sparks

First published 2015 by Ammonite Press an imprint of AE Publications Ltd 166 High Street, Lewes, East Sussex, BN7 1XU, UK

Text © AE Publications Ltd, 2015 Images © Jon Sparks, 2015 Additional product photography © Nikon, 2015 Copyright © in the Work AE Publications Ltd, 2015

ISBN 978-1-78145-115-1

All rights reserved

The rights of Jon Sparks to be identified as the author of this work have been asserted in accordance with the Copyright, Designs, and Patents Act 1988, Sections 77 and 78.

No part of this publication may be reproduced, stored in a retrieval system, or transmitted in any form or by any means without the prior permission of the publishers and copyright owner.

While every effort has been made to obtain permission from the copyright holders for all material used in this book, the publishers will be pleased to hear from anyone who has not been appropriately acknowledged, and to make the correction in future reprints.

The publishers and author can accept no legal responsibility for any consequences arising from the application of information, advice, or instructions given in this publication.

British Library Cataloging in Publication Data: A catalog record of this book is available from the British Library.

Editor: Rob Yarham Series Editor: Richard Wiles Design: Richard Dewing Associates

Typefaces: Giacomo Color reproduction by GMC Reprographics Printed in China

PAGE 2 SUNSET

~

When I saw the setting sun lighting up this stream, I knew I had a chance of a special image. I also knew I had to work fast as the sun was sinking fast and the light wouldn't be around for long. Although it was one of my first outings with the D810, everything felt familiar and all the controls seemed to be in the right place. 24mm, ½ sec., f/16, ISO 64, tripod.

Chapter 3	Menus	94
Chapter 4	Flash	146
Chapter 5	Close-up	168
Chapter 6	Movies	178
Chapter 7	Lenses	192
Chapter 8	Accessories and care	210
Chapter 9	Connections	222
	Glossary	234
	Useful websites	237
	Index	238

OVERVIEW

The Nikon D810 succeeds the D800 and D800E as one of the company's flagship models. Although priced below the D4s (the sports and news photographers' workhorse) the D810 is still very much a top-of-the-range camera. Like its predecessors, it trades heavily on its 36.3-megapixel sensor—the highest pixel count of any regular DSLR. Of course, pixels aren't everything and the extraordinary resolution has to be backed up with excellent design, handling, and performance. While the D810 is specifically marketed to those specialist photographers who can genuinely exploit its exceptional resolution, it's also a highly versatile camera for those (the majority) who don't really need 36 megapixels.

> Evolution of the Nikon D810

Among major camera makers, Nikon has always been noted for continuity as well as innovation. When the main manufacturers introduced their first viable autofocus

35mm cameras in the 1980s, most of them jettisoned their existing lens mounts, but Nikon stayed true to its tried and tested F-mount system. It's still possible to use the vast majority of classic Nikon lenses with the latest digital cameras like the D810, though some camera functions may be lost. For this and other reasons, "evolution" accurately describes

the development of Nikon's digital cameras. Nikon's first DSLR was the E2s. Sporting a then-impressive 1.3-megapixel (Mp) sensor, its body design was based on

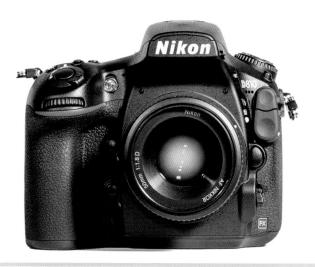

the F801 35mm SLR. However, the true line of descent of the D810 begins with the 2.7-megapixel D1, in 1999. Its sensor adopted the DX format (see next page), which remained in use with every Nikon DSLR prior to the D3.

Following the 2007 introduction of the D3 as Nikon's first full-frame DSLR, the D700 (2008) used the same sensor but in a smaller, lighter body. Physically and functionally, the D800 and D800E (2012) appeared as direct descendants of the D700, but internally there was a huge change from a 12Mp sensor to a 36Mp sensor. At the time this was unique outside the "medium-format" category and there is still no other DSLR with such a high pixel count, although a very similar sensor is used in Sony's mirrorless A7 models. It will

Nikon D1 (1999)

A truly ground-breaking camera, the Nikon D1 was arguably the first DSLR from any maker to offer a viable alternative to film—despite offering a mere 2.7 megapixels.

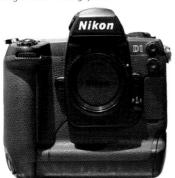

appear odd to some that Nikon's "top" camera, the D4s has a lower pixel count—at 16mp it's less than half that of the D810—but Nikon has always recognized that pixel numbers are only one benchmark; the D4s scores on speed, high-ISO performance, and ruggedness.

The difference between the D800 and D800E lay solely in the optical low-pass filter in front of the sensor—the D800 had it, whereas the D800E did not. The D810 completely dispenses with this filter. In other respects, it is broadly similar to its predecessors, but includes many incremental improvements, such as greater shooting speed (now back to parity with the D700), an upgraded focusing module (same as the D4s), a quieter shutter, and improved movie shooting features.

Nikon D3 (2003)

Nikon's first "full-frame" (or FX) DSLR took the world by storm with its blistering speed, superrugged build, and unprecedented low-light ability proving a significant step for many users.

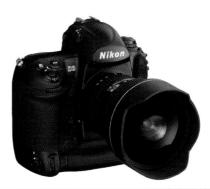

> Nikon FX-format sensor

The DX-format sensor, measuring approximately 23.6 x 15.8mm, was used in every Nikon DSLR prior to the D3, but the number of pixels squeezed into that tiny area has risen from 2.7 million (D1) to around 24 million, now standard across the current DX range. The D3 (2007) was the first Nikon DSLR to adopt a "full-frame" sensor, which Nikon designates FX. Measuring approximately 36 x 24mm, it's almost exactly the same size as a 35mm film frame. More than doubling the area of the DX sensor, the FX gathers more light and, crucially, each individual photosite (pixel) is larger; the D810 may have 50% more pixels than, say, the D7100, but each one is still almost 50% larger in area. The D810's CMOS sensor, with 36.3 million

Nikon D700 (2008)

Nikon's second FX DSLR offered amateurs and professionals alike the same sensor and superb image quality as the D3 in a lighter and more compact body.

effective pixels, produces images at a native size of 7360 x 4912 pixels.

The D810's sensor offers exceptional ability to capture fine detail, but it should be noted that this can only be fully realized when using the very best lenses and impeccable technique. Other optical properties, such as dynamic range and high-ISO performance, are also excellent. but if shooting in low light and at high ISO settings are a priority, the D4s and the Df have an edge. With "only" 16.2 megapixels on the same (FX) size of sensor, these cameras have much larger photosites, enabling them to capture extremely clean, low-noise images, even at high ISO ratings. Both allow the ISO to be set all the way to 204,800, two stops higher than the D810.

Nikon D800 (2012)

×

The most talked about camera of the year, the D800/D800E brought unprecedented levels of resolution to the DSLR, while retaining the relatively light and compact form of the D700.

> Low-pass filters

Normally, when viewing a digital image, it's not apparent that it is made up of individual pixels, but these can sometimes contribute to "artefacts" of various kinds in an image. A common problem in the early days of digital imaging was aliasing, where sharp diagonal or curved lines take on a jagged or stepped appearance.

Moiré can occur when there's interference between areas of fine pattern in the subject and the grid pattern of the sensor. This often takes the form of auroralike swirls or fringes of color. To compensate for this, most digital cameras use an optical low-pass (or "anti-aliasing") filter directly in front of the sensor. This works by blurring the image slightly, and is very effective in removing artefacts but means that images need re-sharpening either in-camera or in post-processing.

With advances in sensor design and processing algorithms, these filters are increasingly thought to be unnecessary—Nikon dispensed with one in the D800E and has now removed it from most of its DSLR range. This does mean that there is a risk of occasional moiré, most likely when shooting subjects with fine, repeating patterns, such as fabrics or some architectural surfaces (e.g. tiles). It is much less likely to arise in landscape shooting. Moiré can be fixed in post-processing, but this can be time-consuming.

> About the Nikon D810

The D810 is not so much "second in line" to the D4s but an alternative at the top of the range, aimed at a different category of shooter. For sports and press work, the speed and ruggedness of the D4s are crucial; for landscape, macro, studio work, and many other areas, the high resolution of the D810 stands out. As a travel camera it's also notably lighter (although it should be said the D610 and Df are lighter again).

While the 36.3-megapixel CMOS sensor has more than double the D4's pixel count, many of the "under-the-hood" features are common to both cameras, including the new EXPEED 4 processing engine and 51 autofocus points. However, the maximum shooting rate of 5 frames per second (when shooting FX) is substantially slower than the D4s, which can go up to 11fps; pro sports photographers will undoubtedly opt for the latter camera, but most other users will find the D810 fast enough.

One point that must be emphasized is that, as a 36-megapixel camera, the D810 produces huge image files, especially if you shoot RAW, and this can demand extra investment in fast, high-capacity memory cards and computer hardware and software.

Like all Nikon SLRs, the D810 is part of a vast system of lenses, accessories, and software. This *Expanded Guide* will guide you through the camera's operation, and its relation to the system as a whole.

MAIN FEATURES OF THE NIKON D810

Sensor

36.3 effective megapixel FX-format RGB CMOS sensor, measuring 35.9 x 24mm and producing maximum image size of 7360 x 4912 pixels. Crop function allows capture in 1.2x, DX, and 5 x 4 formats; selfcleaning function.

Image processor

EXPEED 4 image-processing system, featuring 14-bit analog-to-digital (A/D) conversion with 16-bit image processing.

Focus

51-point autofocus system covering most of the image area, supported by Nikon Scene Recognition System, which tracks subjects by shape, position, and color. Three focus modes: (S) Single-servo AF; (C) Continuous-servo AF; and (M) Manual focus. Five AF-area modes: Single-area AF; Dynamic-area AF; 3D tracking; Grouparea AF; and Auto-area AF. Rapid focuspoint selection and focus lock.

Exposure

Four metering modes: matrix metering; center-weighted metering; spot metering; highlight-weighted metering. 3D Color Matrix Metering III uses a 91,000-pixel color sensor to analyze data on brightness, color, contrast, and subject distance from all areas of the frame. With non-G/D type lenses, standard Color Matrix Metering III is employed. Four exposure modes: (P) Programmed auto; (A) Aperture-priority auto; (S) Shutterpriority auto; (M) Manual.

ISO

ISO range between 64 and 12,800, with extensions down to 32 (Lo) and up to 51,200 (Hi). Exposure compensation between -5 Ev and +5 Ev; exposure bracketing facility (up to nineframe spread).

Shutter

Shutter speeds from 1/8000th sec. to 30 sec., plus B (bulb). Maximum frame advance 5fps (6fps in DX crop mode; 7fps possible with external power supply).

Viewfinder and Live View

Bright viewfinder with 100% coverage and 0.7x magnification. Live View available on rear ICD monitor

Movie mode

Continuous feed in Live View mode allows movie capture in .MOV format (MPEG-4 compression) with image size (pixels) of: 1280 x 720, 1920 x 1080. Frame rates 60fps/50fps/30fps/25fps/24fps at large size; 60fps/50fps at mid-size.

Buffer

Buffer capacity allows up to 100 frames (JPEG fine, large) to be captured in a continuous burst at 4fps, up to 58 NEF (RAW) files (dependent on RAW settings).

Flash

Pop-up flash (manually activated) with Guide Number of 12 (m) or 39 (ft) at ISO 100, supports i-TTL balanced fill-flash for DSLR (when matrix or center-weighted metering is selected) and Standard i-TTL flash for DSLR (when spot metering is selected). Five flash-sync modes: Front-curtain sync; Red-eye reduction; Slow sync; Red-eye reduction with slow sync; Rear-curtain sync. Flash compensation from -3 to +1 Ev; FV lock.

LCD monitor

High-definition 3.2in. (81.3mm), 1,229,000-pixel TFT LCD display with wide color gamut (close to sRGB) and 100% frame coverage.

Custom functions

Over 60 parameters and elements of the camera's operations can be customized through the Custom Setting menu.

File formats

The D810 supports NEF (RAW) (14-bit and 12-bit), TIFF, and JPEG (Fine/Normal/Basic) file formats.

System backup

Compatible with more than 60 current and many more non-current Nikkor lenses (functionality varies with older lenses); SB-series flashguns; Multi-Power Battery Pack MB-D12; Wireless Remote Controller WTR-1; GP-1 GPS unit; Stereo Microphone ME-1 and many other Nikon system accessories.

Software

Supplied with Nikon View NX2 (incorporates Nikon Transfer 2); compatible with Nikon Capture NX-D and many third-party imaging applications.

WINTER LIGHT «

The D810's sensor is extremely capable when it comes to low-light situations. 185mm, 1/400 sec., f/8, ISO 800

* FULL FEATURES AND CAMERA LAYOUT

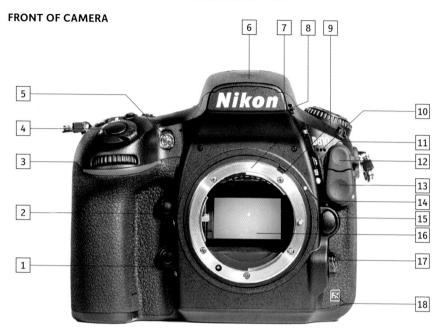

- 1 Fn button
- 2 Depth-of-field preview button
- 3 Sub-command Dial
- 4 Shutter-release button
- 5 AF-assist illuminator/Self-timer/Redeye reduction lamp
- 6 Built-in flash
- 7 Lens mount
- 8 Flash pop-up button
- 9 Meter coupling lever

- 10 Built-in microphone
- 11 Flash/Flash mode/Flash compensation button
- 12 Flash sync terminal cover
- 13 Ten-pin remote terminal cover
- 14 Mounting index
- 15 Lens-release button
- 16 Mirror
- 17 AF-mode button
- 18 Focus mode selector

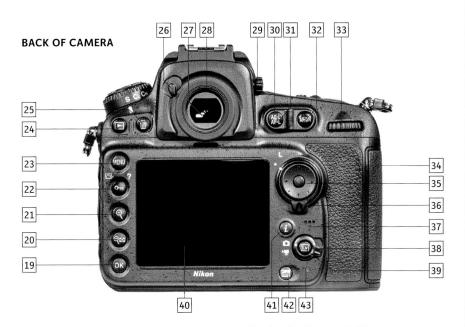

- 19 OK button
- 20 Thumbnail/playback zoom out button
- 21 Playback zoom in button
- 22 Protect/Picture Control/Help button
- 23 MENU button
- 24 Playback button
- 25 Delete/Format button
- 26 Eyepiece shutter lever
- 27 Viewfinder
- 28 Viewfinder eyepiece
- 29 Diopter adjustment dial
- 30 Metering selector
- 31 AE-L/AF-L button

- 32 AF-ON button
- 33 Main Command Dial
- 34 Memory card slot cover
- 35 Multi-selector
- 36 Focus selector lock
- 37 Speaker
- 38 Live view selector
- 39 Live view button
- 40 LCD monitor
- 41 *i* button
- 42 INFO button
- 43 Memory card access lamp

* FULL FEATURES AND CAMERA LAYOUT

TOP OF CAMERA

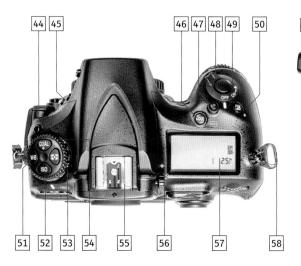

LEFT SIDE

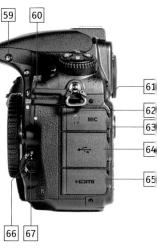

- 44 Release mode dial
- 45 Bracketing button
- 46 Exposure mode/Format button
- 47 Movie record button
- 48 Power switch
- 49 Shutter-release button
- 50 Exposure compensation/ two-button reset button
- 51 White Balance button
- 52 ISO/Auto ISO button

- 53 Metering button
- Image quality/Image size/two-button reset button
- 55 Accessory hotshoe
- 56 Focal plane mark
- 57 LCD control panel
- 58 Camera strap mount

- Flash pop-up button
- Flash/Flash mode/Flash compensation button
- 61 Connector cover
- Headphone connector
- 63 External microphone connector
- 64 **USB** connector
- [65] HDMI mini-pin connector
- 66 AF-mode button
- Focus mode selector

BOTTOM OF CAMERA

RIGHT SIDE

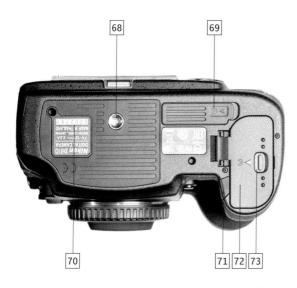

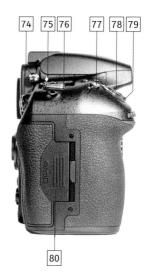

- 68 Tripod socket (¼in)
- 69 Contact cover for optional MB-D12 battery pack
- 70 Camera serial number
- 71 Power connector cover
- 72 Battery compartment
- 73 Battery compartment release lever

- 74 Diopter adjustment dial
- 75 Focal plane mark
- 76 Camera strap mount
- [77] Exposure compensation/ two-button reset button
- 78 Shutter-release button
- 79 Power switch
- 80 Memory card slot cover

» VIEWFINDER DISPLAY

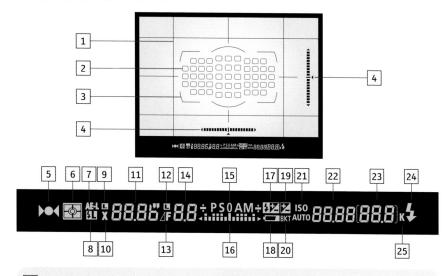

- 1 Framing grid
- 2 Focus points/AF-area mode
- 3 AF area brackets
- 4 Virtual horizon display
- 5 Focus indicator
- 6 Metering
- 7 Autoexposure (AE) lock indicator
- 8 FV lock indicator
- 9 Shutter speed lock indicator
- 10 Flash sync indicator
- 11 Shutter speed/Autofocus (AF) mode
- 12 Aperture lock indicator
- 13 Aperture stop indicator
- 14 Aperture (f no. or no. of stops)
- 15 Exposure mode

- 16 Exposure indicator or Exposure compensation display
- [17] Flash compensation indicator
- 18 Low battery warning
- 19 Exposure compensation indicator
- 20 Exposure and flash, WB, or ADL bracketing indicator
- 21 Auto ISO sensitivity indicator
- 22 ISO sensitivity/Preset white balance (WB) recording indicator/Flash compensation value/Active D-Lighting (ADL) bracketing amount/AF-area mode
- 23 No. of exposures remaining/in buffer/ Exposure or Flash compensation value
- 24 Flash-ready indicator
- [25] "K" (when over 1000 exposures remain)

» LCD CONTROL PANEL

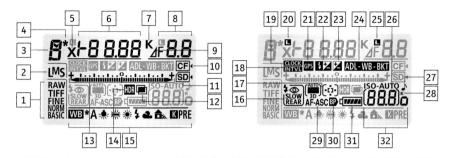

- 1 Image quality
- 2 Image size
- 3 Exposure mode
- 4 Flexible program indicator
- 5 Flash sync indicator
- 6 Shutter speed/Exposure or Flash compensation value/WB fine-tuning/Color temperature/WB preset no./No. of shots in exposure and flash bracketing sequence or in WB bracketing sequence/HDR exposure differential/No. of shots in multiple exposure/No. of intervals for interval timer photography/Focal length (non-CPU lenses)
- 7 Color temp. indicator
- 8 Aperture (f-no. or no. of stops)/Bracketing increment/No. of shots in ADL bracketing sequence or per interval/Maximum

- aperture (non-CPU lenses)/PC mode indicator
- 9 Aperture stop indicator
- 10 CF card indicator
- 11 SD card indicator
- Multiple exposure indicator
- Exposure, Exposure compensation, PC connection indicator
- 14 HDR indicator
- 15 WB/WB fine-tuning indicator
- 16 Flash mode
- 17 AF-area mode, Auto-area AF, or 3D-tracking indicator
- 18 Interval timer indicator/ Time-lapse indicator
- 19 "Clock not set" indicator
- 20 Shutter speed lock icon
- 21 GPS connection indicator
- 22 Flash compensation indicator

- 23 Exposure compensation indicator
- Exposure and flash, WB, or ADL bracketing, or ADL indicator
- 25 Aperture lock icon/HDR or Multiple exposure (series) indicator
- 26 ISO or Auto ISO sensitivity indicator
- 27 "Beep" indicator
- 28 "K" (when over 1000 exposures remain)
- 29 Autofocus mode
- 30 MB-D12 battery indicator
- 31 Battery indicator
- Two. of exposures remaining/No. of shots remaining in buffer/ISO sensitivity/Preset WB recording indicator/ADL bracketing amount/Timelapse recording indicator/Manual lens no./Capture mode indicator

» MENU DISPLAYS

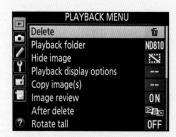

Playback menu

- > Delete
- > Playback folder
- > Hide image
- > Playback display options
- > Copy image(s)
- > Image review
- > After delete
- > Rotate tall
- > Slide show
- > DPOF print order

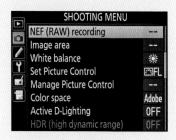

Shooting menu

- > Shooting menu bank
- > Extended menu banks
- > Storage folder
- > File naming
- > Primary slot selection
- > Secondary slot function
- > Image quality
- > IPEG/TIFF recording
- > NEF (RAW) recording
- > Image area
- > White balance
- > Set Picture Control
- > Manage Picture Control
- > Color space
- > Active D-Lighting
- > HDR (high dynamic range)
- > Vignette control
- > Auto distortion control
- > Long exposure NR
- > High ISO NR
- > ISO sensitivity settings
- > Multiple exposure
- > Interval timer shooting
- > Time-lapse photography
- > Movie settings

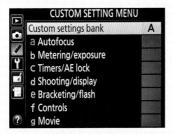

Custom Setting menu

> Custom settings bank

a: Autofocus

- > a1 AF-C priority selection
- > a2 AF-S priority selection
- a3 Focus tracking with lock-on
- > a4 AF activation
- > a5 Focus point illumination
- > a6 AF point illumination
- > a7 Focus point wrap-around
- > a8 Number of focus points
- > a9 Store by orientation
- > a10 Built-in AF-assist
- illuminator

 a11 Limit AF-area mode
- selection
 > a12 Autofocus mode restrictions

b: Metering/exposure

- > b1 ISO sensitivity step value
- > b2 EV steps for exposure
- > b3 Exp./flash comp. step

- b4 Easy exposure compensation
- > b5 Matrix metering
- > b6 Center-weighted area
- > b7 Fine-tune optimal exposure

c: Timers/AE Lock

- > c1 Shutter-release button AE-L
- > c2 Standby timer
- > c3 Self-timer
- > c4 Monitor off delay

d: Shooting/display

- d1 Beep
- > d2 CL mode shooting speed
- > d3 Max. continuous release
- > d4 Exposure delay mode
- > d5 Electronic front-curtain shutter
- > d6 File number sequence
- > d7 Viewfinder grid display
- > d8 ISO display and adjustment
- > d9 Screen tips
- > d10 Information display
- > d11 LCD illumination
- > d12 MB-D12 battery type
- > d13 Battery order

e: Bracketiny/Nash

- > e1 Flash sync speed
- › e2 Flash shutter speed
- e3 Flash control for built-in flash
- > e4 Exposure comp for flash
- > e5 Modeling flash
- > e5 Auto bracketing set

- > e6 Auto bracketing (Mode M)
- > e7 Bracketing order

f: Controls

- > f1 🌦 switch
- f2 Multi selector center button
- > f3 Multi selector
- > f4 Assign Fn button
- > f5 Assign **Pv** preview button
- > f6 Assign **AE-L/AF-L** button
- > f7 Shutter spd & aperture lock
- > f8 Assign BKT button
- > f9 Customize command dials
- > f10 Release button to use dial
- > f11 Slot empty release lock
- > f12 Reverse indicators
- f13 Assign movie record button
- > f14 Live View button options
- > f15 Assign MB-D12 AF-ON
- f16 Assign remote (WR) Fn button
- f17 Lens focus function buttons

g: Movies

- g1 Assign Fn button
- g2 Assign preview button
- > g3 Assign AE-L/AF-L button
- > g4 Assign shutter button

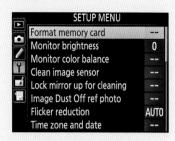

Setup menu

- > Format memory card
- Monitor brightness
- > Monitor color balance
- > Clean image sensor
- > Lock mirror up for cleaning
- > Image Dust Off ref. photo
- > Flicker reduction
- > Time zone and date
- > Language
- > Auto image rotation
- > Battery info
- > Image comment
- > Copyright information
- > Save/load settings
- > Virtual horizon
- > Non-CPU lens data
- > AF fine tune
- > HDMI
- > Location data
- > Network
- > Firmware version

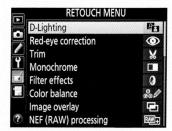

Retouch menu

- > D-Lighting
- > Red-eye correction
- > Trim
- > Monochrome
- > Filter effects
- > Color balance
- > Image overlay
- > NEF (RAW) processing
- > Resize
- > Quick retouch
- > Straighten
- > Distortion control
- > Fisheye
- Color outline
- > Color sketch
- > Perspective control
- > Miniature effect
- > Selective color
- > Edit movie
- > Side-by-side comparison

>>

QUICK NOTES

The D810's My Menu and Recent Settings menu give you rapid access to your favorite or previous settings.

300mm, 1/640 sec., f/9, ISO 200.

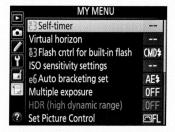

My Menu/Recent Settings

- > Add items
- > Remove items
- > Rank items
- > Choose tab

2 FUNCTIONS

The Nikon D810 is an incredibly capable and powerful tool, and it's probably true to say that few photographers will ever fully exploit all its potential. Of course, this power means complexity, which may seem daunting.

The appearance of complexity also arises because so much of the D810's power is on the surface. You can access key functions instantly through the buttons and dials, without having to delve into menus. For any serious photographer, this is entirely a good thing. Cameras which make you use menus for most settings are slower and more cumbersome in operation, and discourage experimentation.

However, if you do need to ease yourself in, you can just pick up the camera and start shooting, as Program mode will take care of the basics of exposure, and White Balance is initially set to Auto.

The D810 is like Nikon's other pro models in that it does not have the comfort blanket of Auto and Scene modes to take most of the decisions out of your hands. Sooner or later—probably sooner—it will be necessary to make some decisions of your own, the first of which will probably be over the ISO setting (see page 51), perhaps closely followed by Image Quality (see page 62), or Picture Control (see page 87) settings. And they're just the start...

FAMILIARIZATION

77

When you unpack a new camera, it is tempting to start shooting right away—and taking pictures is the best way to learn. However, it makes sense to peruse this book first, to make sure you don't miss out on new features and functions.

12mm, 5 sec., f/11, ISO 64.

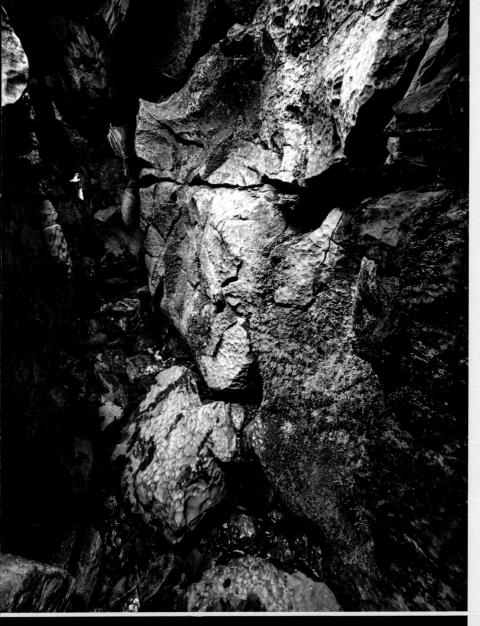

2 » CAMERA PREPARATION

Some basic steps, like charging the battery and inserting a memory card, are essential before you can use the camera. Setting the time, date, and time zone correctly is also a good idea, and the camera will prompt you to do this when it is first switched on (see under Setup menu, page 131).

of the buckle. Adjust the length as required, but leave a decent "tail" for security. When satisfied with the length, tighten the strap firmly and slide up the sleeve to keep the "tail" neatly tucked away. Repeat the operation on the other side.

Attaching the strap

To attach the strap, ensure the padded side faces inwards (so the maker's name faces out). Attach one end to the appropriate eyelet, located at the top left and right sides of the camera. Release the strap from the buckle, then pass the free end through the eyelet. Bring the end back through the buckle, at the side furthest from the eyelet, then double back through the other side

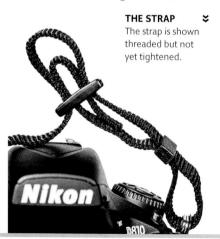

Adjusting for eyesight

The D810 offers dioptric adjustment, between -3 and +1 m⁻¹, to allow for individual variations in eyesight. Ensure this is optimized for your eyesight (wearing glasses or contact lenses if you normally do so) before using the camera. The diopter adjustment control is just to the right of the viewfinder. With the camera switched on, rotate this control until the viewfinder display (e.g. exposure readouts and other data) appears sharpest.

DIOPTER ADJUSTMENT

> Mounting lenses

Switch the camera off before changing lenses. Remove the rear lens cap and the camera body cap (or the lens, if already mounted). To remove a lens, press the lens-release button and turn the lens clockwise (as you face the front of the camera). Align the index mark on the lens with the one on the camera body (white dot), insert the lens gently into the camera, and turn it anti-clockwise until it clicks home. Do not use force: if the lens is correctly aligned it will mount smoothly. Avoid touching electrical contacts on the lens and camera body. Dirty contacts can cause a malfunction. Replace lens and body caps as soon as possible.

Most Nikon F-mount lenses can be used on the D810 (see page 192 for more detail). For lenses with an aperture ring, rotate this to minimum aperture before use on the D810.

LENS-RELEASE BUTTON

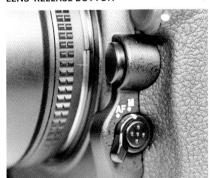

Inserting and removing memory cards

The D810 has dual card slots. One accepts Secure Digital (SD) cards, including SDHC and SDXC cards. The other takes Type 1 Compact Flash cards.

- 1) Switch off the camera and check that the green access lamp (on the camera back below the **LV** switch) is not lit.
- 2) Slide the card slot cover on the right side of the camera gently to the rear, until it springs open.

THE D810 HAS DUAL MEMORY CARD SLOTS

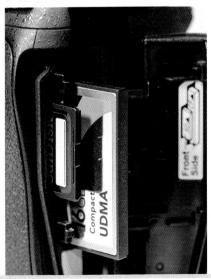

3) To remove a CF card, press the gray card eject button below the card slot. Pull the card gently from its slot.

- **4)** To remove an SD card, press the card gently *into* the slot until it springs out slightly. Pull the card gently from its slot without excessive force, until it is free.
- **5)** Insert memory cards with the label to the rear and the rows of terminals along the card edge facing into the slot. Slide the card into the appropriate slot until it clicks into place. In the case of CF cards, the eject button will spring out fractionally. The access lamp will light briefly.
- 6) Close the card slot cover.

Warning!

The card slot cover has no lock or latch and it is possible to open it accidentally, for instance, when taking the camera from a bag or pouch. Take care at such times. The cover is secure enough in normal shooting.

> Formatting a memory card

It's always recommended to format a new memory card, or one that has been used in another camera, before use with the D810. Often the camera will not recognize a card which has not been correctly formatted.

Formatting is also the quickest way to erase existing images so you can reuse the card—but always confirm first that images have been saved elsewhere.

One way to format a card is to press and hold the two FORMAT buttons (and MODE) for a few seconds, until a blinking FOR appears in the viewfinder and control panel (and Format in the information display, if active). If both card slots are occupied, the icon for the card in the primary slot (see page 102) will blink. Turn the Main Command Dial to select the secondary slot instead. Release the buttons and press them again to format the selected card. Press any other button to exit without formatting it.

You can also format card(s) through the Setup menu (see page 129), which I find quicker. Either way, you must repeat the procedure to format the second card. You cannot format both cards simultaneously.

> Inserting the battery

The Nikon D810 is supplied with an EN-EL15 li-ion rechargeable battery, as used in other models like the D610 and D7100. The battery should be fully charged before first use.

Invert the camera and locate the battery compartment below the handgrip. Release the latch to open the compartment. Insert the battery, contacts first, with its flat side facing towards the

lens. Use the battery to nudge the gold-colored latch aside, then slide the battery gently down until the latch clicks into position. Shut the battery compartment cover, ensuring it locks.

To remove the battery, switch off the camera, and open the compartment cover as above. Press the orange latch to release the battery and slide it gently from the compartment.

Warning!

Always make sure the camera is switched off before removing or replacing the battery.

Battery charging

Use the supplied MH-25 charger to charge the battery. Connect the power cord to a mains outlet. Align the battery, terminals first, with the slot on the charger: the battery will only fit this when correctly orientated. Slide the battery into the slot

until it snaps home. The Charge lamp blinks while the battery is charging, and shines steadily when charging is complete. A fully discharged battery will take around 2½ hours to recharge fully.

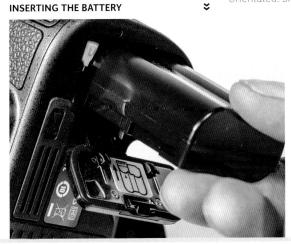

> Battery life

Battery life depends on various factors. Nikon do not recommend use at temperatures below 0°C or above 40°C (but see page 220). Other factors that can reduce battery life include: heavy use of the LCD screen; use of the built-in flash; long auto meter-off delays; and continuous use of autofocus (as when tracking moving subjects). Extensive Live View or movie shooting is particularly draining.

Under stringent (CIPA) conditions, tests show that it is possible to get about 1200 shots from a fully-charged EN-EL15 battery. In normal use, if you avoid the draining factors noted above, you may do considerably better.

The control panel gives an approximate indication of remaining charge; for more detail see **Battery Info** in the Setup menu (see page 131). A low battery icon appears in the viewfinder when the battery is approaching exhaustion. The control panel icon blinks when it is exhausted.

For information on alternative power sources, see page 215.

Tip

The charger can be used abroad (100–240 V AC 50/60 Hz) with a suitable travel plug adapter. Do not use a voltage transformer.

> Switching the camera on

The power switch, surrounding the shutterrelease button, has three settings:

OFF The camera will not operate.

ON The camera operates normally.

Move the power switch beyond **ON** and release (it will not stay in this position). This illuminates the control panel for about 10 seconds. Custom setting d11 allows you to keep the panel illuminated whenever the camera is active, which may be useful for night shooting but reduces battery life.

Tip

If the power switch is turned **OFF** while the camera is recording image file(s), the camera will finish recording before turning off.

POWER SWITCH AND SHUTTER-RELEASE BUTTON

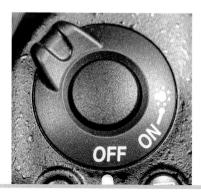

~

> Operating the shutter

The shutter-release button operates in two stages. Pressing it lightly, until you feel initial resistance, clears the information display, menus, or image playback (if active) and activates the metering and focus functions, making the D810 instantly ready to shoot. Press the button more firmly (but still smoothly) to take the picture.

PROTECTING THE D810

×

Although the Nikon D810's buttons and covers have seals, the camera is not waterproof, so it is sensible to take sensible precautions in dusty or damp conditions (see page 219). 145mm, 1/500 sec., f/8, ISO 320.

» BASIC FUNCTIONS

Key camera functions are principally accessed through the two command dials, Mode Dial, and release mode dial. Menu navigation is principally via the Multi-selector.

> Control panel and information display

All key shooting information is displayed in the control panel on the top right side of the camera. The same information, and more, can be viewed in a larger form—the information display—on the rear LCD screen by pressing info.

THE INFORMATION DISPLAY ON THE REAR LCD SCREEN

> Active Information Display

The initial information display is passive: it displays many settings but does not allow you to change them directly. It does, however, reflect changes you make by using buttons and dials. You can make it active, so you can change key settings directly from the information display, by pressing 4. This highlights the entries at the bottom of the screen. Move through them with the Multi-selector and press OK or (i) to enter the corresponding item.

Note:

The term "Active Information Display" is not used in Nikon's own literature. We've used it previously in books on Nikon DSLRs such as the D3300 and D5300. These models don't have a separate control panel and you interact and control the camera almost exclusively through the rear screen.

> Command dials

The Main and Sub-command dials are fundamental to the operation of the D810. Their function is flexible, varying according to the operating mode at the time. The plethora of different options may appear daunting but operation in practice turns out to be much more intuitive than a description in print might suggest.

Main Command Dial

In Shutter-priority or Manual mode, rotating the Main Command Dial selects the shutter speed. In Program mode it will engage program shift, changing the combination of shutter speed and

THE MAIN COMMAND DIAL

aperture. In Aperture-priority mode it has no effect.

Sub-Command Dial

In Aperture-priority or Manual mode, rotating the Sub-command Dial selects the aperture. In Shutter-priority or Program mode it has no effect.

Both dials, especially the Main Command Dial, have a range of other functions when used in conjunction with other buttons. Hold down the appropriate button while rotating the dial to make a selection.

THE SUB-COMMAND DIAL

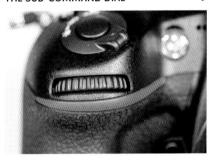

Even more functions can be added, as the command dials can also be used in conjunction with the **Fn**, Preview (**Pv**), and **AF-L/AF-L** buttons. You can choose which functions these perform through Custom Settings f4, f5, and f6 (see pages 120–123).

COMMAND DIAL	OTHER BUTTON	FUNCTION
Main		Select the level of exposure compensation
		(see page 47)
Main	AF-A	Select the flash mode (see page 155)
Sub	AF-A	Select the level of flash compensation (see
		page 158)
Main	QUAL	Select the image quality (see page 63)
Sub	QUAL	Select the image size (see page 65)
Main	ISO	Select the ISO sensitivity (see page 52)
Main	WB	Select the white balance setting (see page
		69)
Sub	WB	Select white balance preset (see page 70)
Main	♦	Select the metering mode (see page 44)
Main	•	Select AF mode (see page 54)
Sub	:	Select AF-area mode (see page 56)

> Multi-selector

The Multi-selector, on the camera back, is also an important part of the control system. Its primary uses are in navigating through images in playback (see page 81), navigating through the menus (see page 94) and selecting the focus point (see page 58).

The collar around the Multi-selector has an L (Lock) position. When this is locked, the Multi-selector can still be used for playback and menu navigation, but the focus point cannot be moved. To enable control of the focus point (see page 58), move the collar to the unlocked position (white dot).

The button at the center of the Multiselector () is used to confirm settings, and largely duplicates the function of **OK**. However, for some crucial operations, such as formatting a memory card, you can't use :: only **OK** will do. This helps reduce the risk that you'll make any major, and perhaps irreversible, changes accidentally.

FREEZING WATER

Here it was crucial to retain detail in the flowing water, so I opted for highlight-weighted metering. I was less concerned if some of the shadows lacked good detail—but, in fact, the dynamic range of the D810 is so good there's barely any shadow-clipping. 82mm, 1/500 sec., f/9, ISO 400.

THE MULTI-SELECTOR

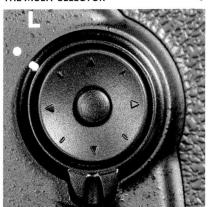

2 » RELEASE MODE

"Release mode" may perhaps seem an obscure term—it determines whether the camera takes a single picture or shoots continuously, and can also allow the shot to be delayed. The release mode dial has seven

possible positions. To prevent accidental switching between release modes the dial is provided with a lock button. Depress this to allow the dial to rotate to the desired position.

SETTING	DESCRIPTION	
S Single Frame	The camera takes a single shot each time the shutter release is fully depressed.	
C L Continuous Low speed	The camera fires continuously as long as the shutter release is fully depressed. The default frame rate is 3fps but this can be varied between 1 and 6 fps using Custom Setting d5	
The camera fires continuously at the maximum possible frame rate as long as the shutter release is fully depressed.		
Q Quiet mode	Shoot as normal but there are no alert beeps and the mirror-return after each shot is damped to provide a quieter release.	
Q c Quiet continuous	The camera fires continuously but there are no alert beeps and mirror-return is damped to provide a quieter release. May be marginally slower than CH under same conditions.	
The shutter is released a set interval after the releas button is depressed. Can be used to minimize came shake and for self-portraits. The default interval is 1 sec., but 2 sec., 5 sec., or 20 sec. can be set using Custom Setting c3.		
Mur Mirror-up	The mirror is raised when the shutter release is fully depressed; press again to take the picture. Useful to minimize vibration caused by "mirror slap". Can be used in conjunction with the electronic front-curtain shutter (see pages 76, 116) to reduce vibration still further.	

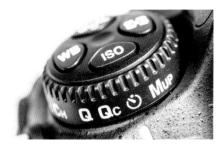

THE RELEASE MODE DIAL, SET TO SELF-TIMER

Tip

CL, CH and Qc release modes are not available when the built-in flash is raised. The maximum shooting rate for all file formats is around 5 frames per second (fps). This can rise to 6fps when you engage 1.2x or DX-crop modes (see page 65), and to 7fps when using these crop modes with certain alternative power sources. The maximum rate is not always attainable—any difficulty in focusing can slow things down, as can the use of slower shutter speeds. The speed of the memory cards can also be a factor that affects frame rate.

> Buffer

Images are initially held in the camera's internal memory ("buffer") before being written to the memory card(s). The maximum number of images that can be recorded in a continuous burst depends upon file quality, drive mode, card speed (see page 218), and how much buffer space is available.

The figure for the number of burst frames possible at current settings is shown in the viewfinder at bottom right when the shutter-release button is half-pressed. This figure assumes Continuous High speed shooting, but is displayed whatever release mode is selected.

If (0) appears, the buffer is full, and the shutter will be disabled until enough data has been transferred to the memory card to free up space in the buffer. This will normally only be an issue when shooting long continuous bursts in Continuous High speed release mode. Even then it is more likely to be noticed as a slowdown to 1 or 2 fps rather than a complete standstill, but on rare occasions you may have to lift your finger from the shutter-release button and re-press to resume shooting.

2 » EXPOSURE MODES

While Nikon's "consumer" DSLRs have a wide range of Auto and Scene modes, professional models like the D810 have just four exposure modes: Program, Shutter-priority, Aperture-priority, and Manual.

In Auto and Scene modes the majority of settings are controlled by the camera. These go beyond basic shooting settings (shutter speed and aperture) to include options such as release mode, whether or not flash can be used, and how the camera processes the shot. On the other hand, the four "core" modes found across the entire range give you complete freedom to make your own choices about these things. The differences between the core modes lie solely in how shutter speed and aperture are controlled.

> Setting the exposure mode

To set the exposure mode, press and hold **MODE** and rotate the Main Command Dial until the initial letter of the desired mode (**P**, **S**, **A**, or **M**) is displayed at top left in the control panel or information display. You can also do this with the camera at your eye, as the initial letter is also displayed in the viewfinder.

Note:

In any mode except **M**, if the camera determines that predetermined exposure limits are exceeded, the shutter speed and/or aperture digits will blink in the viewfinder and control panel. It's usually possible to achieve an acceptable exposure by adjusting the ISO sensitivity (see page 52).

> (P) Programmed auto

In **P** mode the camera sets a combination of shutter speed and aperture that will give correctly exposed results in most situations. This is ideal for snapshots and when time is of the essence, but some may feel it reduces creative control. However, you still have considerable room for maneuver through options like flexible program (see below), exposure lock (page 50), and exposure compensation (page 46).

Note:

Programmed auto mode is not available with older lenses lacking a CPU. If a non-CPU lens is attached, the camera will switch to Aperture-priority mode.

Flexible program

Without leaving **P** mode you can vary the combination of shutter speed and aperture by rotating the Main Command Dial to engage flexible program (also known as program shift). This is a very quick way to achieve practically the same direct control over aperture/shutter speed that you get in (**S**) Shutter-priority or (**A**) Aperture-priority modes. When flexible program is in effect

the ${\bf P}$ indication in the control panel and information display (but not the viewfinder) changes to ${\bf P}^*$.

TRAIN OF THOUGHT

×

Programmed auto mode allows a quick response but also lets you tailor camera settings to suit your own creative ideas. 85mm, 1/80 sec., f/10, ISO 100.

> (S) Shutter-priority auto

In Shutter-priority (**S**) mode, you control the shutter speed while the camera sets an appropriate aperture for correctly exposed results. Control of shutter speed is particularly useful when dealing with moving subjects (see page 40). You can set shutter speeds between 30 sec. and 1/8000 sec. You can fine-tune exposure through exposure lock, exposure compensation, and possibly auto bracketing as well.

LEAP OF FAITH

I set a fast shutter speed to freeze the figure mid-leap—but not too fast. There's just a hint of blur in hands and feet. I think it adds a touch of extra dynamism.

15mm, 1/250 sec., f/8, ISO 200.

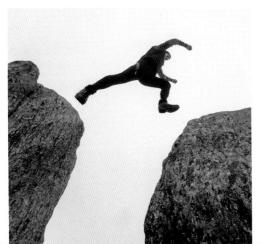

Significance of shutter speed

Shutter speed is significant mainly in relation to the way motion is recorded. Basically, high shutter speeds tend to freeze motion, while slower ones are more likely to record it with a degree of blur. This is relevant both to movement of your subject and to movement of the camera itself. Intentional camera movement, as in panning shots, can create very effective results. On the other hand, unintentional movement, usually termed camera shake, can ruin a shot. Using a fast shutter speed is just one way in which we can avoid or minimize the effects of camera shake. Movement is not just a concern for sports and wildlife specialists. For example, it can be an issue in portraits, especially of children and animals. Even in "static" landscape photography, movement is often present, whether it's scudding clouds, running water, or foliage swaying in the breeze

Note:

×

Shutter-priority auto is not available with older lenses lacking a CPU. If a non-CPU lens is attached, the camera will switch to Aperture-priority mode. The **S** indicator in the Control Panel will blink and **A** will be displayed in the viewfinder.

→ (A) Aperture-priority auto

In Aperture-priority (A) mode, you control the aperture while the camera sets an appropriate shutter speed to give correctly exposed results in most situations. Control of aperture is particularly useful for controlling depth of field (see page 41). The range of apertures that can be set is determined by the lens that's fitted, and not by the camera. Fine-tuning of exposure is possible through exposure lock and exposure compensation, and possibly auto bracketing.

Significance of aperture

Aperture is principally significant as one of the key factors influencing depth of field. Depth of field describes the zone, in front of and behind the actual point of focus, in which objects appear to be sharp in the final image. Sometimes a shallow depth of field is exactly what you want, as it makes the subject stand out against a soft background. For other images you may want to try and have everything sharp from front to back: this is the traditional approach in landscape photography, for instance.

Along with aperture, the other main factors determining depth of field are the focal length of the lens and the distance to the subject. With long lenses and/or nearby subjects, depth of field may remain quite shallow even at small apertures. This is particularly true in macro photography (see Chapter 5, page 168).

LIGHT ROCK

:

Aperture-priority mode is ideal for control over depth of field; here I used a wide aperture to help the rock stand out from its background. 200mm, 1/500 sec., f/4, ISO 64.

Note:

Aperture-priority auto is available with older lenses that lack a CPU. To get the best results when using such lenses, specify the maximum aperture of the lens using the **Non-CPU** lens data item in the Setup menu (see page 134).

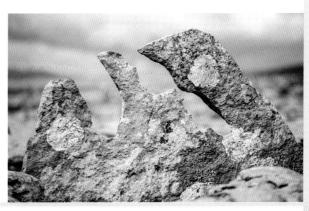

SHUTTER-PRIORITY AND APERTURE-PRIORITY

> Freezing the action

Still photos can capture motion in many different ways and frequently reveal drama and grace that may be missed with the naked eye or in a movie.

Freezing the action (as in the example on page 38) is only one approach. The deliberate use of slower shutter speeds to create controlled blur can be equally effective. A classic use of blur is the panning shot. Panning is usually easiest with a standard or short telephoto lens, provided you can get far enough back from the action.

NIGHT RACE

An evening cycle race gave me a chance to add a little extra to the standard panning shot. The flash gives a sharp image of the rider but panning the camera has created colorful streaks from the streetlights.

110mm, 1/20 sec., f/11, ISO 1000.

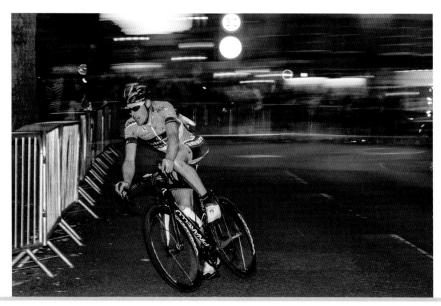

› Aperture and depth of field

When you're shooting landscapes, which have no single "subject", placement of the focus point can be quite important; you can use "hyperfocal distance" calculators or a rule of thumb like "the far end of the foreground".

If you really want to maximize depth of field, you need to try and stack all three key factors (focal length, aperture, distance) in your favor. This isn't always possible and you may have to decide which area is more important—the foreground or background.

FAR AND AWAY

÷

A classic approach to a landscape image. There's no single subject or focal point and most viewers would find it unnatural if any of this were unsharp. A short focal length and small aperture combine with careful placement of the focus point (just beyond the boulders) to maximize useful depth of field.

24mm, 1/250 sec., f/11, ISO 200.

> (M) Manual mode

In **M** mode, you control both shutter speed and aperture for maximum creative flexibility. The Main Command Dial controls shutter speed and the Subcommand Dial controls aperture. Manual mode is most comfortably employed when shooting without pressure of time or in fairly constant light conditions. Many experienced photographers use it habitually to retain complete control.

Shutter speeds can be set between 30 sec. and 1/8000 sec., as in Shutter-priority, but Manual mode offers a couple of additional options, T and B. The range of apertures that can be set is determined by the lens that's fitted.

T and B are the only options which allow exposures longer than 30 seconds. There are many potential subjects where such long exposures are essential, or at least desirable: fireworks displays, moonlit landscapes, star trails in the night sky, and more. You'll need a tripod or some other solid camera support.

The exposure meter gives no reading when T or B are set, as the camera cannot compute exposure when it does not know what the exposure time will be. Sometimes the only way to get the exposure right is by trial and error—which can, of course, be a long-winded process. Check there is plenty of juice in the battery before essaying any really long exposures.

B (Bulb)

If you rotate the Main Command Dial, **Bulb** appears in the viewfinder, control panel, and information display.

In Bulb mode, the shutter remains open as long as the shutter-release button is held down. However, holding it down with your finger can cause camera shake and soon becomes tedious and uncomfortable. It makes much more sense to use a cable release or remote cord (see Accessories, page 215). Exposures longer than 30 minutes are only possible in B.

T (Time)

If you rotate the shutter speed dial to position T, or use the Main Command Dial, *Time* appears in the information display but the viewfinder and control panel show two dashes instead.

In Time mode you press and release the button and the shutter remains open, either until you press it again or until 30 minutes have elapsed.

FIREWORKS

If there's no cable release to hand, the T setting is a good bet to minimize vibration when exposures longer than 30 sec. are required—as they often are for the best shots of fireworks. 24mm, 51 sec., f/16, ISO 100, tripod.

Using the Analog exposure displays

In Manual mode, an analog exposure display appears in the center of the viewfinder readouts and in the information display. This shows whether the photograph would be under- or overexposed at current settings. Adjust shutter speed and/or aperture until the indicator is aligned with the 0 mark in the center of the display: the exposure now matches the camera's recommendations. The D810's excellent metering means that this will generally be correct, but if time allows it is always helpful to review the image and check the histogram display after taking a shot (see Playback, page 84). If necessary, adjustments can then be made for creative effect or to achieve a specific result.

2 » METERING MODES

Metering—the measurement of light levels—is crucial in producing good images. The Nikon D810 provides four different metering modes—between them they should cover any eventuality. Switch between them using and the Main Command Dial. The viewfinder and information display both show which metering mode is in use.

METERING MODE BUTTON

Matrix (3D Color Matrix Metering III)

Using a 91,000-pixel color sensor, 3D Color Matrix Metering III analyzes the brightness, color, and contrast of the scene. When used with Type G or D

Nikkor lenses, the system also uses information about the distance to the subject to further refine its reading. With other CPU lenses, this range information is not used (Color Matrix Metering III). If non-CPU lenses are to be used, Color Matrix Metering can still be employed provided the focal length and maximum aperture are specified using the Non-CPU lens data item in the Setup menu.

Matrix metering is recommended for the vast majority of shooting situations and will generally produce excellent results.

> Center-weighted metering

This very traditional form of metering will be familiar to anyone with experience of older 35mm SLR cameras. Here the camera meters from the entire frame, but gives greater importance to the central area. At default setting, this area is a circle 12mm in diameter. Provided a CPU lens is attached, this can be changed to 8, 15, or 20mm using Custom Setting b6. You can also choose Average metering, which meters equally from the whole frame area.

Center-weighted metering can be useful in areas such as portraiture, where the key subject occupies the central portion of the frame.

> Spot metering

In this mode the camera meters from a circle 4mm in diameter (just 1.5% of the frame). If a CPU lens is fitted, this circle will be centered on the current focus point, allowing you to meter quickly from an offcenter subject. With a non-CPU lens, or if Auto-area AF is in use, the metering point will be the center of the frame.

Effective use of spot metering requires some experience, but in critical conditions it offers unrivalled accuracy. It is important to understand that spot metering attempts to reproduce the subject area as a midtone and this must be allowed for (e.g. by using exposure compensation) if the subject is significantly darker or lighter than a mid-tone.

› Highlight-weighted metering

This mode makes its debut on the D810. It appears to be related to matrix metering, in that it analyzes the entire frame, but is adjusted to retain maximum detail in the highlights. This makes it useful for brightly lit subjects against a dark background, such as a spotlit performer on a darkened stage. Wedding photographers will no doubt find it helpful when dealing with those white dresses. And it can have its place in landscape photography too, as another possible way of approaching scenes with brilliant white clouds or patches of snow.

NEW LEAVES

×

There's a lot of dark areas in this image, but I wanted the ferns to register as mid-tones rather than as highlights, so spot metering seemed a better bet than highlight-weighted metering. 180mm, 1/125 sec., f/4, ISO 100, tripod.

» EXPOSURE COMPENSATION AND BRACKETING

The D810 will deliver accurate exposures under most conditions, but no camera is infallible. Nor can it read your mind or anticipate your creative ideas. Sometimes the camera needs a little help to get the result spot-on.

All metering systems still rely, to some extent, on the assumption that key subject areas have average tonal value and should be recorded as a mid-tone. Most photographers have seen the results which sometimes arise, such as snow scenes appearing unduly dark. Where very light tones predominate, the metering will tend to reproduce them as mid-tones, i.e darker than they should be. Where very dark tones predominate, the converse is true.

In the days of film, considerable experience was needed to accurately anticipate the need for exposure compensation. With their instant feedback on exposure, digital cameras smooth the learning curve. It's always helpful—time permitting—to check the image, and specifically the histogram, after shooting (see page 84). However, the basic principle is simple enough: increase exposure to make the subject lighter (to keep light tones looking light): use positive compensation. Reduce exposure to make the subject darker (to keep dark tones looking dark): use negative compensation.

If this judgement is difficult, or lighting conditions are particularly extreme, an extra level of "insurance" is available through exposure bracketing (see page 48). Shooting RAW gives extra room for maneuver in post-processing, both to adjust overall tonal values and to recover detail apparently lost in both shadows and highlights. However, it's still best to aim for accurate exposure in the first place.

Note:

Exposure compensation will vary both aperture and shutter speed in P mode. In A mode, only the shutter speed varies, and in S mode, only the aperture. Exposure bracketing works similarly.

Tip

Active D-Lighting (see page 87) and D-Lighting (page 138) can also help to achieve better results in tricky lighting conditions. In addition, shooting NEF (RAW) images also gives more room for maneuver.

> Using Exposure compensation

- 1) Exposure compensation can be set between -5 Ev and +5 Ev, in steps of ½ Ev (default), ½ Ev, or 1 Ev. Use Custom setting b2 to change the increment. Note that any such change will also apply to flash compensation.
- 2) Press and rotate the Main Command Dial to set the negative or positive compensation required. You can see the compensation value change in the viewfinder, information display, and control panel.
- **3)** Release **2**. **2** will appear in all displays, and—in modes other than M—the Analog Exposure Display appears. The compensation level is indicated in

EXPOSURE COMPENSATION BUTTON

this, and the **M** at its center flashes. The chosen exposure compensation value is also shown numerically in the information display, and can be confirmed in the viewfinder or on the control panel by pressing **Z** again.

- **4)** Take the picture as normal. If time allows, check that the results are satisfactory.
- **5)** To restore normal exposure settings, press and rotate the Main Command Dial until the value returns to *0.0*. Try and remember to do this as soon as possible, otherwise it will apply to later shots which don't need exposure compensation.

Tip

Avoid exposure compensation in Manual mode. This doesn't affect the actual shutter speed or aperture values but can skew the exposure readouts.

2 » EXPOSURE BRACKETING

Often the quickest and most convenient way to ensure that an image is correctly exposed is to take a series of frames at differing exposures, and select the best one later. The D810's bracketing facility allows this to be done very quickly, especially when using CH (Continuous High speed) release mode.

- 1) Select the type of bracketing required using Custom setting e5. Select AE only to ensure that only exposure values are varied. If flash is not active, AE & Flash has the same effect
- 2) While pressing **BKT**, rotate the Main Command Dial to select the number of shots required for the bracketing burst. You can choose between 2, 3, 5, 7, and 9 shots. The selected number is displayed in the control panel.

BKT BUTTON

- **3)** Still holding **BKT**, rotate the Subcommand Dial to select the exposure increment between each shot in the sequence. Possible values are: 0.3 Ev, 0.7 Ev, 1 Ev, 2 Ev, and 3 Ev.
- **4)** Frame, focus, and shoot normally. The camera varies the exposure with each frame until the sequence is completed. If you shoot the bracketed sequence as a burst in CH or CL release mode, the camera will pause at the end of the sequence even if you keep the shutter-release depressed.
- **5)** To cancel bracketing and return to normal shooting, press **BKT** and rotate the Main Command Dial until **OF** appears in the information display, or the **BKT** icon disappears in the viewfinder. The bracketing increment that you chose using the Sub-command Dial will remain

Tip

Using exposure bracketing while shooting moving subjects is a lottery: the frame with the best exposure may not coincide with the subject being in the best position. Ideally, use another method to get the exposure settings right before shooting action sequences.

in effect next time you initiate bracketing. (I nearly always leave this set to **1.0**.)

If the memory card(s) become full before the sequence is complete, the camera will stop shooting. Replace a card or delete images to make space; the camera will then resume the sequence. Similarly, if the camera is switched off before the sequence is finished, it will resume when next switched on.

The D810 offers various forms of bracketing—choose between them using Custom Setting e6. The options are: AE & Flash; AE only; Flash only;

ROCK SHOW

Exposure bracketing has been used here (from left to right):

-1 Ev; 0 Ev; +1 Ev; 12mm, 1/200 sec./1/100 sec./1/50 sec., f/11, ISO 100, tripod.

AE & Flash varies both the exposure and the flash level. Flash only varies the flash level without changing the base exposure.

WB bracketing; and ADL bracketing.

WB bracketing varies the white balance setting. ADL bracketing varies the level of Active D-Lighting applied (see page 87).

Tip

For occasional bracketing in Manual mode, it's often easier to vary the shutter speed or aperture yourself. If metered exposure is 1/125 at f/11, a three-shot bracket with 1 Ev interval only requires a few clicks on the Main Command Dial to give speeds of 1/60 sec. and 1/250 sec. as well.

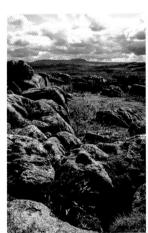

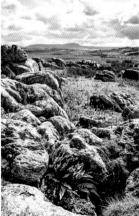

> Exposure lock

Exposure lock is, for many users, the quickest and most intuitive way to fine-tune the camera's exposure setting. It's useful, for instance, in situations where very dark or light areas (especially light sources) within the frame can over-influence exposure. Exposure lock allows you to meter from a more average area, by pointing the camera in a different direction or stepping closer to the subject, then hold that exposure while re-framing the shot you want.

Note:

Nikon does not recommend using exposure lock when you're using matrix metering, but don't let that stop you if matrix metering does not produce the desired result.

Using Exposure lock

- 1) Aim the camera in a different direction, or zoom the lens to avoid the potentially problematic dark or light areas. If you're using center-weighted or spot metering, look for areas of middling tone (but which are receiving the same sort of light as the main subject).
- **2)** Half-press the shutter-release button to take a meter reading, then keep it pressed as you press **AE-L/AF-L** to lock the exposure value.
- 3) Keep AF-L/AF-L pressed as you reframe the image and shoot in the normal way. By default, AF-L/AF-L locks focus as well as exposure. This can be changed using Custom Setting f6 Assign AF-L/AF-L button (see page 122). There are several options, but the most relevant for using exposure lock is AE Lock only. You can also opt for AE Lock (hold). In this case you can release AF-L/AF-L after step 2, and exposure will remain locked until you press AF-L/AF-L again, or the meters turn off.

» ISO SENSITIVITY SETTINGS

The ISO sensitivity setting governs the sensor's response to greater or lesser amounts of light. The wide and flexible ISO ranges of digital cameras—especially those with larger sensors like DSLRs—are among their very best features. The ability to pick a different ISO for every single shot, if you need to, is truly liberating.

At higher ISO settings, less light is needed to capture an acceptable image. As well as accommodating lower light levels, higher ISO settings are also useful when you need to use a small aperture for increased depth of field (see page 41) or to use a fast shutter speed to freeze rapid movement (see page 40). Conversely, lower ISO settings are useful in brighter conditions, and/or when you want to use

wide apertures or slow shutter speeds. The D810 offers ISO settings from 64 to 12,800. Image noise inevitably increases at higher settings, though the D810 manages it very well. In addition there are "extension" settings beyond the standard range. Lo0.3 is equivalent to 50 ISO, Lo0.7 to 40 ISO, and Lo1.0 to 32 ISO.

There are also **Hi** settings beyond the regular range. These take the ISO ratings to levels unimaginable with film. It must be said that noise does become more obvious, but nonetheless it is possible to produce usable images. These settings are **Hi0.3** (equivalent to 16,000 ISO), **Hi0.7** (20,800 ISO), **Hi1.0** (25,600 ISO), and **Hi2.0** (51,200 ISO).

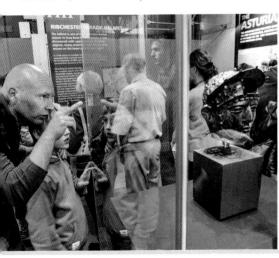

MUSEUM PIECE

"

The small museum was crowded with people who had come to see the Ribchester Paradé Hellmet one of the finest Roman artefacts in Britain—and there was really nowhere to set up lighting stands. Fortunately, image quality is still very good even at high ISO ratings. I was also quite glad to be using a VR lens (see page 206). 24mm. 1/6 sec., f/6.3, ISO 3200

Tip

The higher ISO speeds represent a real alternative to using flash under most conditions, but increased image noise will undoubtedly take the edge off the D810's ability to capture super-fine detail. Viewed at 100%, images may appear pretty dreadful. This is a good time to remember that 100% "pixel peeping" is not normal viewing, and images may still be perfectly acceptable for full-screen viewing and printing to a fair size. Experiment with these settings to see what level of image noise is acceptable for your needs.

> Setting the ISO

The most convenient way to set the ISO is normally by pressing **ISO** and rotating the Main Command Dial until the desired setting is shown in the information display, control panel, and viewfinder.

Alternatively, use the ISO sensitivity settings item in the Shooting menu. Easy ISO is another option. If enabled in Custom setting d8, this allows the ISO to be set simply by rotating the Main Command Dial (in Aperture-priority mode) or Sub-command dial (in Shutter-priority or Program modes).

> Auto ISO

The ISO sensitivity settings item in the Shooting menu has a sub-menu called Auto ISO sensitivity control. It's important to understand that this does not make ISO setting fully automatic (as it is in Auto and Scene modes on Nikon's "consumer" DSLRs). On the D810, it's more of a failsafe—you still set the ISO, but the D810 will automatically depart from the selected ISO if it determines that this is necessary for correct exposure.

For example, if you are using Shutterpriority with a shutter speed of 1/1000 sec. and an ISO setting of 100, prevailing light levels may not allow correct exposure within the aperture range available on the lens. The camera will then adjust the ISO until it can achieve acceptable exposure at an available aperture.

Using ISO options

Maximum sensitivity allows you to limit the maximum ISO, which the camera can employ when applying Auto ISO sensitivity control. For instance, you may feel that image noise is unacceptable at ISO levels above 3200, and would therefore set this as the limit in this sub-menu. Obviously, what constitutes "acceptable" is partly a matter of taste and partly dependent on how you intend to use the images.

The **Minimum shutter speed** submenu allows you to set a shutter speed

> ISO choices

limit below which the camera will not go. This only applies in P and A modes; in S and M modes the camera will continue to use the shutter speed you have set.

The sub-menu includes an **Auto** option; within this you can make a choice along a scale from **Slower** to **Faster**. If you err towards **Faster**, the camera will increase the ISO more quickly to maintain higher shutter speeds. The camera's decision about what shutter speed is acceptable is influenced by the focal length in use; longer lenses require higher shutter speeds to avoid camera shake. If you use a range of focal lengths, the flexibility offered by the Auto option is appealing.

BLURRING WATER

For this image, I used the lowest available ISO setting and a small aperture to get the longest possible shutter speed to blur the water. 24mm, 1 sec., f/22, ISO 32, tripod.

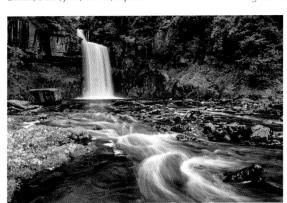

As well as accommodating lower light levels, higher ISO settings are also useful when you need a small aperture for increased depth of field (see page 41) or a fast shutter speed to freeze rapid movement (see page 40). Conversely, lower ISO settings are useful in brighter conditions, and/or when you want to use wide apertures or slow shutter speeds.

However, it's not a completely "free lunch". Higher ISO settings do affect the quality of images. Most obviously, image noise increases—the D810 manages it extremely well, but even so it does eventually become apparent, especially in images viewed or printed at large sizes. Noise appears as speckles of varying brightness or color. It's most obtrusive in areas that should have an even tone, such as clear skies.

Higher ISO settings also reduce the

dynamic range (the camera's ability to catch detail across a wide range of brightness, i.e. in deep shadows and bright highlights). Colors also become less saturated.

2 » FOCUSING

The D810 has a wide range of focus options, but they all boil down to how the camera focuses, determined by the focus modes, and where it focuses, determined by the AF-area modes.

> Focus modes

To switch between manual focus and autofocus use the focus selector switch on the front of the camera by the lens mount. To choose the AF mode (AF-S or AF-C), press ①, in the center of this switch, and rotate the Main Command Dial. While you do this, the settings can be seen in the viewfinder, control panel, and information display. The control panel and information display continue to indicate the chosen mode.

AF-S Single-servo AF

The camera focuses when you half-press the shutter release. Once focus is acquired, the focus indicator (a green dot) shows in the viewfinder. Focus remains locked on this point as long as you maintain half-pressure. This mode is recommended for accurate focusing on static subjects.

The shutter cannot release to take a picture unless focus has been acquired (focus priority).

FOCUS SELECTOR SWITCH

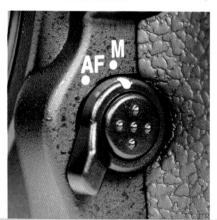

AF-C Continuous-servo AF

In this mode—recommended for moving subjects—the camera continues to seek focus as long as you keep the shutter release half-pressed. If the subject moves,

Tip

The focus priority/release priority settings can be changed using Custom settings a1 (for AF-C) and a2 (for AF-S).

the camera will refocus. The default setting here is **release priority**, allowing the camera to take a picture even if perfect focus has not been acquired. The D810 employs predictive focus tracking—if the subject moves while Continuous servo AF is active, the camera analyzes the movement and attempts to predict where the subject will be when the shutter is released.

Back-button autofocus

To focus the camera, in either autofocus mode, pressing **AF-ON** has the same effect as pressing the shutter release halfway. In fact, many pros choose to use only this button to activate focus (often called "back-button AF"). The logic is that this

allows you to get the best of both worlds (AF-C and AF-S). With the camera set to AF-C, you can focus by pressing **AF-ON**, then release it. The camera then does not refocus if you press the shutter-release button. On the other hand, if you keep pressure on **AF-ON**, the camera focuses continuously.

The end result is that you can effectively switch seamlessly between AF-C and AF-S, without any pause in shooting, merely by using **AF-ON**. It also means that the camera only refocuses when you tell it to, by deliberately pressing **AF-ON**.

To enable back-button AF, visit Custom setting a4 and select **AF-ON only**. Then ensure that the camera is set to Continuous-servo AF.

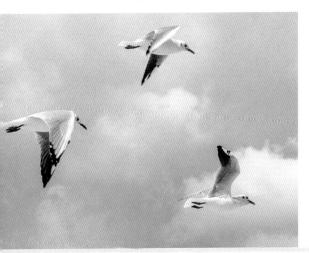

BIRD WATCHING

<<

AF-C mode tracks moving subjects (and at least the left-hand gull was within the compass of the focus areas). 70mm, 1/500 sec., f/11, ISO 320.

> (M) Manual focus

In time-honored fashion, focusing is done manually using the focusing ring on the lens. The D810's sophisticated AF capabilities might seem to make manual focus redundant, but many photographers still appreciate the extra level of control and involvement. Also, certain subjects and circumstances can bamboozle even the best AF systems.

The D810's bright, crisp viewfinder makes manual focusing straightforward. The process hardly requires description: set the focus mode selector to M and use the focusing ring on the lens to bring the subject into focus.

Electronic rangefinder

While focusing manually, you can still exploit the camera's focusing technology via the electronic rangefinder, which confirms when a subject is in focus. This can be faster and more precise than relying solely on the viewfinder image. It requires a lens of f/5.6 or faster (f/8 when using the central focus points), and light levels that would allow AF to be used.

The rangefinder requires you to select an appropriate focus area, as if you were using one of the AF modes. When the subject in that area is sharp a white dot appears at far left of the viewfinder readout; when not in focus, arrows help indicate whether focus is too near or too far.

> AF-area modes

The D810 has 51 focus points covering the central part of the frame (indicated by a faint outline in the viewfinder). To focus on the desired subject, the camera must use appropriate focus point(s)—this is the function of AF-area modes. To choose the AF-area mode, press and hold \odot and rotate the Sub-command Dial.

Single-area AF

In this mode, you select the focus area, using the Multi-selector to move quickly through the 51 focus points. The chosen focus point is illuminated in the viewfinder.

This mode is best suited to relatively static subjects, and marries naturally with AF-S autofocus mode.

Dynamic-area AF

Dynamic-area AF has several sub-modes. These can only be selected when the AF mode is AF-C (page 54).

In all sub-modes, you still select the initial focus point, as in Single-area AF. If the subject moves, the camera will then employ other focus points to maintain focus, but it's still trying to track the subject you selected, and will default back to the original focus point if possible.

The sub-mode options determine the number of focus points that will be employed for this: 9, 21, or all 51 points.

3D tracking

This uses a wide range of information, including subject colors, to track subjects that may be moving erratically.

Group-area AF

In this mode, you select a group of five focus points (though only the outer four appear in the viewfinder). You can move the group around, using the Multiselector, as you do with a single focus point. When you focus, the camera will take data from all five points and focus on the closest subject that coincides with one of them. This can improve initial focus acquisition when the subject is moving rapidly or erratically.

Tip

For action shooting, unless the subject is moving directly towards or away from the camera, I generally find 3D tracking the most effective mode.

Group-area AF is available whether AF mode is AF-S or AF-C (page 54). In AF-S, if a face or faces are detected, the camera will prioritize them for focusing.

Auto-area AF

This mode makes focus point selection fully automatic; in other words, the camera decides what the intended subject is. The camera employs facedetection technology, and if a human face is detected will prioritize it for focusing—which may or may not be what you want.

D810 VIEWFINDER

×

The viewfinder displays the focus points as well as an in-focus indicator at the left of the menu bar.

2 » FOCUS POINTS

The D810's 51 focus points cover the central part of the frame, almost equal to the DX crop area. This allows quick and accurate selection to cover most subjects, whether it's a static focus point when using AF-S or the initial focus point in AF-C.

Understandably, you can't manually select the focus point when Auto-area AF is engaged.

FLOWERS IN FOCUS

The ability to select focus points can be particularly crucial in close-up shooting—as with these flowers of pink purslane. 100mm macro (DX-crop), 1/100 sec., f/13, ISO 200, tripod.

Focus point selection

- 1) Make sure the focus selector lock (around the Multi-selector) is in the unlocked position (opposite the white dot).
- 2) Using the Multi-selector, move the focus point (or group) to the desired position. Pressing the center of the Multi-selector selects the central focus point, or centers the group (unless you change the options in Custom setting f1).
- **3)** Half-press the shutter-release button (or press **AFON**) to focus at the desired point. Press fully to take the shot.

Note:

Custom setting a7 (page 110) allows you to opt for focus point wrap-around, meaning that if you move the focus point to the edge of the available area, a further press on the Multi-selector in the same direction takes it to the opposite edge of the area.

Focus lock

Although the D810's focus points cover a wide area, they do not extend right to the edges of the frame—except in DX-crop, when they do give virtually 100% coverage. This suggests that DX-crop and/or DX lenses can be advantageous when shooting action subjects.

If you need to focus on a subject that lies outside this area, the simplest procedure is as follows:

- 1) Adjust framing to bring the subject within the area covered by the focus points.
- **2)** Select a focus point and focus on the subject in the normal way.

- **3)** Lock focus. In Single-Servo AF mode, this can be done either by keeping half-pressure on the shutter-release button, or by pressing and holding **AFON**. In Continuous-Servo AF, only **AFON** can be used to lock focus.
- **4)** Reframe the image as desired and fully press the shutter-release button to shoot. If you keep half-pressure on the shutter-release button (in AF-S), or hold down **AF-ON** (in either AF mode), focus remains locked for further shots.

Tip

If you're using back-button AF (see page 55), focus lock is arguably even simpler: at step 3, a single press on **AF-0N** sets focus and it remains set until you press **AF-0N** again.

Note:

At default settings. **AFON** locks exposure as well as focus, but this can be changed using Custom Setting f6.

> Low-light focusing

The 11 focus points closest to the center of the frame are the most sensitive. They are capable of focusing with lenses having a maximum aperture of f/8; the others need an aperture of f/5.6 at best. They are also the most likely to keep on working when light levels drop really low.

Lenses with an f/8 maximum aperture are rare—there's nothing in Nikon's lens lineup with a maximum aperture smaller than f/5.6—but many lenses become

effectively f/8 or worse when used with teleconverters (see page 202).

DIFFICULT PATH

**

Using RAW (see next page) enables you to make the best of images shot in tricky light conditions. 50mm, 1/250 sec., f/10, ISO 200.

NIGHT LIGHTS

×

I did use flash here, but only for fill-in: a high ISO setting was still necessary. The camera had no trouble focusing under street lighting. 100mm, 1/100 sec., f/4, ISO 3200.

2 » IMAGE QUALITY

Image quality settings are not some miraculous way of ensuring great pictures—that's still ultimately down to the eye of the photographer. "Image quality" refers to the file format, or the way that image data is recorded. The D810 can record three file types: NEF (RAW), TIFF, and JPEG. The essential difference is that TIFF and JPEG files undergo significant processing in-camera to produce files that should be usable right away (for instance, for direct printing from the memory card), without the need for further processing on a computer.

NEF (RAW) files record the raw data from the camera's sensor "as is", giving much greater scope for further processing to achieve exactly the desired pictorial qualities. This requires suitable software such as Nikon Capture NX-D or Adobe Photoshop (see Chapter 9, page 227). RAW or Camera RAW is a generic term for this

Tip

In fact, every RAW file includes an embedded JPEG image. This is used for image review and playback, and is also the basis of the histogram and highlights displays (page 84). However, you can't extract this JPEG for standalone use.

kind of file; NEF is a specific RAW file format used by Nikon.

NEF files can be recorded in either 12-bit or 14-bit depth. 14-bit files capture four times more color information, but produce larger file sizes, which may in turn mean that the camera takes fractionally longer to write them to the card. Any such slow-down is only likely to be noticeable when shooting at high frame rates.

The D810 is the first Nikon DSLR to offer the additional option of capturing images as sRAW, more fully known as Small-size NEF (RAW). In theory, at least, these allow you to continue capturing RAW images with fewer worries about any slowdown in shooting rates, something that sports photographers in particular have been demanding for some time. For more detail see under Image size (page 65).

The D810 can also simultaneously record two versions of the same image, one NEF (RAW) and one JPEG. The JPEG can provide a quick reference file for immediate needs, while the NEF (RAW) version is processed later for ultimate quality. You can opt for the JPEG to be saved to one memory card and the RAW to the other (see Secondary slot function in the Shooting menu, page 102).

> Setting image quality

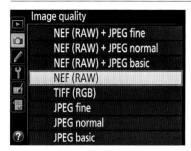

There are two ways to set image quality:

1) Hold down **QUAL** and rotate the Main Command Dial until the required setting

is displayed in the control panel or information display. This is usually quicker.

2) In the Shooting menu, select Image quality using the Multi-selector, then highlight and select the required setting. To determine whether NEF (RAW) files are recorded at 12-bit or 14-bit depth, or to opt for sRAW, use NEF (RAW) record. To determine whether NEF (RAW) files are recorded at 12-bit or 14-bit depth, or to opt for sRAW, use NEF (RAW) recording in the Shooting menu.

Image quality options

	image quanty options	
NEF (RAW)	12- or 14-bit NEF (RAW) files are recorded for the ultimate quality and creative flexibility. Alternatively, 12-bit sRAW files can be recorded. For NEF (RAW), there are three further options: compressed, lossless compressed, or uncompressed. Select with NEF (RAW) recording in the Shooting menu.	
TIFF	8-bit uncompressed TIFF files are recorded.	
JPEG fine	8-bit JPEG files are recorded with a compression ratio of approximately 1:4; suitable for demanding applications.	
JPEG normal	8-bit JPEG files are recorded with a compression ratio of approximately 1:8; suitable for many less critical uses.	
JPEG basic	8-bit JPEG files are recorded with a compression ratio of approximately 1:16, suitable for online use but not recommended for printing.	
NEF (RAW) + JPEG fine NEF (RAW) + JPEG normal NEF (RAW) + JPEG basic	JPEG normal simultaneously, one NEF (RAW) and one JPEG.	

2 » IMAGE AREA AND IMAGE SIZE

The D810 offers multiple options for both Image area and Image size. Image area refers to the portion of the sensor used to capture the image; Image size refers to the dimensions (in pixels) of the final image file.

> Image area

The D810 normally captures images using the whole of its 35.9 x 24mm FX-format sensor (labelled **36 x 24** for brevity). Alternative settings can be chosen through the Shooting menu: select **Image area**, then **Choose image area**.

DX (24 x 16) uses the central 24 x 16mm area of the sensor, equivalent to a DX-format camera. The image size is still around 15 megapixels, which is ample for many purposes. DX-crop enables the use

of DX lenses (see below), and may also allow a higher frame rate. It boosts the effective focal length of your lenses (see page 194), and it means that the focus sensors cover most of the frame.

5:4 (30 x 24) captures images from an area 30mm wide; this aspect ratio is closer to many standard print sizes.

The **1.2x (30 x 20)** setting crops the image moderately while maintaining the standard aspect ratio. It also has a 1.2x "teleconverter" effect (see page 202).

The viewfinder display adapts to image area selection by showing a heavy outline around the chosen area. The area excluded can also be shown grayed out, which can make framing easier, but only when **AF point illumination** (Custom Setting a6) is **Off**.

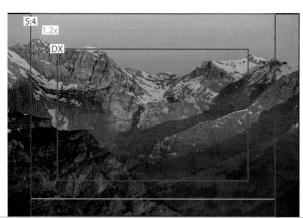

IN THE FRAME The available still-image area selections,

area selections, superimposed on the full FX frame.

Using DX lenses

DX lenses are designed for optimum performance with smaller DX-format sensors, as used in cameras like the D7100. They do not cover the full area of the FX-format sensor, so the corners of the frame are blacked out—an extreme case of vignetting (see pages 104 and 198).

By default, the D810 automatically detects when DX lenses are fitted and sets a DX-format crop. This option can be turned off via **Auto DX crop** under **Image area** in the Shooting menu.

> Image size—JPEG and TIFF

When shooting JPEG or TIFF, the D810 offers three options for image size. The final image dimensions also depend on the chosen Image area (see table below).

When Image area is set to FX, Medium is roughly equivalent to a 20-megapixel camera, and Small to a 9-megapixel camera. These smaller sizes take up much less space

on memory cards and computer hard drives, but in respect of criteria like noise and dynamic range these images will be far superior to those produced by most smaller cameras. Even Small size images exceed the maximum resolution of almost any computer monitor and are far beyond the approximately two megapixels of an HD TV. They can yield good quality prints to at least A4 size. However, if you habitually use these image size settings you might question the point of buying a 36-megapixel camera in the first place.

Setting image size

There are two ways to set image size:

- 1) Hold down **QUAL** and rotate the Subcommand Dial until the required setting is displayed in the control panel/information display. This is usually quicker.
- 2) In the Shooting menu, select Image size using the Multi-selector, then highlight and select the required setting.

Image size options and dimensions

inage size options and annensions			
Image area	Large	Medium	Small and sRAW
FX (36 x 24)	7360 x 4912	5520 x 3680	3680 x 2456
5:4 (30 x 24)	6144 x 4912	4608 x 3680	3072 x 2456
1.2x (30 x 20)	6144 x 4080	4608 x 3056	3072 x 2040
DX	4800 x 3200	3600 x 2400	2400 x 1600

> Image size—RAW

The D810 is the first Nikon to offer the option of capturing sRAW or Small-size NEF (RAW) images. It is also, therefore, the first to have an **Image size** dialog among its **NEF (RAW) recording** options in the Shooting menu (you can't select RAW Image size options using **QUAL** and the Sub-command Dial). The image sizes yielded by sRAW are the same as for Small images when shooting JPEG/TIFF (see the table on page 65).

sRAW images are produced by downsampling from the original sensor data. As well as creating an image with smaller pixel dimensions, they are always recorded at 12-bit depth. There is no 14-bit option as there is with full-size RAW images. In fact some independent tests suggest that these files are really only

11-bit. The result is that there is less data to play with and therefore less room for maneuver in post-processing. It does appear in tests that there is less chance of recovering good shadow/highlight detail when images are significantly under- or overexposed. On the plus side, however, image noise appears very well controlled in sRAW images shot at high ISO ratings.

It also appears that the gain in shooting speed/buffer capacity with sRAW is not all that it's cracked up to be—in fact, shooting full-size RAW in 12-bit with **NEF (RAW)** compression set to Compressed may yield a longer burst than sRAW. This appears to be due to the extra processing load in downsampling for sRAW. For the same reason, shooting sRAW may also have some impact on battery life.

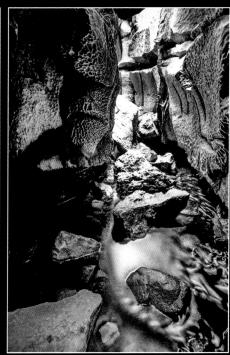

sRAW LIMITS

These two shots have identical exposure settings and were also processed identically in Lightroom (0.33 stop overall exposure, +100 on the shadow slider, and local highlight reduction). I'm sure there's more I could do but the difference is already striking. The sRAW image (right) shows garish colors in the shadow areas, where they aren't empty black. The true RAW file may look a bit subdued by comparison but there is a lot more detail in the shadows that could be used to get a finer image.

19mm, 30 sec., f/11, ISO 64, tripod.

2 » WHITE BALANCE

Light sources, natural and artificial, vary enormously in color. The human eye and brain are very good (though not perfect) at compensating for this and seeing people and objects in their "true" colors, so that we nearly always see grass as green, and so on. Digital cameras also have a capacity to compensate for the varying colors of light and, used correctly, the D810 can produce natural-looking colors under almost any conditions you'll ever encounter.

The D810 has a sophisticated system for determining white balance automatically, which produces very good results most of the time. For finer control, or for creative effect, the D810 also offers a wide range of user-controlled settings.

Tip

Sometimes "correct" color is not desirable. A classic example is shooting landscapes by the warm light of early morning or late evening, where the reddened hue of the sunlight is part of the appeal. Auto White Balance may neutralize this effect. To avoid this, try the Direct sunlight setting, or better still, shoot RAW images.

Tip

When shooting RAW images, the incamera white balance (WB) setting is not crucial, as white balance can be adjusted in later processing. However, it affects how images look on playback and review, so there is still some value in setting WB appropriately.

> Setting the white balance

There are two ways to set the white balance:

Using the Active Information Display

1) Hold down **WB** and rotate the Main Command Dial until the required symbol is displayed in the control panel. This is generally the quicker method, but the second method below offers extra options.

2) In the Shooting menu, select White balance using the Multi-selector, then highlight and select the required setting. In most cases, a graphical display appears, with which you can fine-tune the setting using the Multi-selector. Or just press OK to accept the standard value.

> Fine-tuning white balance

The basic options offered by **WB** and the Main Command Dial, or the top level of the Shooting menu item, are just the start.

Fine-tuning with the Sub-command Dial

For most of the standard white balance settings, if you hold **WB** and turn the Sub-command Dial, you'll see a letter and number in the information display. Turn the dial to the left to shift the image towards amber (settings **a1-a6**). Turn it to the right to shift the image towards blue (settings **b1-b6**).

WHITE BALANCE

*

These images were shot with different white balance settings to show the changes in color caste: 1) Incandescent; 2) Cool-white fluorescent; 3) Direct sunlight; 4) Flash; 5) Cloudy; 6) Shade.

Fine-tuning in the Shooting menu

When you select **Auto** in the Shooting menu, there are two sub-options: **Normal** (AUTO1), which keeps colors correct as far as possible, and **Keep warm lighting** colors (AUTO2), which does not fully correct warm hues such as those generated by incandescent lighting. This could be worth experimenting with for sunrise or sunset shots as well.

If you select **Incandescent**, **Direct sunlight**, **Flash**, **Cloudy**, or **Shade**, then press ▶ , a graphical display appears, with which you can fine-tune the setting using the Multi-selector. When done, press ★ to accept the new value.

When you select **Fluorescent**, a submenu appears from which you can select the appropriate variety of fluorescent lamp. (The default is 4: **Cool-white fluorescent**.) If required, you can then press to do some further fine-tuning with the graphical display, as above.

Note:

If you use Method 1 to select **Fluorescent**, the precise value will be whatever was last selected in the sub-menu under the Shooting menu. If you've never done this, the default will apply.

Note:

Energy-saving bulbs, which have largely replaced traditional incandescent (tungsten) bulbs in domestic use, are compact fluorescent units. Their color temperature varies but many are rated around 2700°K, equivalent to Fluorescent setting 1: Sodium-vapor lamps. With any new or unfamiliar light source it's always a good idea to take test shots if possible, or allow for adjustment later by shooting RAW files.

PRE Choose color temp.

This option allows you to dial in a specific color temperature. If you select it using the Main Command Dial, you can adjust the numerical value using the Sub-command Dial. If you select it in the Shooting menu, you gain an extra option to adjust the balance on a green-magenta scale alongside the color temperature scale.

Preset Manual White Balance

You can set the white balance to precisely match any lighting conditions, by taking a reference photo of a neutral white object, or by copying white balance data from an existing image on the memory card. This is

lcon	Menu option	Color temp.	Description			
AUTO	AUTO/Normal Keep warm ligh	3500-8000°K ting colors	Camera sets the white balance automatically.			
*	Incandescent	3000°K	Use under incandescent (tungsten) lighting, such as household bulbs.			
	Fluorescent (submenu offers seven options):					
	1) Sodium- vapor lamps	2700°K	Use under sodium-vapor lighting, often used in sports venues.			
	2) Warm-white fluorescent	3000°K	Use under warm-white fluorescent lighting.			
	3) White fluorescent	3700°K	Use under white fluorescent lighting.			
\	4) Cool-white fluorescent	4200°K	Use under cool-white fluorescent lighting.			
	5) Day-white fluorescent	5000°K	Use under daylight white fluorescent lighting.			
	6) Daylight fluorescent	6500°K	Use under daylight fluorescent lighting.			
	7) High temp. mercury-vapor	7200°K	Use under high color temperature lighting, such as mercury-vapor lamps.			
*	Direct sunlight	5200°K	Use for subjects in direct sunlight.			
4	Flash	5400°K	Use with built-in flash or separate flash unit.			
2	Cloudy	6000°K	Use in daylight, under cloudy or overcast skies.			
À //,	Shade	8000°K	Use on sunny days for subjects in shade.			
K	Choose color temp.	2500°K- 10,000°K	Select color temperature manually.			
PRE	Preset manual	n/a	Derive white balance direct from subject, light source, or existing photo.			

» COLOR SPACE

undoubtedly a valuable facility when absolute color accuracy is required (for instance, for professional images of fabrics or artwork), but it is, quite frankly, a complicated procedure that few of us will ever employ. If you do need to do this for JPEG or TIFF images, see the Nikon manual for details; you'll see that it covers a total of 10 pages.

It's normally much easier to shoot RAW and tweak the white balance later; a reference photo is helpful for this when high precision is required. The RAW route is not only easier in itself, but also avoids the pitfall that the Preset Manual setting will go on being applied to shots when it's no longer appropriate.

Tip

The endpapers of this book are designed to serve as "gray cards", ideal for reference photos for setting a preset white balance or for precise post-processing of RAW images.

The D810 offers sRGB and Adobe RGB color spaces; these define the range (or gamut) of colors which are recorded. sRGB (the default setting) has a narrower gamut but images often appear initially brighter and more punchy. It's the color space typically used on the Internet and in most photo printing stores, for example, and is appropriate for images that will be used or printed straight off, with little or no post-processing. Most mobile devices and the majority of computer screens have a narrower gamut even than sRGB. The D810's monitor screen gets pretty close to it.

Adobe RGB has a wider gamut and is commonly used in professional printing and reproduction. It's a better choice for images that are destined for professional applications or where significant post-processing is anticipated.

To select the color space, use the **Color space** item in the Shooting menu.

High-end computer screens generally have a wider gamut than sRGB but only a small proportion can equal or do better than Adobe RGB; these are generally very expensive.

» TWO-BUTTON RESET

The D810 offers a quick way to reset a large number of camera settings (listed below) to default values. Hold down **QUAL** and **\(\mathbb{Z}\)** (marked with green dots) together for at least two seconds. The information display will blank out briefly while the reset is completed.

	DEFAULT SETTING	
Focus point	Center	
Exposure mode	(P) Programmed auto	
Metering mode	Matrix	
Flexible program	Off	
Exposure compensation	Off	
AE lock hold	Off	
Aperture lock	Off	
Shutter speed lock	Off	
Bracketing	Off	
AF mode	AF-S	
AF-area mode	Viewfinder: single-point AF	
	Live View and movie: Normal-area AF	
Flash mode	ode Front-curtain sync	
Flash compensation	Off	
FV lock	Off	
Exposure delay mode	Off	
+ NEF (RAW)	Off	
Image quality	JPEG Normal	
Image size	Large	
White balance	Auto (Normal)	
Picture Control	Current Picture Control reset to base settings	
IIDR	Off	
ISO sensitivity	100	
Auto ISO	Off	
Multiple exposure	Off	
Interval timer shooting	Off	
Bracketing	Off	
Monitor color balance	Standard	
Highlight display	Off	
Headphone volume	15	

2 » LIVE VIEW

LV LIVE VIEW ACTIVATION SWITCH

When Live View first began to appear on DSLRs, it was generally seen as an adjunct to the viewfinder, not a substitute for it. The SLR is essentially designed around the viewfinder and it still has many advantages for the majority of picture-taking—it's more intuitive and offers the sense of a direct connection to the subject. It also carries much less risk of camera shake, and viewfinder-based autofocus is faster.

However, cameras like the D810 change the equation, at least for those who really aim to exploit its massive resolution to the fullest extent. Such critical shooters will use tripods more regularly, but this reduces the ergonomic advantage of the viewfinder. Also, Live View focusing, though much slower than viewfinder-based AF, is more accurate. I find it particularly useful in macro shooting (see page 168).

Live View is also the jumping-off point for shooting movies with the D810. Movies

are covered in Chapter 6 (see page 178)—however, familiarity with Live View gives you a head-start when you first move into shooting movies.

> Using Live View

To activate Live View, make sure the **Liv** switch on the rear of the camera is set to the still photography position **...** Press the button at its center to start shooting.

The mirror flips up, the viewfinder blacks out, and the rear monitor screen displays a continuous live preview of the scene.

Press the release button halfway to focus, fully to take a picture, as when shooting normally. If you're shooting in CH or CL release mode, the mirror stays up,

LIVE VIEW

Live View display options include an analog exposure display (exposure preview only).

and the monitor remains blank between shots, making it hard to follow moving subjects. To exit Live View press the center button again.

Live View display options

A range of shooting information is displayed at top and bottom of the screen, partly overlaying the image. Pressing **info** changes this information display, cycling through a series of screens as shown in the table below.

Exposure Preview

Normally the Live View display shows the scene at a standardized brightness. However, the D810 gives you the option of a live preview, showing the effect of current exposure settings on the final image. To activate this preview, simply press of during Live View shooting. If the results look under- or overexposed, you can use Exposure compensation (page 46) to

rectify matters (in mode M, adjust aperture, shutter speed or ISO). The screen also shows an analog exposure display at the right-hand side, and can display a histogram (see above). Press **OK** again to exit Exposure Preview.

There are some limitations: for obvious reasons, the preview can't show what the results will be if you're planning to use flash for the actual shot, or if bracketing is in effect. It may also be less than 100% accurate if Active D-Lighting or HDR are being used. And, as ever, the screen can be hard to see properly in bright sunlight.

Tip

Whether you engage Exposure Preview or not, the Live View image does reflect the selected Picture Control.

Live View info	Details	
Information ÜN	Information hars superimposed at top and bottom	
	of screen	
Information OFF	Top information bar disappears, key shooting	
	information still shown at bottom	
Framing guides	Grid lines appear, useful for critical framing	
Histogram	(Available in exposure preview only)	
Virtual horizon	Displays a horizon indicator on the monitor to assist	
	in leveling the camera.	

> Live View quick adjustments

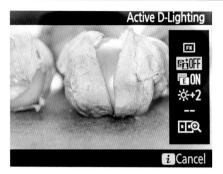

LIVE VIEW QUICK ADJUSTMENT

A number of key settings can be quickly adjusted on screen in Live View. Press ◆ to reveal these items at the right side of the screen. Scroll up or down using ▲ / ▼; press ▶ or ★ to access the highlighted item.

The items in the following table are included.

Live View quick adjustments	Details	
lmage area	See page 64. Settings changed here also apply in	
	normal shooting.	
Active D-Lighting	See page 87. Settings changed here also apply in	
	normal shooting.	
Electronic front-curtain	Use to enable Electronic front-curtain shutter in Mup	
shutter	shooting mode (see pages 34, 116). Settings changed	
	here also apply in normal shooting.	
Monitor brightness	Adjust screen brightness with ▲ /▼. This only affects	
	the screen image and has no effect on the exposure	
	level of the actual images you shoot. Settings changed	
	here do not apply in normal shooting.	
Display white balance	Select white balance settings (no fine-tuning).	
	Settings changed here do not apply in normal	
	shooting.	
Split-screen display	een display Enable split-screen display zoom (see opposite).	
zoom		

Tip

Display white balance is most likely to be useful if you're shooting with flash, as the color balance of the flash may be very different from the ambient light you're using to view and frame the shot.

Split-screen display zoom

The split-screen display is another feature which makes its Nikon DSLR debut in the D810. As the name suggests it splits the screen into two. Each half shows a magnified view of part of the image. By default, the magnification is only slight, but you can zoom in much more closely. The most obvious use for this is as a check on whether the horizon, or other key horizontal line, is level: it's more precise than the virtual horizon indicator (see page 134).

- 1) With Live View active, press .
- 2) Scroll to the Split-screen display zoom icon and press ▶ or (OK).
- 3) By default, the left-hand box is selected (shown by a yellow border). To switch to the right-hand box, press ?/0-n.

LIVE VIEW SPLIT-SCREEN DISPLAY

- 4) To move the selected box anywhere within the appropriate half of the frame, use the Multi-selector.
- 5) To zoom in (both boxes zoom equally), press ♥■. To zoom out press ♥■. Five presses reaches maximum magnification, which is equal to the maximum zoom in the normal Live View display.
- 6) To focus on the subject in the selected box, half-press the shutter release or press AF-ON. The camera will focus in the box even if the focus point was previously placed in another area.
- 7) To exit split-screen and return to the normal Live View display, press 4 again.

> Focusing in Live View

FOCUSING IN LIVE VIEW

The focus area is a red rectangle, which turns green when focus is acquired and can be positioned anywhere on screen.

Focusing in Live View operates differently from normal shooting; because the mirror is locked up, the usual focusing sensors are unavailable. Instead, the camera takes its focus information directly from the main image sensor. This is significantly slower than normal AF operation—so Live View is often unsuitable for fast-moving subjects—but it is very accurate. You can zoom in on the scene for a critical focus check: this can be extremely useful when ultra-precise focusing is required, as in macro work.

Live View has its own autofocus options: two AF modes and four AF-area modes

Live View AF modes

The AF-mode options are Single-servo AF (AF-S) and Full-time servo AF (AF-F). AF-S

corresponds to AF-S in normal shooting: the camera focuses when the shutter release is pressed halfway, and focus remains locked as long as the shutter release remains depressed.

AF-F corresponds roughly to AF-C in normal shooting. The camera continues to seek focus as long as Live View remains active. When the shutter-release button is pressed halfway the focus will lock, and remains locked until the button is released, or a shot is taken.

Select the Live View AF mode as follows:

- 1) Activate Live View.
- **2)** Press ••• and use the Main Command Dial to toggle between AF-S and AF-F, highlighted in yellow on the screen.

Live View AF-area mode

AF-area modes determine how the focus point is selected. Live View AF-area modes do not correspond to the ones used in normal shooting. See below for details of the four Live View AF-area modes. Select the Live View AF-area mode as follows:

- 1) Activate Live View.
- 2) Press and use the Sub-command Dial to select the AF-area mode (highlighted in yellow) on the monitor.

> Using Live View AF

WIDE Wide-area AF and Normal area AF

In both these AF-area modes, the focus point (outlined in red) can be moved anywhere on the screen, using the Multiselector in the usual way. The difference is simply that in 📆 the area is much smaller. Pressing 🗨 zooms the screen view, helpfully centered on the focus point. Press repeatedly to zoom closer. This allows ultra-precise focus control, ideal for macro photography (page 168). Once the focus point is set, autofocus is activated as normal by half-pressing the shutter-release button. The red rectangle turns green when focus is achieved.

Tip

Display white balance is most likely to be useful if you're shooting with flash, as the color balance of the flash may be very different from the ambient light you're using to view and frame the shot.

FOLIAGE IN FOCUS

ion 🕏

Normal area AF is the best choice for precision and accuracy—very necessary here as depth of field was minimal. 50mm macro, 1/10 sec., f/8, ISO 200, tripod.

[9] Face-priority AF

When this mode is active, the camera automatically detects up to 35 faces and selects the closest. The selected face is outlined with a double yellow border. You can override this and focus on a different person by using the Multi-selector to shift the focus point. To focus on the selected face, press the shutter-release button halfway.

info Subject-tracking AF

When Subject tracking is selected, a white rectangle appears at the center of the screen. Align this with the desired subject using the Multi-selector, then press 🔝. The camera "memorizes" the subject and the focus target then turns yellow. It will now track the subject as it moves, and can even reacquire the subject if it temporarily leaves the frame. To focus, press the shutter-release button halfway; the target rectangle blinks green as the camera focuses and then becomes solid green. If the camera fails to focus the rectangle blinks red instead: pictures can still be taken but focus may not be correct. To end focus tracking press 💭 again.

> Manual focus in Live View

Manual focus is engaged simply by rotating the focus ring on the lens. However, the Live View display continues to reflect the selected Live View AF mode. It's helpful to have Wide-area AF or Normal-area AF selected, as the display still shows a red rectangle of the appropriate size. You don't have to focus manually on this point, but if you zoom in for more precise focusing, the zoom centers on the area defined by the rectangle. You can also scroll to any point on screen using the Multi-selector.

Aperture in Live View

Unlike viewfinder photography, where the aperture remains at maximum until the shot is taken, in Live View the lens is stopped down. This obviously offers a continuous depth of field preview. However, if you change the aperture setting while in Live View, the aperture itself doesn't update unless you exit Live View and re-enter, or take a shot.

To take full advantage of precise focusing in Live View, it helps to have the aperture at its widest as minimal depth of field makes subjects snap in and out of focus more clearly. By pressing the Pv button, you can temporarily open the aperture for this purpose—we could call this "reverse depth of field preview". Press Pv again, or take a shot, to revert aperture to the selected setting.

» IMAGE PLAYBACK

The D810's large, bright, high-resolution LCD screen makes image playback both pleasurable and highly informative. It also has a wide color gamut, close to the sRGB color space, which means that the monitor image gives an excellent indication of how images will look on a computer screen or in print.

To display the most recent image, press []; if Image Review is On (see Playback menu, page 98), images are also displayed automatically after shooting. In continuous release modes, Image review begins after the last image in a burst is captured; images are shown in sequence.

Note:

To conserve the battery, the monitor turns off after a period of inactivity. The default is 10 sec. but intervals between 4 sec. and 10 min. can be set using Custom Setting c4.

> Viewing other images

To view other images on the memory card, use ▶ to view images in the order of capture, ◀ to view in reverse order ("go back in time").

> Viewing images as thumbnails

To view multiple images, press ♀ ☐ ☐ repeatedly to display 4, 9, or 72 images. Use ▲ / ▼ to bring other images into view. The currently selected image is outlined in yellow. To return to full-frame view, press ○ €.

> Memory card selection

A small icon at bottom left on the playback screen shows which memory card slot is being used for playback. To switch between card slots, display 72 images as above, then press **Q E** again to show a dialog which allows you to select the memory card. If there are multiple folders on the card(s) you can also use this dialog to choose between them.

> Playback zoom

To assess sharpness, or for other critical viewing, you can zoom in on a section of an image.

- 1) Press (to zoom in on the currently selected image. Repeated presses increase the magnification. A small navigation window appears briefly, with a yellow outline indicating the visible area.
- **2)** Use the Multi-selector to view other areas of the image.
- **3)** Rotate the Main Command Dial to view corresponding areas of other images at the same magnification.
- **4)** To return to full-frame viewing, press **(OK)**.

Maximum magnification is reached after 11 presses. This actually gives a magnification of 200%, making the image pixelated and of debatable value. Nine presses gives 100% magnification. Even pressing nine times is a tedious

process, so it's useful to know that you can enable a shortcut—a single press on takes you direct to this point.

To do this, use Custom setting f2 Multi selector center button: select Playback mode, then Zoom on/off. There's a choice between Low, Medium, and High magnification. Medium equates to nine presses/100%, making it the obvious choice. The zoomed display centers on the focus point which was active when the picture was taken. Pressing again reverts to full-frame playback.

Deleting images

To delete the current image, or the selected image in Thumbnail View, press . A confirmation dialog appears. To proceed with deletion press again; to cancel, press .

Protecting images

> Viewing photo information

The D810 records masses of information (known as metadata) about each image taken, and this can also be viewed on playback using \triangle/\bigvee to scroll through up to nine pages of information (see the table below).

To determine which pages are visible, visit **Playback display options** in the Playback menu (see the table). When you've selected the screens you want to see, scroll to **Done** and press **OK**).

PLAYBACK PAGES	SELECTION	DETAILS
File information	Always available	Displays large image, basic file information displayed at bottom of screen.
None (image only)	Enable from Playback menu	Displays large image with no other data.
Overview	On by default; disable from Playback menu	Displays small image, simplified small image, simplified histogram, summary information. Focus point used can also be shown; select using Playback display options>Focus point.
Location data	Only appears when a GPS device is attached during shooting (see page 230).	
Shooting data	Enable from	Pages 1-3 are always available.
(3 or 4 pages)	Playback menu	Page 4 only appears when Copyright Information is recorded (see page 132).

> Histogram displays

The histogram is a kind of graph showing the distribution of dark and light tones in an image. For assessing whether images are correctly exposed, it's much more objective than examining the playback image itself—especially in bright conditions, when it's hard to see the screen image clearly. The histogram display is a core feature of image playback and usually the page I view first. It reveals a great deal both about overall exposure and about shadow and/or highlight clipping (see page 90).

RGB HISTOGRAM DISPLAY

A fairly typical histogram. This is taken from Nikon View NX2, but the principles are exactly the same. It shows a good spread of tones from dark to light, and small differences between the red, green, and blue color channels, but there is some shadow clipping in the green and blue channels.

The overview playback page shows a single histogram; checking RGB histogram under Playback display options (see above) gives access to a display showing individual histograms for the three color channels (red, green, and blue). When shooting RAW, it's important to remember that the Histogram displays (and Highlights—see opposite) are based on the JPEG preview embedded with each RAW file. They are not, therefore, a foolproof quide to the potential to recover highlight or shadow detail in that RAW file. This is particularly true if you set one of the more "punchy" Picture Controls (see page 87) such as Vivid or Landscape, as IPEG processing then discards more of the RAW data. However, these Picture Controls may give an overall impression closer to how you might want the image to look.

> Highlights

The D810 can also display a flashing warning for areas of the image with "clipped" highlights—i.e. completely white with no detail recorded (see page 90). This is another way of obtaining a quick check that an image is correctly exposed, and

more objective than just relying on a general impression of the image on the monitor. Again, however, remember that the Highlights display is based on the JPEG preview, not the actual RAW data.

HIGH NOTES

>>

The highlight display was useful in ensuring that there was minimal clipping. There's virtually none in the musician's white top but some remains in the highly reflective surfaces of the clarinet.

200mm (DX-crop), 1/500 sec., f/9, ISO 200.

> » IMAGE ENHANCEMENT

The D810 offers two main kinds of in-camera image adjustment and enhancement. First, certain settings can be applied before shooting an image (preshoot controls).

Second, changes can be made to existing images on the memory card (postshoot options); access these from the Retouch menu (see page 136).

POND LIGHT

These two images show a comparison of shots with (left) and without Active D-Lighting set. 12mm, 1/125 sec./1/250 sec., f/11, ISO 200.

> Pre-shoot controls

Many of the controls that we've already considered have obvious and direct effects. in the final image: aperture, shutter speed, ISO, white balance, and many more. In addition, the D810 provides other important ways to control the qualities of the image, notably Nikon Picture Controls and Active D-Lighting. These settings are directly relevant to JPEG/TIFF images, but can't necessarily be ignored when shooting RAW, as we'll see.

› Nikon Picture Controls

Active D-Lighting

Active D-Lighting enhances the D810's ability to cope with scenes that show a wide range of brightness (dynamic range). In simple terms, it reduces the overall exposure to improve highlight capture, while mid-tones and shadows are boosted as the camera processes the image. Don't confuse it with the similarly-named D-Lighting, which is a post-shoot option. Active D-Lighting works with moving subjects, which can cause problems for HDR.

- **1)** In the Shooting menu, select **Active D-Lighting**. Alternatively, access it from the Quick settings screen (see page 76).
- 2) From the list of options, select Off, Low, Normal, High, Extra high, or Auto to determine the strength of the effect. Press OK. This setting will apply to all images until you reset Active D-Lighting.

Tip

Because Active D-Lighting alters the overall exposure, it's advisable to turn it off when shooting RAW.

Picture Controls allow the user to determine how JPEG and TIFF images will be processed in the camera. They also affect the preview image associated with each RAW file, and therefore affect how this image appears on the camera back. Histogram and Highlights displays for RAW images are also based on this preview. In addition, Picture Controls do affect the appearance of the Live View preview image.

The D810 offers seven pre-loaded Picture Controls: Standard, Neutral, Vivid, Monochrome, Portrait, Landscape, and Flat. These are mostly fairly self-explanatory. Portrait, for example, uses moderate settings for contrast, sharpening, and saturation with the aim of delivering natural colors and flattering skin tones. The new Flat Picture Control deserves a little more explanation (see below).

Each Picture Control has preset values for Sharpening, Clarity, Contrast, and Brightness. For color images, there are also settings for Saturation and Hue. The Monochrome Picture Control has Filter effects and Toning instead.

It's possible to fine-tune the values of these settings within each Picture Control. You can also create and save your own custom Picture Controls, and further ready-made Picture Controls are available on the Internet.

CLOUDSCAPE

The same subject shot using Flat (below) and Vivid (bottom) Picture Controls. 24mm, 1/100 sec., f/11, ISO 64.

Selecting Nikon Picture Controls

- **1)** From the Shooting menu, select **Set Picture Control**.
- 2) Use the Multi-selector to highlight the required Picture Control and press **(OK)**.

Modifying Picture Controls

Both the pre-loaded Nikon Picture Controls and custom Picture Controls from other sources can be modified in-camera. Use **Quick Adjust** to make swift, across-the-board changes or make manual adjustments to specific parameters (sharpening, contrast, and so on).

- 1) From the Shooting menu, select **Set**Picture Control
- **2)** Use the Multi-selector to highlight the required Picture Control and press ▶.
- **3)** Scroll up or down with the Multiselector to select **Quick Adjust** or one of the specific parameters. Use ▶ or ◀ to change the value as desired.
- **4)** When all parameters are as required, press **(OK)**. The modified values are retained until that Picture Control is modified again, or reset to default.

Creating Custom Picture Controls

You can create up to nine additional Picture Controls, either in-camera or using the Picture Control Utility included with Nikon View NX2. Custom Picture Controls can also be shared with other Nikon DSLRs. For further details see the Help pages within Picture Control Utility.

Creating Custom Picture Controls in-camera

- 1) From the Shooting menu, select Manage Picture Control.
- **2)** Select **Save/edit** and press ▶ .
- **3)** Use the Multi-selector to highlight an existing Picture Control and press ▶.
- **4)** Edit the Picture Control (as described above under Modifying Picture Controls). When all parameters are as required, press **OK**).
- **5)** On the next screen, select a destination for the new Picture Control. By default, the new version takes its name from the existing Picture Control on which it is based, with the addition of a two-digit number (e.g. VIVID-02) but you can give it a new name (up to 19 characters long) using the Multi-selector to select text. (For more on text entry see page 100.)
- **6)** Press **()** to store the new Picture Control.

Flat Picture Control

Flat is a new addition to the established lineup of Picture Controls, making its debut on the D810. As the name suggests, it produces images with a very subdued appearance, characterized by low contrast and saturation and (by default) no in-camera sharpening.

The Flat Picture Control is aimed mainly at movie-makers who intend to work on the color and contrast, for instance, of their footage in post-production. It's designed to preserve as much data as possible, giving maximum headroom for later adjustments and allowing movie shooters some of the flexibility and control that stills photographers gain by shooting RAW.

You might think, therefore, that stills photographers will have little use for the Flat Picture Control. This is probably true if you're shooting JPEG, unless you really want that subdued look for some specific purpose (to give shots an antique look, perhaps). However, if you're shooting RAW, and rely mostly on the Histogram and Highlights displays to assess your images, then it's worth considering. As mentioned above, the Histogram and Highlights displays are based on the JPEG preview embedded with each RAW file. As such, they will give a more accurate guide to the potential of the RAW file when you use a Flat Picture Control. Conversely, if you set Vivid or Landscape, these displays are much more likely to suggest that there is clipping (loss of data) in shadows or highlights—that data may still be there in the RAW file but has been discarded in the creation of the JPEG preview.

> HDR

"Contrast", "dynamic range," "tonal range": all refer to the range of brightness between the brightest and darkest areas of a scene. Our eyes adjust continuously, allowing us to see detail in both bright areas and deep shade. By comparison, even the best cameras can fall short, losing detail ("clipping") in shadows, highlights, or even both.

Shooting RAW gives some chance of recovering highlight and/or shadow detail in post-processing, while Active D-Lighting or D-Lighting (see pages 87 and 138) can help with JPEG images. However, all of these have their limits. Sometimes it's simply impossible to capture the entire brightness range of a scene in a single exposure. Both the histogram display (page 84) and the highlights display (page 85) help to identify such cases.

One solution is to shoot more than one exposure and then combine the results. The D810 can automate this, creating a high dynamic range (HDR) JPEG image by merging two separate shots taken at different exposures, one biased towards the shadows and one towards the highlights. HDR can be combined with Active D-Lighting for even greater range.

- 1) From the Shooting menu, select HDR (high dynamic range)—this will not be available if Image quality is set to RAW. Select HDR mode and press ▶.
- 2) Select On (series) to take a series of HDR images. Select On (single photo) to take just one. A HDR icon appears in the control panel.
- 3) Choose the exposure differential. Auto allows the camera to determine this automatically, or you can select 1Ev, 2Ev, or 3Ev.
- **4)** Choose the smoothing level. This influences the blending between the two source images. If extraneous bright or dark

"halos" appear in the final image, try again with a higher smoothing level.

- **5)** Shoot as normal. The camera will automatically shoot two images in quick succession. It then takes a few seconds to combine them and display the results. During this interval *Job Hdr* appears in the viewfinder and you can't take further shots.
- **6)** If you selected **On (single photo)** at step 2, HDR shooting is automatically canceled. To shoot more HDR images, repeat the process from step 1.

HIGH WATER

*

An HDR image (left), combining two (simulated) source frames (center and right). 102mm, source images: 1/50 and 1/320 sec., f/11, ISO 200, tripod.

» LIGHT AND EXPOSURE

> Backlighting

Backlighting is just one of a range of terms—"contre-jour" is a good one, if you're feeling pretentious. You'll also hear "against the light", which sounds negative, as if light is somehow the enemy. However, it does resonate with the fact that backlighting is sometimes viewed as being difficult. "Into the light" sounds much better, and a high proportion of my favorite shots are taken this way. I don't

consider it difficult, exactly, but there are a few things to think about: dynamic range (page 87) can be very high, and flare (page 197) can also rear its ugly head. Still, the results can be worth it.

THROUGH THE GLASS

Backlighting can make something special out of the simplest of subjects. 32mm, 1/250 sec., f/11, ISO 200.

> Side-lighting

Side- (or oblique) lighting is good at defining forms and textures. At really acute angles, the light accentuates fine details, from crystals in rock to individual blades of grass. Side-lighting often implies high contrast, so it can be worth looking at the Histogram and/or Highlights displays (page 84), but the D810's excellent dynamic range means it can cope well with most situations—especially when shooting RAW.

LIGHT WATER

×

The light here was perfectly angled to pick out details in the rocks as well as lighting up the waterfall—but the dynamic range was very high and I looked closely at the Histogram and Highlights displays before making the final exposure.

48mm, 1.3 sec., f/29, ISO 32, tripod.

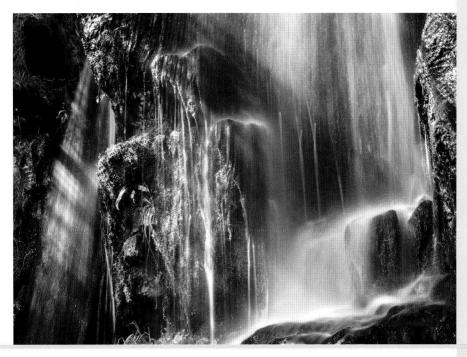

3

» MENUS

The options that you can access through dials and buttons are just the beginning. There are many more ways in which you can customize the D810 to suit you, but these are only revealed by delving into the menus.

The Playback menu, outlined in blue, covers functions related to playback, including viewing and deleting images. The Shooting menu, outlined in green, is used to control shooting settings, such as ISO, White Balance, or Active D-Lighting. Many of these, as we've already seen, can be accessed by other means. The Custom Setting menu, outlined in red, lets you fine-tune and personalize many aspects of the camera's operation. The Setup menu, outlined in orange, governs a range of functions such as LCD brightness, plus others that you may need to change only rarely, such as language and time settings. The Retouch menu, outlined in purple, lets you create modified copies of images on the memory card. Finally My Menu is outlined in gray—it is a handy place to store items from the other menus that you find yourself using regularly. Alternatively, it can become a Recent Settings menu.

Navigating the menus

The general procedure for navigating and selecting items from the menus is the same throughout:

- **1)** To display the menu screen, press **MENU**.
- 2) Scroll up or down with the Multiselector to highlight the different menus. To enter a menu, press ▶.
- 3) Scroll up or down with the Multiselector to highlight specific menu items. To select an item, press ▶. In most cases this will take you to a further set of options.
- 4) Scroll up or down with the Multi-selector to choose the desired setting. To select, press ▶ or ♠. In some cases you may need to scroll up to Done and then press ♠. to make changes effective.
- **5)** To return to the previous screen, press **◄**.
- **6)** At any point, to exit without effecting any changes, press **MENU**. To exit the menus completely, semi-depress the shutter-release button.

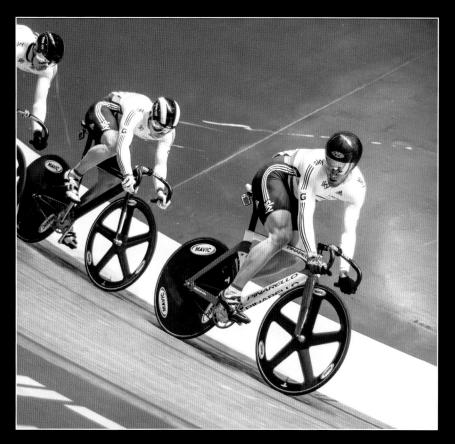

BANKING

*

Indoor venues usually have consistent lighting, so the same exposure and white balance settings will work on every visit. Extended menu banks make it easy to retrieve these (see page 101). 50mm (DX-crop), 1/1600 sec., f/1.8, iSO 1600.

» PLAYBACK MENU

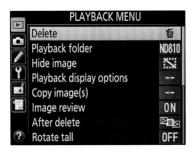

The Playback menu contains options affecting how images are viewed, stored, deleted, and printed. Some items are only accessible when a memory card—with image(s)—is present.

> Delete

This function allows you to delete images from the memory card, either singly or in batches.

Tip

You can access help from within the menus by pressing ?/O¬¬¬¬ . Help information is available when a ? icon appears in the bottom left corner of the monitor.

To delete selected images

- **1)** Highlight **Delete** and press **▶**.
- 2) In the next screen, choose **Selected**. Images in the active playback folder or folders (see opposite) are displayed as thumbnails.
- 3) Use the Multi-selector to scroll through the displayed images. Press and hold Example to view the highlighted image full-screen. Press to mark the highlighted shot for deletion. It will be tagged with a first icon. If you change your mind, highlight a tagged image and press again to remove the tag.
- **4)** Repeat this procedure to select further images.
- **5)** Press **(N)** to see a confirmation screen. Select **YES** and press **(N)** to delete the selected image(s); to exit without deleting any images, select **NO**. Note that images on the SD card and CF card are displayed separately and if the same image(s) are on both cards you need to repeat the procedure to delete them from both.

Note:

Individual images can also be deleted when using the playback screen, and this is usually more convenient.

To delete all images on a card

- **1)** To delete all images on a card, highlight **Delete** and press **▶**.
- **2)** In the menu options screen, highlight **All** and press **▶**.
- **3)** Choose which card's images you wish to delete.
- **4)** Press ► or press **OK** to see a confirmation screen. Select **YES** and press **OK** to delete all image(s); to exit without deleting any images, select **NO**.

Tip

When cards contain many images, this can take some time. It is almost always quicker to format the card instead (see page 26). However, there is a significant difference: **Delete all** does not delete protected or hidden images (see below); formatting the card does remove these.

> Playback folder

By default, the D810's playback screen will only display images created on the D810: if you insert a memory card containing images captured on a different model of camera (even another Nikon DSLR) they will not be visible. This can be changed using this menu.

Note:

The current (or active) folder is chosen through the Shooting menu (see page 102).

Playback folder options

ND810 (default)	Displays images in all folders created by the D810.	
All	Displays images in all folders on the memory card.	
Current	Displays images in the current folder only.	

Hide image

Hidden images are protected from deletion and cannot be seen in normal playback. The only way to access them is through this menu.

- **1)** In the Playback menu, highlight **Hide image** and press **▶**.
- 2) In the menu options screen, choose Select/set. Images in the active playback folder or folders are displayed as thumbnails.
- **4)** Press **(OK)**.

Again, images on the SD card and CF card are displayed separately and you will need to repeat the procedure to hide image(s) on both cards.

Playback display options

This enables you to choose what (if any) information about each image will be displayed on playback (see page 83 for more, including a table showing all the options). To enable or disable any option, press ▶ to check or uncheck it. To make these choices effective, press ♠.

Copy image(s)

This allows image(s) recorded on one memory card to be copied to the other card (assuming both card slots are occupied, and that there is space on the destination card). Select source determines which card images will be copied from; the other card then automatically becomes the destination. Select image(s) allows you to select individual images or entire folders for copying. Having selected a folder, Deselect all and Select all allow you to check or uncheck individual images respectively. Select destination folder determines which folder on the destination card will be used (you can also create a new folder).

Tip

Backing up precious images is good, but this is a slow way to do it. If you find yourself using this item repeatedly, consider enabling automatic backup as images are taken (see Secondary slot function in the Shooting menu, page 102).

Image review

If Image review is **On** (the default setting), images are automatically displayed on the monitor after shooting. If **Off**, images are only displayed by pressing . This helps economize battery power.

After delete

Enables you to determine "what happens next" after an image is deleted (in normal Playback, not via the Delete menu). Show next means that the next image in the order of shooting will be displayed. Show previous means that the previous image in the order of shooting will be displayed. Continue as before means that the next image to be displayed is determined by the order in which you were viewing images before deleting. That is, if you were scrolling back through the sequence, the previous image will be displayed, and vice versa.

Rotate tall

This determines whether portrait format ("tall") images will be displayed the "right way up" during playback. If set to **OFF**, which is the default, these images will not be rotated, meaning that you need to turn the camera through 90° to view them correctly, but they will use the full screen area. If set to **ON**, portrait images will be displayed in correct orientation but will appear smaller.

Slide show

Enables you to display images as a slide show, either on the camera's own screen or through a TV (see page 233). All images in the folder or folders selected for playback (under the Playback Folder menu) will be played in chronological order.

- 1) Make sure the playback screen is set to Image only (see page 83) to ensure an uncluttered slide show.
- 2) In the Playback menu, select Slide show.
- 3) Select Frame interval. Choose 2, 3, 5, or 10 seconds. Press (OK).
- 4) Select Start and press (OK).
- 5) When the show ends, a dialog is displayed. Select **Restart** and press **(K)** to play again. Select **Frame interval** and press **(OK)** to return to the Frame interval dialog. Select **Exit** and press **(OK)** to exit.
- **6)** If you press **()** during the slide show, the slide show is paused and the same screen displayed. The only difference is that if you select **Restart** and press **()**, the show will resume where it left off.

DPOF print order

This allows you to select image(s) to be printed when the camera is connected to, or the memory card is inserted into, a suitable printer, i.e. one that complies with the DPOF (Digital Print Order Format) standard. See Chapter 9 for more information (page 231).

» SHOOTING MENU

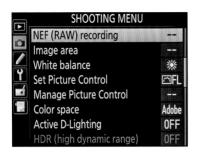

The Shooting menu contains numerous options, but many are also accessible through other means, and have already been discussed.

> Shooting menu bank

This is a handy way to store particular combinations of Shooting menu settings which you use repeatedly. For instance, I could create a "Landscape" menu bank which sets Image Quality to NEF (RAW), NEF (RAW) recording to 14-bit, White Balance to Direct Sunlight, and ISO setting to 64, which are my usual settings for landscape photography. I can then instantly apply all of these parameters, at any time by activating this menu bank. You can create up to four menu banks for different situations.

To create a Shooting menu bank

- **1)** In the Shooting menu, select **Shooting** menu bank and press $\bigcirc K$.
- 2) Select one of the four available banks—by default named A, B, C, and D—and press (K). The normal Shooting menu screen now appears. If Shooting menu bank A has not been used previously it will show the current settings; the other banks remain at default settings until used. Work down through the menu, making any desired changes to settings, and then exit by pressing MENU. If desired, rename the selected bank as follows. Names can be up to 20 characters long.

Renaming Shooting menu banks

- **1)** In the Shooting menu, select **Shooting** menu bank and press **(OK)**.
- **2)** Select **A**, **B**, **C**, or **D**, and press **▶**.
- 3) A "keyboard" appears. Navigate around this using the Multi-selector. To use the highlighted character press (K). To make corrections, hold (C) and use the Multi-selector to position the cursor, then press to delete the highlighted character.
- **4)** To save the new name press **(OK)**. To exit without saving, press **MENU**.

Use a Shooting menu bank

- 1) In the Shooting menu, select Shooting menu bank and press $\bigcirc \mathbf{K}$.
- **2)** Select one of the four available banks and press **OK**).

Note:

Shooting menu banks are still shown by A, B, C, and D in the main Shooting menu screen, but new names will appear in the Shooting menu bank menu.

Extended menu banks

Normally, your choices of exposure mode, shutter speed, and aperture are not included in the settings saved in Shooting menu banks. By switching to Extended menu banks you can ensure that these are included. You might not wish to do this for, say, landscape photography, where light levels are highly variable, but it can be handy if you regularly visit venues (such as sports halls), where the light levels are consistent. Selecting the appropriate menu bank then recalls the exposure settings you've found to work well in a particular venue.

Note:

Shutter speed is recorded only for Shutter-priority and Manual modes; aperture is recorded only for Aperture-priority and Manual modes.

> Storage folder

If you alternate different memory cards they will all end up holding folders of the same name. This isn't usually a problem, but you might wish to avoid it. You might also want to create specific folders for specific shoots. On extended trips, when you may be storing thousands of images on your memory cards, creating an ordered series of folders may be helpful.

You can't name folders freely: only the first three digits are editable and only numbers can be used.

To create a new folder number

- **1)** In the Shooting menu, select **Storage folder** and press **(OK)** or **▶**.
- **2)** Select **Select folder by number** and press **OK**) or **▶**.
- a) Edit the three-digit number: press ✓ or ▶ to highlight a digit, ▲ or ▼ to change it. If the indicated number is already in use, a "blocked folder" icon appears.
- **4)** Press **OK** to create a new folder. It automatically becomes the active folder.

To change the Storage folder

- **1)** In the Shooting menu, select **Select folder** from list and press **(OK)** or **▶**.
- **2)** Select **Select folder** and press **(OK)** or **▶**.

> File naming

By default, image files are named as follows: if **Color space** is sRGB, the name begins DSC_; if **Color space** is AdobeRGB, the name begins _DSC. This is followed by a four-digit number and a three-letter extension (e.g. JPG for JPEG files). You can edit the initial three-letter string, perhaps replacing it with your initials, so that instead of DSC_4567.JPG a file could be CJS_4567.JPG.

To edit the three-letter string

- **1)** Select **File naming** and press **OK** or **▶**.
- 2) In the next screen, select File naming and press **(OK)** or **▶**.
- **3)** Edit the three-digit string, using the on-screen "keyboard" as described under **Renaming Shooting menu banks**.
- **4)** Press **OK** to accept the new name.

> Primary slot selection

Determines which card slot (CF or SD) is designated as the primary slot. If only one card is present, the camera will automatically use it, whether or not that slot is designated primary.

> Secondary slot function

When memory cards are present in both slots, the secondary slot can be used in three ways. By default (Overflow), images are only recorded to the secondary slot when the card in the primary slot is full.

Backup means that each image is written to both cards simultaneously. RAW primary–JPEG secondary is slightly more complicated. If Image quality is NEF (RAW)+JPEG, then the NEF version is recorded to the primary slot and the JPEG version to the secondary. At other quality settings, this option behaves like Backup.

> Image quality

Use this to choose between NEF (RAW), TIFF, and JPEG options, as described on page 62.

> JPEG/TIFF recording

This menu has sections for **Image size** and **JPEG** compression.

Image size

Choose between Small, Medium, and Large image sizes, as described on page 65. This choice applies to both JPEG and TIFF images.

JPEG compression

Choose how JPEG images are compressed. Size priority means that all images are compressed down to a set size, dependent on settings for Image area, Image quality, and Image size. Optimal quality means that image sizes are allowed to vary, allowing for better file quality.

> NEF (RAW) recording

Governs how NEF (RAW) files are recorded.

Image size

This lets you choose between full-size RAW and sRAW files (see page 66).

NEF (RAW) file compression

There are three options for NEF (RAW) file compression, as outlined in the table below.

NEF (RAW) bit depth

This allows you to select between 12-bit or 14-bit depth (see page 66).

Image area

Use this to choose between FX, DX, 1.2x, and 5:4 image areas, as described on page 64. You can also Enable or Disable Auto DX Crop (see page 65). I always disable it.

NEF (RAW) file compression

Lossless compressed (default)	Files are compressed by about 20-40% with no detectable effect on image quality.
Compressed	Files are compressed by about 40-55%, with a very small effect on image quality.
Uncompressed	Files are not compressed. Uncompressed files take up more memory card space and write times are slightly increased.

> White balance

This menu allows you to set the white balance, as already discussed on page 68.

Set Picture Control and Manage Picture Control

These menus govern the use of Nikon Picture Controls, as already discussed on page 87.

> Color space

Choose between sRGB and Adobe RGB color spaces (see page 72 for explanation).

> Active D-Lighting

Choose level of Active D-Lighting, as already discussed on page 87.

> HDR (high dynamic range)

Enable and control HDR shooting, as described on page 91.

› Vignette control

Vignetting is a darkening, or fall-off in illumination, towards the corners of the image, most obvious in even-toned areas like clear skies. Almost all lenses show slight vignetting at maximum aperture, but

it usually disappears when the lens is stopped down. The D810 can compensate for vignetting during the in-camera processing of TIFF and JPEG images. Use this menu to choose between **Normal** (the default setting), **High**, **Low**, and **Off**.

Note:

Vignette control only operates when a Type D, G, or E lens is attached. It does not work with DX lenses, or when shooting DX-format images or movies.

> Auto distortion control

If **ON**, this automatically corrects for distortion (see page 198) which may arise with certain lenses. It's available only with Type D, G, or E lenses (see page 205), excluding fisheye and PC lenses, and does not apply when shooting movies.

Tip

If using a DX lens, make sure that **Auto DX** crop is **On**, or **Image area** is set to **DX**; otherwise Auto distortion control may produce undesirable results.

> Long exposure NR

Photos taken at long shutter speeds can suffer from increased noise (see page 51) so extra image processing is available to counteract this. If Long exposure noise reduction (NR) is **On**, it operates when exposure times are 1 sec. or longer. During processing, **Job nr** blinks in the displays. The time this takes is roughly equal to the shutter speed in use, and you can't take another picture until processing is complete. This can obviously cause significant delays, so many users prefer to use post-processing to reduce image noise instead. Long exposure NR is **Off** by default.

> High ISO NR

Photos taken at high ISO settings can also show significant noise. The default setting is **Normal**, which can be changed to **Low** or **High**. High ISO noise reduction (NR) can also be set to **OFF**, but even then a modest amount of NR will be applied to images taken at the highest ISO settings.

> ISO sensitivity settings

Governs ISO settings, as already discussed in depth on page 51.

› Multiple exposure

When you can merge images on the computer, precisely and flexibly, it might seem that cameras like the D810 hardly need a multiple exposure facility. However, the Nikon manual states "multiple exposures produce colors noticeably superior to those in software-generated photographic overlays." This is debatable, especially if you shoot individual RAW images for careful post-processing before merging them on the computer, but clearly this feature does offer an effective way to combine images for immediate use, e.g. as JPEG files for printing.

To create a multiple exposure

- 1) Select Multiple exposure and press ▶.
- 2) Select Multiple exposure mode and press . Select On (series) to keep shooting multiple exposures or On (single photo) to shoot just one Press (K).

INTO THE DEPTHS

<<

I chose a long exposure rather than high ISO for this image to maximize color depth and dynamic range. 28mm, 5 sec., f/11, ISO 200, tripod.

- **3)** Select **Number of shots** and use the Multi-selector to choose a number (between 2 and 10) then press **OK**).
- **4)** Select **Auto gain** and choose **ON** or **OFF** (see below for explanation) then press **OK**).
- **5)** Select **Done** and press **OK**
- **6)** Frame the photo and shoot normally. In continuous release modes, the designated number of images will be exposed in a single burst. In single-frame release mode, one image in the sequence will be exposed each time the shutter-release button is pressed. Normally the maximum interval between such shots is 30 sec. This can be extended by setting a longer monitor-off delay in Custom setting c4.

Tip

You can assign Multiple exposure to the **BKT** button via Custom setting f8. You can then hold the button and rotate the Main Command Dial to select Multiple exposure mode, Subcommand Dial to select Number of shots.

Auto gain

Auto gain (**On** by default) adjusts the exposure, so that if you are shooting a sequence of three shots, each is exposed at a third of the exposure value required for a normal exposure. You might turn it off when a moving subject is well lit but the background is dark, so that the subject is well exposed and the background isn't over-lightened.

> Interval timer shooting

The D810 can take a number of shots at pre-determined intervals. If Multiple exposure is activated first, they will be combined into a single image; otherwise they will be recorded as separate images. Set up the camera—a tripod is recommended. An appropriate fixed white balance setting (i.e. not Auto) should ensure you don't see unexpected color shifts in the end result. If you expect the light to remain fairly constant, use Manual mode for consistent exposure. If the light is likely to vary—for instance, you're shooting a time-lapse through sunrise and the advance of day—you might use one of the other modes. Aperture-priority is often recommended. If using an auto mode, close the eyepiece blind once you've framed the image.

- 1) Select Interval timer shooting and press ▶ or (OK).
- 2) Select On and press >.
- 3) Select Start options and press ▶. Use the Multi-selector to set the date and time of the start (up to a week ahead). Press OK
- **4)** Select **Interval** and press **▶**. Use the Multi-selector to set the interval between shots (the default is 1 minute). Press **⊙K**).
- 5) Select No of intervalsxshots/interval and press ▶. Use the Multi-selector to set the number of intervals, and the number of shots to be taken at each interval. The screen shows the resulting total number of shots. Press (ok).
- **6)** Select **Exposure smoothing** and choose **Off** or **On**. Exposure smoothing aims to minimize brightness differences between successive shots. Press **(X)** to complete setup and reach the primary Interval timer shooting screen.
- **7)** Highlight **Start>On** and press **OK**). If you selected **Now** under **Start** options, shooting begins in about 3 sec.

> Movie settings

Determines key settings for movie shooting. See Chapter 6 Movies (page 180).

> Time-lapse photography

Time-lapse photography also shoots a series of still frames but, unlike the interval timer, which records each shot as a separate image, time-lapse combines them into a silent movie. The frame size and other settings for this are as decided in **Movie settings** (see below). Camera setup is similar to Interval timer photography (see above).

- **1)** Select **Time-lapse photography** and press **▶**.
- 2) Select Interval and press ►. The default interval between shots is 5 sec.; use the Multi-selector to change this. Press (OK).
- **3)** Choose the **Shooting time**. The default is 25 minutes; use the Multiselector to change this. The maximum you can set is 7h. 59min. Press **OK**).
- **4)** Select **Exposure smoothing** and choose **Off** or **On**. Exposure smoothing aims to minimize brightness differences between successive shots. Press**OK**
- **5)** In the main **Time-lapse photography** screen, select **Start** and press **OK** to proceed; shooting begins after approximately 3 sec.

» CUSTOM SETTING MENU

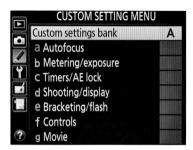

The Custom Setting menu allows you to fine-tune almost every aspect of the camera's operation to suit your personal preferences. The menu is divided into seven main sub-menus, identified by key letters and a color: a: Autofocus (red); b: Metering/Exposure (yellow); c: Timers/AE Lock (green); d: Shooting/display (light blue); e: Bracketing/flash (dark blue); f: Controls (lilac), and g: Movie (purple).

Navigating the Custom Setting menu is essentially the same as the other menus. However, from the main menu screen, the first press on ▶ takes you into the list of sub-menus. Scroll through these to the desired group and press ▶ to see its constituent items.

Although the menu is organized into seven main groups, individual items do

appear as a continuous list, so you can scroll straight down from a12 to b1, and so on. If you scroll up you can go from a1 to g4. The custom setting identifier code (e.g. a4) is shown in the appropriate color for that group. If you change the setting from default value, an asterisk appears over the initial letter of the code

› Custom setting banks

Analogous to the Shooting menu banks discussed on page 100, this is a handy way to store particular combinations of Custom settings that you may use repeatedly. You can create up to four such banks for different shooting requirements. The procedure for creating and renaming Custom setting banks is exactly equivalent to that for Shooting menu banks on page 100.

> Restoring default settings

To restore the current Custom setting bank to standard camera default values, highlight that menu bank then press **(1)**. A confirmation dialog appears; select **Yes** and press **(0)** to confirm.

a: Autofocus

a1: AF-C priority selection and a2: AF-S priority selection

Normally, in AF-C (Continuous-servo) release mode, the camera can take a picture even if it has not acquired perfect focus (release priority). Custom setting a1 allows you to choose focus priority instead, meaning that pictures can only be taken once focus is acquired. There's also an intermediate setting of Release + focus, which applies when shooting in CH or CL release mode. It allows the frame rate to slow to improve the chances of focusing accurately. In other release modes, Release + focus is effectively the same as Release priority.

Similarly, Custom setting a2 allows you to change the priority setting for AF-S (Single-servo AF)—but the default is **focus priority**, and there's no Release + focus option.

a3: Focus tracking with lock-on

This governs how rapidly the camera reacts to sudden, large changes in the distance to the subject. If this is **Off**, the camera reacts instantly to such changes, but this means it can be fooled when other objects pass in front of the intended subject. Longer delays reduce its sensitivity to such intrusions. Options run from **5** (Long), via **3** (Normal), the default setting, to **1** (Short), as well as **Off**.

a4: AF activation

This determines how you can activate autofocus. The default setting, **Shutter/ AF-ON**, allows autofocus to be activated either by half-pressure on the shutter-release button or with the **AF-ON** button. **AF-ON** only means that only **AF-ON** can be used to activate autofocus. This is the setting required for Back-button autofocus (see page 55).

a5: Focus point illumination

It's a shame Nikon didn't call this "Focus point display", to make a clearer distinction between it and item a6. This item determines when and how the focus point(s) are visible. There are separate options for different focus modes.

Manual focus mode Choose On or Off to determine whether the active focus point is displayed when you are focusing manually. Focus points are irrelevant, and may be a distraction, when you're purely using the focusing screen. However, if you are using the electronic rangefinder (see page 56), it is important to know where the focus point is.

On when Dynamic-area AF (see page 56) is in use, the camera will show the focus

points surrounding the one you have selected, as these may also be used to aid focus. If you select **Off**, only the selected focus point is shown. When 3D tracking is in use, if this item is **On**, the camera displays a dot at the center of the active focus point.

Group-area AF illumination Determines how the focus points are indicated when Group-area AF (see page 57) is in use—they can be displayed as large rectangles, as they are in other focusing modes, or as much smaller ones, which can give a clearer view of the subject.

a6: AF Point illumination

This determines whether the active focus point is illuminated in red in the viewfinder. If not, it's outlined in black. The default is Auto, which means the focus point is illuminated only when this will give better contrast with the background. Alternatively, it can be **On** or **Off**.

a7: Focus point wrap-around

This governs whether the active focus point wraps to the opposite edge of the available area (see page 59). The options are **Wrap** or **No wrap** (default).

a8: Number of focus points

This governs the number of focus points available when selecting the focus point

manually (see page 58). By default it uses the full **51 points** but you can also opt to use **11 points**. This can speed up the selection process.

a9: Store by orientation

This enables the camera to remember different selections for the initial placement of the focus point according to the orientation of the camera. You might use this in fast-moving shooting where you want to switch quickly between two views. For example, when shooting running or cycling events, you'll often want to use the uppermost focus point to focus on a competitor's face as this is usually high in the frame. But what counts as "high in the frame" changes according to whether the camera is in portrait or landscape orientation. To enable this function, select Focus point in this menu.

You can also select **Focus point and AF-area mode.** This allows you to choose quite different AF operation for "landscape shots" and "portrait shots", for instance, using Group-area AF when the camera is in landscape orientation

Note:

Even with **11 points** selected for **a8: Number of focus points**, the camera still uses all 51 points for automatic selection, focus tracking, and so on.

and 3D tracking when it is in portrait orientation.

a10: Built-in AF-assist illuminator

This determines whether the AF-assist illuminator (see page 12) operates. Options are **On** (default) or **Off**. It's unnecessary most of the time, but can add to battery drain.

a11: Limit AF-area mode selection

You can speed up AF-area mode selection by taking some modes off the list. For instance, if you never use Grouparea or Auto-area AF, you can deselect them here. Scrolling through the list (using ** and the Sub-command Dial)

then becomes a fraction quicker. This only applies to normal photography, not to Live View or movie shooting.

a12: Autofocus mode restrictions

This lets you take one or other of the AF modes out of use. Selecting AF-S or AF-C in this menu means only that mode is available. One scenario for using this is if you are using back-button autofocus (see page 55), which relies on AF-C being selected at all times.

FOREGROUND FOCUS

*

Customizing the behavior of autofocus is useful whether you're shooting action or landscapes. 14mm, 1/40 sec., f/14, ISO 64.

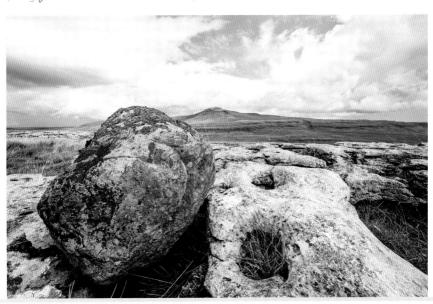

→ b: Metering/Exposure

b1: ISO sensitivity step value

This governs the increments you use when setting ISO sensitivity value (see page 52); options are 1/3 step (default), 1 step, or 1/2 step. Larger intervals make it a bit quicker to scroll from, say, 100 to 1600. You might ask how much difference you can really see between 250 and 320, for instance.

b2: EV steps for exposure cntrl

This governs the increments which the camera uses for setting shutter speed and aperture, as well as for bracketing, and so on. Again the options are 1/3 step (default), 1 step, or 1/2 step. Setting a larger step can speed up operation, but taking out the intermediate steps seems more drastic in this case.

b3: Exp./flash comp. step value

Similar to the previous two items, this determines the increments you can use when setting exposure or flash compensation. Again, the options are 1/3 step (default), 1 step, or 1/2 step.

b4: Easy exposure compensation

This determines how you can apply exposure compensation (see page 46) in **P**, **S**, and **A** modes. When it's **Off** (the default setting), you must press **2** and rotate the Main Command Dial. When it's

On, you can apply exposure compensation simply by rotating the Sub-command Dial (P and S modes) or Main Command Dial (A mode).

Auto reset means that compensation setting(s) made in this way return(s) to Off when the camera or meter turns off. Settings made using still don't reset automatically.

b5: Matrix metering

Use this to turn Face detection **On** or **Off**. Face detection can be handy when shooting individual or group portraits as it means that the metering prioritizes correct exposure for the face(s).

This selection has no impact when using center-weighted or spot metering, nor in Live View or movie shooting.

b6: Center-weighted area

This governs the diameter of the primary area when center-weighted metering is in use (see page 44). The options are 8mm, 12mm (default), 15mm, 20mm, and Average. Average means metering is based equally on the entire frame. With non-CPU lenses only 12mm and Average are available.

b7: Fine tune optimal exposure

This allows for a sort of permanent exposure compensation; you can apply

separate settings for each of the four metering methods (matrix, center-weighted, spot, and highlight-weighted—see page 44) in steps of ½ Ev, up to +/-1 Ev.

Usually, the regular exposure compensation procedure is preferable, but this option could be useful for specific needs. You might, for example, prefer portraits to have a consistently lighter feel, and could fine-tune the

center-weighted setting for this purpose. You will need to remember that this is in effect, as the normal exposure compensation indicator will not be displayed—you can only confirm the setting by revisiting this menu item.

AGAINST THE DARK

×

Careful metering was needed as the dark fence could have caused the flowers to be overexposed. 75mm, 1/500 sec., f/8, ISO 400.

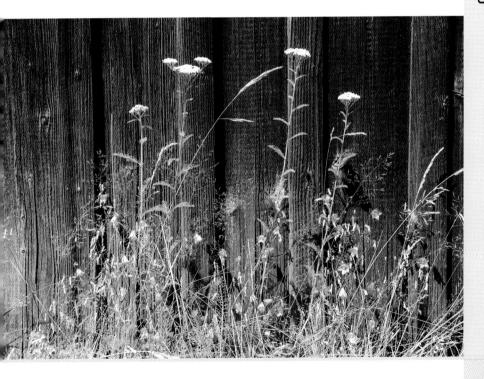

c1: Shutter-release button AE-L

This determines whether you can lock exposure by half-pressure on the shutter-release button. By default, this item is Off, half-pressure locks focus only (see Focus lock, page 59), and you can only lock exposure with AF-L/AF-L (see page 50).

c2: Standby timer

This governs the interval before the exposure meter turns off when the camera is idle (i.e. you don't take any pictures, or operate any of the other controls). A shorter delay benefits battery life.

The default is **6 secs**; other options range from **4 secs** up to **30 minutes** plus **No limit**, which means the meter remains active until you turn the camera off.

c3: Self-timer

This has three sub-menus governing the operation of the self-timer (see also page 34).

Self-timer delay determines the interval between pressing the button and the shot being taken. The default is **10** secs; alternatives are **2**, **5**, and **20** secs.

You can take a single shot, or shoot several with one press of the release button. **Number of shots** can be set from **1–9**, and **Interval between shots** can be set to **0.5**, **1**, **2**, or **3 secs**.

c4: Monitor off delay

Governs how long the LCD monitor screen remains illuminated when the camera is idle. Shorter delays improve battery economy. You can set the delay separately for Playback, Menus, Information display, Image review, and Live View. For most, the options range from 4 sec. to 10 mins. For Image review there's also a 2 secs option. For Live View the range is 5 min to 30 min, plus No limit.

Note:

The information display always shows both ISO and frame count. The final option is *Show ISO/Easy ISO*. This allows you not only to see the ISO setting as above, but to change it simply by rotating one of the command dials. In A mode, you use the Main Command Dial whilst in S or P mode you use the Subcommand Dial. This has its attractions, but you can't use it in Manual, when both command dials are required for their primary purpose, so it can also be confusing.

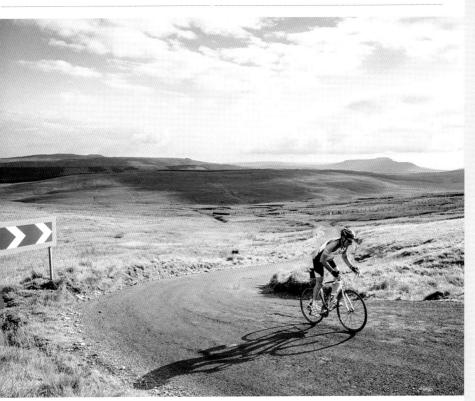

CLIMB TIME

^

I've found self-timer sequences very handy when walking or cycling alone. Although they don't allow for critical timing of action shots, shooting nine frames at 0.5-sec. intervals gives a reasonable chance that one or two will be "keepers". In this case I'd driven to the location and had a tripod with me—but when I don't, I keep an eye out for places to set the camera: gate posts, walls, tree-stumps, and so on. 24mm, 1/100 sec., f/11, ISO 100, tripod.

d: Shooting/Display

d1: Beep

If you wish, the camera can emit a beep when the self-timer operates, and to signify focus acquisition when shooting in AF-S mode. This is set to **Off** by default (as it should be!)

There are two sub-menus. **Volume** includes the **Off** setting; enable the beep by selecting **1**, **2**, or **3**. **Pitch** can be **High** or **Low**.

d2: CL mode shooting speed

Governs the frame rate when using CL (Continuous Low speed) release mode (see page 34). The default is **3fps** (frames per second), and options run from **1** to **6fps**—though setting 6fps would make CL identical to CH, which seems pointless.

d3: Max continuous release

This determines the maximum number of shots that you can take in a single burst when using CL, CH, or Qc release mode. The upper limit is 100. You can take it right down to 1 if you wish, but that would defeat the object of continuous release mode.

d4: Exposure delay mode

You can create a delay of **1s**, **2s**, or **3s** when you press the shutter-release button. This is a possible alternative to the self-timer or

mirror lock-up to reduce vibration when shooting on a tripod. It's **Off** by default.

d5: Electronic front-curtain shutter

The D810's shutter is already impressively quiet for a DSLR, but the electronic front-curtain shutter can help reduce vibration even further. This can be significant if you want to fully exploit the D810's resolution—the merest hint of motion blur can take the edge off fine detail.

It only operates in Mup (Mirror-up) release mode and means that the mechanical shutter is opened when the mirror is raised by the first press on the shutter-release button. The electronic shutter operates when you press the button a second time to take the shot. It's probably worth waiting at least a couple of seconds before doing this.

Nikon only recommend its use with Type G, D, or E lenses, and the fastest available shutter speed is 1/2000 sec.

d6: File number sequence

This controls how image numbers are set. If it's **Off**, file numbering is reset to 0001 whenever you insert a new memory card, format an existing card, or create a new storage folder (see page 101). If it's **On**—which is the default—numbering continues

from the previous highest number used. **Reset** creates a new folder, and also begins numbering from 0001.

d7: Viewfinder grid display

This allows the camera to display grid lines in the viewfinder—these can help you keep the camera level and assist with precise framing. They can also alert you if a lens is delivering noticeable distortion (see page 198). The options are **Off** (default) and **On**.

d8: ISO display and adjustment

By default (Show frame count), the figure at bottom right of the control panel and the viewfinder display shows how many more exposures can be accommodated on the memory card at current Image size, Image area, and Image quality settings. Alternatively, you can choose to display the current ISO sensitivity setting (Show ISO sensitivity). As ISO is a key factor in exposure, this is well worth considering.

d9: Screen tips

Allows the camera to display pop-up "labels" to identify items you select in the information display. Options are **On** (default) and **Off**.

d10: Information display

Determines the appearance of the information display. By default (Auto) the camera switches automatically from **Dark** on light to Light on dark to suit lighting conditions, but you can manually select an option to apply one or the other at all times.

d11: LCD illumination

This governs illumination of the top-plate control panel. By default (**Off**), it is only illuminated when you move the power switch to On means the control panel will be illuminated whenever the exposure meter is active. Clearly, **Off** is more economical for battery life.

d12: MB-D12 battery type

If you're using an optional MB-D12 battery pack (see page 215) with AA batteries, set this to match the type of cells. Options are: LR6 (AA alkaline); HR6 (AA Ni-MH); FR6 (AA lithium).

d13: Battery order

Again, this applies if you're using an optional MB-D12 battery pack. It determines whether the camera will draw on its own battery first, or on those in the MB-D12. The latter is the default setting.

> e: Bracketing/flash

e1: Flash sync speed

This determines the fastest flash sync speed (see page 155 for an explanation). Settings run from **1/250s** (the default) down to **1/60s**.

There are also settings of 1/320s (Auto FP) and 1/250s (Auto FP). These enable flash sync at any shutter speed when a Nikon Speedlight is attached. see High speed flash sync, page 164.

e2: Flash shutter speed

The previous item controls the fastest shutter speed which can be used with flash. This one determines the slowest shutter speed to which the camera can be set when using flash in P or A exposure modes (see page 152). The options run from **1/60s** (default) to **30s** in 1 Ev steps. In M or S modes, any speed down to 30 sec. can be set anyway.

e3: Flash cntrl for built-in flash

This governs how the built-in flash is regulated. See the table opposite.

e4: Exposure comp. for flash

This determines how exposure compensation (see page 158) operates when flash is active. If you select **Background only**, the compensation setting affects the ambient exposure only; flash output is unchanged. If **Entire frame** is

selected (which is the default), flash output is also increased or reduced by the same amount.

e5: Modeling flash

This applies when the built-in flash is active or you attach a compatible optional flash unit. If it's **On** (which is the default), the flash emits a pulse of light when you press the Pv button, giving an indication of the flash effect. It's limited, but you can see where shadows fall.

e6: Auto bracketing set

Bracketing is discussed in detail from page 48. The options are: AE & flash (default), AE only, Flash only, WB bracketing, ADL bracketing.

e7: Auto bracketing (Mode M)

This determines which settings are bracketed when using Manual mode. It only applies when AE 6 flash or AE only is selected in Custom Setting e6 (above). If AE only is selected, or there's no flash in use, then the first three settings allow the camera to bracket exposures by varying shutter speed (Flash/speed), by varying speed and aperture (Flash/speed/aperture), or by varying aperture only (Flash/aperture). To ensure aperture remains constant, select Flash/speed and vice versa

e8: Bracketing order

This determines the order in which autobracketed exposures are taken—by default, the first shot is taken at the metered exposure (▶ > Under > over). The alternative (Under > ▶ > over) places the metered exposure in the middle of the sequence. To me this seems more logical.

> f: Controls

f1: 🖈 switch

By default, moving the On/Off switch to tilluminates the top-plate control panel; this is labeled LCD Backlight (). If you select and Information display, this also activates the information display.

f2: Multi-selector center button

This governs which functions are activated, in different modes, when you press the center of the Multi-selector (()) (see the table on the next page).

f3: Multi-selector

The normal way to "wake up" the camera when meters, and so on, are inactive is by half-pressing the shutter-release button.

Main setting	Explanation	Sub-menu options
TTL (default)	Flash output is regulated	
	automatically by the camera's	
	metering system.	
Manual	You determine the strength	From Full down to 1/128
	of the flash.	power.
Repeating	Fires the flash multiple times	Output (flash power)
flash	during a single exposure,	Times (number of flashes)
	giving a stroboscopic effect.	Frequency (number of flashes
	3	per second).
Commander	Uses the built-in flash as a	Set Mode and Compensation
mode	trigger for remote flash	for Built-in flash and external
	unit(s) (see page 164).	units/groups; select Group
	() ()	and Channel for external units.

> f: Controls

By selecting **Restart standby timer** instead of **Do nothing**, you can also wake up the camera by operating the Multi-selector.

f4: Assign Fn. button

Various functions can be assigned to the Fn button, both on its own and in conjunction with the command dials. These include functions which are normally assigned to other buttons (such as depth of field preview, normally assigned to the Pv button).

There are separate lists of options for a simple press and for using the button in conjunction with a command dial; however, some options in the two lists are

incompatible. For example, if you pick a Press option that is incompatible with the one you picked under **Press + command dials**, your earlier choice is deactivated, and an error message will be displayed.

Note:

When navigating menus, for instance, almost duplicates the function of (N), except that certain critical settings can only be implemented by using (N).

	f2: Multi-selector center button			
Options-Shooting	Select center focus point (default)			
mode	Preset focus point (select focus point in the usual way			
	then hold • and press until focus point flashes)			
	Highlight active focus point			
	Not used			
Options-Playback	Thumbnail on/off (default)			
mode	View histograms			
	Zoom on/off (see page 82)			
	Choose slot and folder			
Options-Live View	Select center focus point (default)			
	Zoom on/off			
	Not used			

	f4: Assign Fn. button: Press
Preview	Fn activates depth of field preview.
FV lock	Fn locks flash value (compatible flashguns only)—
	see page 159. Press again to cancel.
AE/AF lock	Exposure and focus both lock when you press Fn.
AE lock only	Exposure locks while you hold Fn.
AE lock only	Exposure locks when you press Fn and remains locked.
(Reset on release)	Exposure locks when you press Fn and remains locked
	until you press it again, or release the shutter, or
	standby timers expire.
AE lock (Hold)	Exposure locks when you press Fn and remains locked
	until you press it again, or standby timers expire.
AF lock only	Focus locks when you press Fn.
AF-ON	Pressing Fn activates focus: focus can't be activated
	with half-press on shutter release.
5 Disable/enable	If flash is off, pressing Fn activates it in front-curtain
	sync mode. If flash is off, holding Fn deactivates it.
Bracketing burst	Fn activates a bracketing burst at last used settings.
+NEF (RAW)	When Image quality is set to JPEG, pressing Fn ensures a
	NEF copy of the next shot will also be recorded.
Matrix metering	Hold Fn to activate matrix metering (see page 44).
Center-weighted	Hold Fn to activate center-weighted metering (see
metering	page 44).
Spot metering	Hold Fn to activate spot metering (see page 45).
Highlight-weighted	Hold Fn to activate highlight-weighted metering (see
metering	page 45).
Disable synchronized	Affects operation when camera is connected to a
release	wireless remote control. Disable synchronized release
	means that only master camera can trigger photos;
Remote release only	Remote release only means that only the remote control can do this.

	f4: Assign Fn. button: Press
Viewfinder grid display	Press Fn to show/hide framing grid in viewfinder.
Viewfinder virtual horizon	Press Fn to show a virtual horizon in viewfinder (see page 134).
MY MENU	Press Fn to display My Menu.
Access top item in My Menu	Press Fn to go straight to Item 1 in My Menu.
Playback	Fn duplicates function of .
NONE (default)	Pressing Fn has no effect.
	f4: Assign Fn. button: Press + Command dials
Choose Image area (default)	Press Fn and rotate either command dial to select FX, 1.2x, 5:4, or DX image areas (see page 64). You can also use this menu item to uncheck any of the available areas in this list: for instance, uncheck 1.2x and 5:4, so that using Fn and dial simply toggles between FX and DX.
Shutter spd & aperture	Use Fn and dial to lock shutter speed and/or aperture at level already selected: Main Command Dial locks shutter speed in S and M modes; Sub-command Dial locks aperture in A and M modes.
1 step spd/aperture	If Fn is pressed while command dials are rotated, changes to aperture/shutter speed are made in 1 Ev steps.
Choose non-CPU	Use Fn and either command dial to select among lenses
lens number	specified using Non-CPU lens data (see page 134).
Active D-Lighting	Press Fn and rotate either command dial to select between Active D-Lighting options (see page 87).
Exposure delay mode	Press Fn and rotate either command dial to select an exposure delay (see page 134).
NONE (default)	Rotating a command dial while pressing Fn has no effect.

f5: Assign Preview button

The same wide range of functions can be assigned to the Pv button as to the Fn button (above). The only difference is in the default settings.

For **Press**, the default setting (not surprisingly!) is **Preview**.

For Assign Preview button: Press + Command dials the default setting is None. As with f2, some Press options are incompatible with some Press + command dials options.

f6: Assign AE-L/AF-L button

Again, you can assign a wide range of different functions to **AF-L/AF-L**. The options are almost exactly the same as for Fn and Pv, except that **1 step spd/aperture** and **Active D-Lighting** aren't available under **Press + Command dials**.

For **Press**, the default setting (naturally!) is **AE/AF lock**.

For **Press + command dials**, the default setting is **None**.

f7: Shutter spd & aperture lock

If you need to take a series of shots where it is critical that shutter speed and/or aperture do not vary, you can use this to lock them at the level(s) already selected: **Shutter speed lock** applies in S and M modes; **Aperture lock** applies in A and M modes. In P mode both parameters continue to be variable.

If you use this feature frequently, you can speed up access by assigning the Fn, Pv, or **AE-L/AF-L** buttons (Press + Command dials) to toggle this feature on and off—see the items f4, f5, and f6 above.

f8: Assign BKT button

BKT is used by default to enable bracketing (see page 48). Alternatively, you can use it to control multiple exposure or high dynamic range (HDR) shooting (see table below).

Selection in Custom setting f8	BKT + Main Command Dial controls:	BKT + Sub-command Dial controls:
BKT	Number of shots in	Exposure increment
	bracketing burst (2, 3, 5, 7, 9)	between shots in burst
Multiple exposure	Toggles multiple	Number of shots in
	exposure on/off	multiple exposure
HDR (high dynamic	Toggles HDR between	Exposure differential
range)	series/single photo/off	between source images
range)	series/sirigle prioto/orr	Detween 30arce in

f9: Customize command dials

You can change the operation of the command dials in various ways. There are five sub-menus:

Reverse rotation This reverses the effect of rotating the dials in a given direction. You can customize this separately for **Exposure compensation** and for **Shutter speed/aperture** settings.

Change main/sub Normally, when shooting in modes A, S, and M, the Main Command Dial sets shutter speed and Subcommand Dial sets the aperture: this item modifies these roles. Under Exposure setting, On reverses the usual roles completely. Alternatively, you can select On (Mode A) to use the Main Command Dial for aperture selection in mode A, while retaining normal operation in other modes.

Similarly, under **Autofocus setting**, you can reverse the normal effect of rotating the command dials while holding . If this is **On**, holding and rotating Main Command Dial selects AF-area mode, and Sub-command Dial selects AF mode.

Aperture setting This determines whether the aperture ring (where present, i.e. on older lenses) can be used to set apertures, or the Sub-command Dial (see page 31). On non-CPU lenses, only the aperture ring can be used anyway.

Menus and playback This allows you to use the Main Command Dial to navigate playback images and menus. On allows you to use it to scroll through individual images in image review and playback. On (image review excluded) allows the dial to be used only in playback initiated with ▶, not with images displayed immediately after shooting. With either option enabled, the Sub-command Dial can be used to skip from page to page when images are displayed as thumbnails.

In menu navigation, with either option enabled, the Main Command Dial can be used to scroll through menu items, while the Sub-command Dial can be used to enter sub-menus (rotate right) or go up a level (rotate left).

Sub-dial frame advance This adds some extra options to the Sub-command Dial. If you're using the Main Command Dial to scroll through images on playback, you can set the Sub-command Dial to jump forward or back by **10** or **50** images, or to jump to the next **Folder** (assuming there is more than one folder on the memory card).

f10: Release button to use dial

Normally, buttons such as **QUAL** or **WB** must be kept pressed while you rotate the appropriate command dial to make changes. If you activate this option by selecting **Yes**, you can continue to make changes with the dial alone after releasing

the button, though only until you press the shutter-release button, or press the relevant control button again (or until the camera ques onto standby).

Other buttons to which this applies are ISO, A. AE-L/AF-L, AF-A, BKT, and MODE.

The same also applies to the Fn, Pv, **AE-L/AF-L** and ● buttons if you've given them certain specific functions (see the *Nikon Reference Manual*, page 353).

f11: Slot empty release lock

By default (**Enable release** selected in this menu), the shutter can be released even if no memory card is present. Images are held in the buffer and can be displayed on the monitor (demo mode), but are not recorded.

Alternatively you can select **Release locked** instead. This means that the shutter can't be released unless there's a memory card in the camera. The obvious lack of response protects you against shooting away happily for hours, only to discover later that none of your images have been recorded.

The default setting is useful when carrieras are on display at a shop or trade show, but find in normal use I always change it as soon as I receive a new camera.

f12: Reverse indicators

This governs the display of exposure indicators in the viewfinder, control panel, and information display. By default (-0+) overexposure is indicated by bars on the

right side and underexposure on the left. Selecting +0- reverses the indicators.

f13: Assign movie record button

This gives • a function during normal photography and still-image Live View. The default is **None**, i.e. this button remains inactive. There are four other options, all under **Press + command dials**: White balance, ISO sensitivity, Choose image area, and Shutter spd & aperture lock.

f14: Live View button options

This simply allows you to **Disable** LV, to avoid any accidental initiation of Live View. If you rarely or never use Live View, this is worth doing. The default option is, of course, **Enable**.

f15: Assign MB-D12 AE-L/AF-L button

If you're using an optional MB-D12 battery pack (see page 215), this allows you to allocate a range of a functions to its **AE-L/AF-L** button. The range of options is more limited than those available for the camera's own **AE-L/AF-L** button (see Custom setting f6), and there are no **Press + command dials** options.

There is an extra refinement, however: in this menu you can also select **Same as Fn button**. This allows **AF-L/AF-L** on the MB-D12 to perform the same function as whatever you've selected for Fn on the camera (see Custom setting f4).

f15: Assign MB-D12 AE-L/AF-L button			
Pressing Fn activates focus: focus can't be activated with			
half-press on shutter release.			
Focus locks when you press Fn.			
Exposure and focus both lock when you press Fn.			
Exposure locks while you hold Fn.			
Exposure locks when you press Fn and remains locked			
until you press it again, or release the shutter, or standby			
timers expire.			
Exposure locks when you press Fn and remains locked			
until you press it again, or standby timers expire.			
Locks flash value (compatible flashguns only)—see page			
159. Press again to cancel.			

	f16: Assign remote (WR) Fn button		
Preview	Activates depth of field preview.		
FV lock	Locks flash value (compatible flashguns only)—see		
	page 159. Press again to cancel.		
AE/AF lock	Exposure and focus both lock when you press Fn.		
AE lock only	Exposure locks while you hold Fn.		
AE lock only	Exposure locks when you press Fn and remains locked		
(Reset on release)	until you press it again, or release the shutter, or		
	standby timers expire.		
AF lock only	Focus locks when you press Fn.		
AF-ON	Pressing Fn activates focus: focus can't be activated		
	with half-press on shutter release.		
Disable/enable	If flash is off, pressing Fn activates it (in front-curtain		
	sync mode). If flash is off, holding Fn deactivates it.		
+NEF (RAW)	When Image quality is set to JPEG, pressing Fn		
	ensures a NEF copy of the next shot will also be		
	recorded.		
Lv	Pressing Fn activates Live View.		
NONE (default)	Pressing Fn has no effect.		

f16: Assign remote (WR) Fn button

Similarly, allows you to assign various functions to the Fn button on a Nikon wireless remote control. See the table on the opposite page.

f17: Lens focus function buttons

Certain Nikkor lenses have focus function buttons, and you can assign various roles to these (but only if AF-L is set on the lens's focus function switch).

f17: Lens focus function buttons

	117. Ecus rocas ranction battons
AF lock only	Focus locks when you hold lens Fn.
AE/AF lock	Exposure and focus both lock when you hold lens Fn.
AE lock only	Exposure locks while you hold lens Fn.
Preset focus point	Hold lens Fn to use pre-selected focus point (see
	Custom setting f2, page 120).
AF-area mode	Preselect an AF-area mode by selecting this option
	and pressing ▶ to access list (3D-tracking is not
	available). Select and press OK). Then, holding lens
	Fn activates that AF-area mode.
Disable/enable	If flash is off, pressing lens Fn activates it in front-
	curtain sync mode. If flash is off, holding lens Fn
	deactivates it.
Disable synchronized	Affects operation when camera is connected to
release	a wireless remote control. Means that only master
	camera can trigger photos;
Remote release only	Remote release only means that only the remote
	control can do this.

g: Movie

This menu allows you to assign functions to certain key buttons—these only apply when the camera is in movie mode and can be completely different from the functions performed by the same button when shooting stills.

g1: Assign Fn Button

This governs the function performed by Fn when camera is in movie mode. See the table on the next page.

	g1: Assign Fn Button		
Power aperture (open)	Opens the aperture when you press Fn (see page 185)		
Index marking	Press Fn during movie shooting to add an index mark,		
	which can be used to jump to specific points when		
	playing and editing movies.		
View photo shooting	Press Fn to show current still photo settings (shutter		
info.	speed, aperture, ISO); press again to show current		
	movie settings.		
None	No effect.		

g2: Assign Preview button

You can assign exactly the same range of functions to the Pv button. Again, the default is **NONE**.

g3: Assign AE-L/AF-L button

You can also assign a range of functions to **AE-L/AF-L**. These include **Index marking** and **View photo shooting info** (see above), plus **AE/AF lock**, **AE lock only**, **AE lock** (**hold**), and **AF lock only**. The default setting is **AE/AF lock**.

Note:

If you select *Power aperture (open)* in g1, setting g2 is automatically set to *Power aperture (close)*, and vice versa.

g4: Assign shutter button

This determines the behavior of the shutter-release button when the Live View selector is set to **>**

By default (Take photos), fully pressing the shutter-release button ends movie recording (if in progress) and takes a still photo (see page 189). Alternatively, you can select Record movies. When you do this, half-pressure on the button begins movie Live View (effectively duplicating the function of **Lv**). Fully pressing the button begins recording a movie clip, and a second press ends it; this effectively duplicates the function of • . If you're shooting movies seriously, this can streamline the operation, but leaves you no quick way to capture a still photo. This setting also allows you to use a remote cord or wireless remote controller to start and end movie shooting.

» SETUP MENU

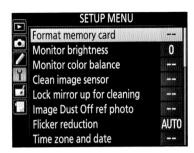

The Setup menu controls a number of important camera functions, though many are ones you will need to access only occasionally.

> Format memory card

The one item in this menu that you may use regularly. Some may prefer the alternative "two-button" method (see page 26), but I find this way quicker and more convenient.

To format a memory card

- **1)** Select **Format memory card** and press **(OK)** or **▶**.
- **2)** Select **SD card slot** or **CF card slot** and press **©K** or **▶**.
- 3) Select Yes and press **OK**).

> Monitor brightness

Change the brightness of the rear LCD display with ▲ or ▼. This has no effect on the images themselves (e.g. as viewed on your computer). The point is to adapt the display to changing light levels in your surroundings. The screen shows a "stepwedge" with ten bands ranging from very dark to very light gray. It should be possible to distinguish clearly between all of them.

Monitor brightness for Live View shooting is adjusted separately (see page 76).

Tip

Nikon warn that with very high brightness settings (+4 or +5), the monitor may display colors less accurately.

> Monitor color balance

Adjust the color balance of the monitor using the Multi-selector. When you enter this menu, the screen shows the most recent image taken. There are obvious pitfalls in using a photo for reference; if colors in the image look wrong, it could be

that it was shot using an inappropriate white balance setting. In this case, adjusting screen settings to make it look right only masks the fact that colors in the image itself are wrong.

If there are no images on the memory card, the screen shows a gray rectangle instead. For the reasons just given, I prefer to use this to judge the color balance of the screen, so would use this menu when there are no images on the card(s) in the camera. If necessary, simply remove the card(s) for the few seconds it takes to use this menu.

Clean image sensor/Lock mirror up for cleaning

For more details see page 219.

> Image Dust Off Ref Photo

Nikon Capture NX-D (see page 228) can automatically remove dust spots on images, by comparing them to a reference photo which maps dust on the sensor. This can save a lot of "grunt work" compared to manually removing spots from individual images. This menu item allows you to take a suitable reference photo.

To take a dust-off reference photo

1) Fit a lens (preferably full-frame and of at least 50mm focal length). With a zoom

lens, use the longest setting. Locate a featureless, white object such as a sheet of paper, large enough to fill the frame.

- 2) Select Image Dust Off Ref Photo and press ▶.
- **3)** Select **Start** or **Clean sensor and then start** and press **OK**). Select **Start** if you have already taken the picture(s) from which you want to remove spots.
- **4)** Frame the white object at a distance of about 4in. or 10cm. Press the shutter-release button halfway; focus is automatically set to infinity, creating a soft white background against which dust spots stand out clearly.
- **5)** Press the shutter-release button fully to capture the reference image.

> Flicker reduction

Some light sources can produce visible flicker in the Live View screen image and in movie recording. To minimize this, use this menu to match the frequency of the local mains power supply. **60Hz** is more common in North America; **50Hz** is normal in the European Union, including the UK; the **Auto** setting will normally adjust automatically.

> Time zone and date

Sets date, time, and time zone, and specifies the date display format (Y/M/D, M/D/Y, or D/M/Y). First set your usual time zone, then set the time correctly. If you travel to a different time zone, change the time zone setting and the time will be corrected automatically.

Note:

If a GPS receiver is attached (see page 230), it can set the clock using the very accurate data from the satellite system. Enable this in the *Location data* menu item (also on page 230).

> Language

Set the language which the camera uses in its menus and dialogs, choosing from 36 European and Asian languages.

> Auto image rotation

If set to **ON** (default), information about the orientation of the camera is recorded with every photo taken, ensuring that they will appear the right way up when viewed with Nikon View NX2, Nikon Capture NX-D, or most third-party imaging applications.

> Battery info

Displays information about battery status, including charge level, number of shots taken since last charge, and overall age of battery (assessed against nominal lifespan). The information displayed may change if an optional battery pack is fitted.

> Image comment

You can append brief comments (up to 36 characters) to images. Comments appear in the Info page on Playback (see page 227) and can be viewed in Nikon View NX2 and Nikon Capture NX-D. To attach a comment, select Input comment and press . Use the Multi-selector to input text as described on page 100. When finished, press . Select Attach comment, then select Done, and press OK. The comment will be attached to all new shots until turned off again.

Copyright Information

Copyright is a fundamental right, and exists automatically in every photo you take. There should be no need to "copyright" images. However, making a clear statement that your images are copyright can provide protection against the theft or misappropriation of your creative work. It doesn't confer any additional rights, but may make it easier to enforce the rights you already have.

This menu allows copyright information to be embedded into metadata, using the usual text input method, described on page 100.

There are separate fields for **Artist** (i.e. photographer) and **Copyright**; however, in most countries, these are usually one and the same person, as copyright automatically belongs to the person creating the image. There is an exception for photographers shooting in the course of permanent employment (not freelancers under contract), when copyright belongs to the employer.

Warning!

This information can disappear when photos are uploaded to the Internet: Save for Web in older versions of Photoshop strips such metadata by default, and many social media and image "sharing" sites also strip out metadata.

To attach copyright information to all subsequent photos, select **Attach copyright** information, then press **(OK)**.

Tip

Copyright exists in any photo you take, without registration.

However, in the US and a few other countries, registration—although a cumbersome bureaucratic process—can add extra protection.

> Save/load settings

This allows you to save many camera settings (see the table opposite) to a memory card. If the same card (or another to which the settings file has been copied) is inserted later, the saved settings can be quickly restored. This could be useful, for instance, if more than one user share the camera, or when the camera is sent away for servicing. It can also be used to transfer settings to another D810, but not to any other model. The settings file is named NCSETUPF and the procedure will fail if the file name is changed.

Menu	Settings
Playback menu	Playback display options
	Image review
	After delete
	Rotate tall
Shooting menu	Shooting menu bank
	Extended menu banks
	File naming
	Primary slot selection
	Secondary slot function
	Image quality
	Image area
	JPEG/TIFF recording
	NEF (RAW) recording
	White balance (including fine tuning)
	Set Picture Control
	Auto distortion control
	Color space
	Active D-Lighting
	Long exposure NR
	High ISO NR
	ISO sensitivity settings
	Vignette control
	Movie settings
Custom Setting menu	All Custom Settings in all settings banks
Setup menu	Clean image sensor (auto settings)
	Flicker reduction
	Time zone and date display format (does not reset
	the time and date themselves)
	Language
	Auto image rotation
	Image comment
	Copyright information
	Non-CPU lens data
	HDMI
	Location data
	Eye-Fi upload
My Menu/Recent	All My Menu items
Settings	All recent settings
3	Choose tab

> Virtual horizon

Displays a horizon indicator on the monitor to assist in leveling the camera. Green bars indicate when the camera is level.

The virtual horizon display shows both left-right tilt (roll) and front-back tilt (pitch). The tilt indicator can be really useful in ensuring that horizons are level when shooting landscapes and seascapes, for example. The pitch indicator helps keep the camera back vertical, to avoid converging verticals when shooting architecture and similar subjects (see page 240).

Alternatively, the analog displays in the viewfinder and control panel can be used as a tilt-meter, in conjunction with the Fn button; enable this in Custom setting f4.

> Non-CPU lens data

Many older Nikon lenses, often rugged and optically excellent, can be used on the D810. When lenses lack a built-in CPU, little information is available to the camera and shooting options are drastically reduced. Important functions can be restored by specifying the focal length and maximum aperture of a given lens in this menu. Data can be stored for up to nine such lenses.

> AF fine tune

AF fine tune allows the camera to compensate for slight variations in autofocus performance (back-focus or front-focus) between different lenses (CPU lenses only). The camera can store details for up to 20 lenses and will subsequently recognize them automatically.

AF fine tune should be used only when you are certain that back-focus or front-focus exists; however it gains extra importance with the critical resolution offered by the D810. It is **OFF** by default.

Detecting back-focus or front-focus requires careful testing. One method is to compare results using standard AF with those from Live View. Use a solid tripod to avoid camera movement and ensure the same focus point is being targeted by both AF systems.

> HDMI

You can connect the camera to HDMI (High Definition Multimedia Interface) TVs and monitors (see page 233). This menu allows you to set the camera's output to match the HDMI device: see the specifications for the device.

> Location data

Set up a connection with a compatible GPS device (see page 230).

> Eye-Fi upload

This item will only be visible if an Eye-Fi card is inserted (see page 227). It allows you to **Enable** (default) or **Disable** wireless upload of photos.

> Network

This menu item is normally grayed out and inaccessible. It is relevant only when the D810 is connected to a Communication Unit UT-1, and either an Ethernet cable or a wireless transmitter WT-5 (see page 215).

ON THE LEVEL

The virtual horizon (opposite) can help to keep things upright when shooting in either landscape or portrait format. 50mm, 1/125 sec., f/9, ISO 320.

> Firmware version

Firmware is the onboard software that controls the camera's operation. Nikon issues updates periodically. This item shows the version presently installed, so you can verify whether it is current.

When Nikon release new firmware, download it, and copy it to a memory card. Insert this card in the camera then use this menu to update the camera's firmware.

Note:

Firmware updates may include new functions and menu items, which can make this Guide (and the Nikon Reference Manual) seem out of date.

» RETOUCH MENU

The Retouch menu allows you to make corrections and enhancements to images, including cropping, color balance, and much more. These changes do not affect the original image; instead, a copy is created to which the changes are applied. Further retouching can be applied to the new copy, but you can't apply the same effect twice to the same image.

Copies are always created in JPEG format but the size and quality depends on the format of the original (a few exceptions, such as Trim and Resize, produce copies smaller than the original).

Note:

Images in sRAW format (see page 66) are not available for retouching.

› To create a retouched image

Retouching can begin either from the Retouch menu, or from normal playback.

- 1) If starting from the Retouch menu, select the desired retouch option and press ▶. A screen of image thumbnails appears. Select the required image using the Multi-selector, as in normal image playback. Press OK. If subsidiary options appear, make a further selection and press ▶ again. A preview of the retouched image appears.
- 2) If starting from normal playback, select the required image and press **OK**. Now select the desired retouch option and press ▶. If subsidiary options appear, make a further selection and press ▶ again. A preview of the retouched image appears.
- **3)** Depending on the type of retouching to be done (see details below), there may be further options to choose from.

Format of original photo	Quality and size of copy		
NEF (RAW)	Fine, Large		
TIFF	Fine, size matches original		
JPEG	Quality and size match original		

> Side-by-side comparison

> Trim

This option is not part of the regular Retouch menu; it only appears if you display the menu by pressing ♠ when a retouched copy, or its source image, is selected in full-frame playback. It displays the copy alongside the original source image. Highlight either image with ◀ or ▶ and press ♠ to view it full frame. Press ▶ to return to normal playback; to return to the playback screen with the highlighted image selected, press ♠.

This allows you to crop an image to eliminate unwanted areas or to better fit it to a print size. When this option is selected, a preview screen appears, with the crop area marked by a yellow rectangle. You can change the aspect ratio of the crop by rotating the Main Command Dial. Adjust the size of the cropped area by pressing end to reduce the size, end to increase it. Adjust its position using the Multiselector. Press to preview the cropped image. Press to create a cropped copy.

Aspe	ect rat	tio		Possible size	s for trimmed	Гсору		
	3:2			7040 x 4688	6400 x 4264	5760 x 3840	5120 x 3416	4480 x 2984
				3840 x 2560	3200 x 2128	2560 x 1704	1920 x 1280	1280 x 856
				960 x 640	640 x 424			
	4:3	i i i i i i i i i i i i i i i i i i i	nije.	6544 x 4912	6400 x 4800	5760 x 4320	5120 x 3840	4480 x 3360
				3840 x 2880	3200 x 2400	2560 x 1920	1920 x 1440	1280 x 960
				960 x 720	640 x 480			
	5:4			6144 x 4912	6000 x 4800	5408 x 4320	4800 x 3840	4208 x 3360
				3600 x 2880	3008 x 2400	2400 x 1920	1808 x 1440	1200 x 960
				896 x 720	608 x 480			
	1:1			4912 x 4912	4800 x 4800	4320 x 4320	3840 x 3840	3360 x 3360
				2880 x 2880	2400 x 2400	1920 x 1920	1440 x 1440	960 x 960
				720 x 720	480 x 480			
	16:9			7360 x 4144	7040 x 3960	6400 x 3600	5760 x 3240	5120 x 2880
				4480 x 2520	3840 x 2160	3200 x 1800	2560 x 1440	1920 x 1080
				1280 x 720	960 x 536	640 x 360		
					138 1314 16			

> D-Lighting

D-Lighting should not be confused with Active D-Lighting (see page 87), though there are similarities in the final effect.

Active D-Lighting is applied before shooting, and has an effect on the original exposure; D-Lighting is applied later. In essence, D-Lighting lightens the shadow areas of the image. The D-Lighting screen shows a side-by-side comparison of the original image and the retouched version; a press on ♠ zooms in on the retouched version. Use ▲ or ▼ to select the strength of the effect—High, Medium, or Low.

> Red-eye correction

This is aimed at dealing with the notorious problem of "red-eye", caused by on-camera flash (see page 156). This option can only be selected for photos taken using flash. The camera then analyzes the photo, looking for evidence of red-eye; if none is found the process ends. If red-eye is detected a preview image appears and you can use the Multi-selector and the zoom controls in the usual way to view it more closely.

> Monochrome

Create monochrome copies, either straight Black-and-white, Sepia (a brownish-toned effect), or Cyanotype (a bluish-toned effect). For Sepia or Cyanotype, you can make the toning effect stronger or weaker with \triangle or ∇ .

MONOCHROME EFFECTS

Cyanotype (top) and Sepia(below).

> Filter effects

These mimic several common photographic filters (perhaps we should say once common in the days of film). **Skylight** reduces the blue cast which can affect photos taken on clear days with a lot of blue sky. Applied to other images, its effect is very subtle, even undetectable. **Warm filter** has a much stronger warming effect. **Red, Green**, and **Blue intensifier** are all fairly self-explanatory, as is **Soft**.

Cross screen, however, is an enigmatic name—perhaps "Star" would have been a better name. It creates a "starburst" effect around light sources and other very bright

STARBURST EFFECT

\$

points, like sparkling highlights on water. There are multiple options within this item—see the table below.

Option heading	Options available
Number of points	Create four-, six-, or eight-pointed star
Filter amount	Choose brightness of light sources that are affected
Filter angle	Choose angle of the star points
Length of points	Choose length of the star points
Confirm	See a preview of the effect; press ♥ॗॗॗॗॗ to see it
	full-screen
Save	Create a copy incorporating the effect

> Color balance

When this option is selected, a preview screen appears and the Multi-selector can be used to move around a color grid. The effect is shown both in the preview and in the histograms alongside; use \P to zoom in on the preview.

> Image overlay

Image overlay allows you to combine two existing photos into a new image. This can only be applied to originals in RAW format, not sRAW, TIFF, or JPEG. The two source images must have the same bit depth and compression settings (see page 63).

Nikon claim that the results are better than combining the images in Photoshop, as Image overlay makes direct use of raw data from the camera's sensor, but this is debatable; a large calibrated computer screen gives a better preview of the result.

To create an overlaid image

1) In the Retouch menu, select Image overlay and press ▶. The next screen has panels labeled Image 1, Image 2, and Preview. Initially, Image 1 is highlighted. Press (OK).

Tip

Although Image overlay works from RAW images, the size and quality of the resulting image depend on your current Image quality and Image size settings. Before embarking on Image overlay make sure these settings are as required. You can also create a new RAW image by this method—it's the only Retouch menu option which allows you to do this.

- 2) The camera displays thumbnails of RAW images on the memory card. Select the first image required for the overlay and press **(N**). Press ► to move to Image 2 and select the second image.
- **3)** Use the Gain control below each image to determine its "weight" in the final overlay. The preview changes to show the effect.
- 4) Use ◀ / ▶ to move between Image 1 and 2 if further changes are required. You can press **(OK)** to change the selected image in either position.
- 5) Finally, press ▶ to reach the Preview panel. With Overlay highlighted, press ♠ ➡ to preview the overlay. Return to the main screen by pressing ♠ ➡ . To save the combined image, highlight Save and press ♠.

> NEF (RAW) processing

This menu creates JPEG copies from images originally shot as RAW files. It doesn't replace full RAW processing on computer, but it does allow you to create quick copies for immediate sharing or printing. Options available for the processing of RAW images are displayed in a column to the right of the preview image (see the table opposite, top).

Description
Choose Fine, Normal, or Basic (see page 63).
Choose Large, Medium, or Small (see page 65).
Choose a white balance setting; options are similar to
those described on page 71.
Adjust exposure (brightness) levels from +2 to -2.
Choose any of the range of Nikon Picture Controls
(see page 87) to be applied to the image. Fine-tuning
options can also be applied.
Choose level of noise reduction where appropriate
(see page 105).
Choose color space (see page 72).
Apply Vignette control (see page 104).
Choose D-Lighting level (High, Normal, Low, or
Off)—see page 87.

When satisfied with the previewed image, select **EXE** and press **OK** to create the JPEG copy. Pressing **P** exits without creating a copy.

> Resize

This option creates a small copy of the selected picture(s), suitable for immediate use with various external devices. Four possible sizes are available, as listed in the

table below. **Resize** can be accessed from the Retouch menu or from Image playback, but there are slight differences in the procedure. From the Retouch menu, you select a picture size first and then select the picture(s) to be copied at that size. From Image Playback, you select a picture first and then choose the copy size; this way you can only copy one picture at a time.

Option	Size	Description
2.5M	1920 x 1280	Display on HD TV, larger computer monitor, recent iPad
1.1M	1280 x 856	Display on typical computer monitor, older iPad
0.6M	960 x 640	Display on standard TV, iPhone 4/5
0.3M	640 x 424	Display on majority of mobile devices

> Quick retouch

Provides basic, one-step retouching for a quick fix, boosting saturation and contrast. D-Lighting is applied automatically to retain shadow detail. Use ▲ or ▼ to increase or reduce the strength of the effect, then press or to create the retouched copy.

> Straighten

It's best to get horizons level at the time of shooting, and the virtual horizon (page 134) can help. However, errors can still happen. This option offers a fall-back, with correction up to 5° in 0.25° steps. Use ▶ to rotate clockwise, ◀ to rotate anticlockwise. Inevitably, this crops the image.

> Distortion control

Some lenses create noticeable curvature of straight lines (see page 198): this menu allows you to correct this in-camera. This inevitably crops the image slightly. **Auto** allows automatic compensation for the known characteristics of Type G and D Nikkor lenses; it can't be used on images taken with other lenses.

Manual can be applied whatever lens was used. Use ▶ to reduce barrel distortion, ◀ to reduce pincushion distortion. The Multi-selector can also be used for fine-tuning after Auto control is applied.

> Fisheve

Instead of correcting distortion, this menu exaggerates it to give a fisheye lens effect. Use ▶ to strengthen the effect, ◀ to reduce it.

> Color outline

This detects edges in the photograph and uses them to create a "line drawing" effect. There are no options to alter the effect.

> Color sketch

This creates a copy resembling a colored pencil drawing. Controls for **Vividness** and **Outlines** adjust the strength of the effect.

> Perspective control

Corrects the convergence of vertical lines in photos taken looking up, for example, at tall buildings. Grid lines aid in assessing the effect, and the strength of the effect is controlled with the Multi-selector. The process inevitably crops the original image, so if you're shooting an image where you plan to use perspective control later, make sure you leave room around the subject. For alternative approaches to perspective control, and an illustration, see page 204.

> Miniature effect

This option mimics the fad—already done to death—for shooting images with extremely small and localized depth of field (see page 41), making real landscapes or city views look like miniature models. It usually works best with photos taken from a high viewpoint, as these generally provide a clearer separation of foreground and background. A yellow rectangle shows the area which will remain in sharp focus; you can reposition this using ▲ or ▼. Use ◀ /

► to make the "in-focus" zone appear wider or narrower and $\mathbb{Q} \blacksquare$ to flip it through 90°.

Press \P to preview the results and press \P to save a retouched copy.

> Selective color

You can select up to three specific color(s) to be preserved in the retouched copy, while any other hues are transformed to monochrome.

- **1)** Choose **Selective color** in the Retouch menu. Press **▶**.
- 2) Select an image from the thumbnail screen and press (OK).
- **3)** Use the Multi-selector to place the rectangular cursor over an area that has the desired color. Press it to select it.

- **4)** Turn the Main Command Dial and then use ▲ or ▼ to adjust the color range (i.e. to be more or less selective with the color). A preview shows the effect.
- **5)** To select another color, turn the Main Command Dial again to highlight another "swatch" and repeat steps 3 and 4.
- 6) To save the image, press OK

> Edit movie

This item has a rather inflated title; it merely allows you to trim the start and/or end of a movie clip.

- **1)** Select a movie clip in full-frame playback (do not play the movie).
- **2)** Press **⊙K** select **Edit Movie** and press **►**.
- **3)** Select Choose start point or Choose end point and press **OK**).
- **4)** Press **(K)** to start playing the movie. Press **(V)** to pause. Rotate the Main Command Dial to jump forward or back in 10-second steps.
- 5) Press ▲ to set the start or end point. Select Yes and press (○K) to save the trimmed clip as a copy. The original is retained.
- **6)** Repeat if necessary to trim the other end of the clip.

» MY MENU AND RECENT SETTINGS

My Menu is a convenient way to speed up access to menu items and settings that you use frequently. Items from any other menu can be added to My Menu to create a handy shortlist, up to a maximum of 20 items

Alternatively, you can activate the Recent Settings menu, which stores the 20 most recent settings made using the other menus. This requires less effort than adding items to My Menu, but the most recent items won't always be the same as the ones you use most frequently over the longer term. For example, if you've been busy in the Retouch menu, Recent Settings may fill up with things like Selective Color and Trim, which will be little use to you if you want quick access to shooting settings when out in the field.

To add items from My Menu

- **1)** In My Menu, highlight **Add items** and press **▶**.
- **2)** A list of the other menus now appears. Select the appropriate menu and press ▶.
- **3)** Select the desired menu item and press **OK**).
- **4)** The My Menu screen reappears with the newly added item at the top. Use ▼ to move it lower down the list if desired. Press **(OK)** to confirm the new order.

To remove items from My Menu

- **1)** Highlight **Remove items** and press **▶**.
- 2) Highlight any item and press ▶ to select it for deletion. A check mark appears beside the item.
- 3) Select additional items in the same way.
- **4)** Highlight **Done** and press **OK**). A confirmation dialog appears. To confirm the deletion(s) press **OK**) again. To exit without deleting anything, press **MENU**.

To rearrange items in My Menu

- **1)** Highlight Rank items and press ▶.
- 2) Highlight any item and press **OK**).
- 3) Use ▲ or ▼ to move the item up or down: a yellow line shows where its new position will be. Press **(K)** to confirm the new position.
- **4)** Repeat steps 2 and 3 to move further items. When finished, press **MENU** to exit.

> Recent Settings

The Recent Settings menu stores up to 20 items. You must activate Recent Settings before any items can be recorded. It only stores items from menus and not does not store changes made with buttons and dials.

Tip

Recent Settings only stores items from the menus. It does not record changes made using buttons and dials. For instance, if you change Image quality using the Shooting menu, this will be recorded, but if you use QUAL and Main Command Dial, this will not appear in Recent Settings.

To activate Recent Settings

- **1)** In My Menu, select **Choose tab** and press **OK**).
- 2) Select Recent Settings and press **(OK)**. The name of the menu changes to Recent Settings.

Once activated, Recent Settings begins to record the settings which you use in the other menus. Select any item from the list and press to access the range of options for that setting, just as you do when accessing it from its "home" menu. To revert to My Menu you must use the **Choose tab** procedure again.

To remove items from the Recent Settings menu

It is possible to delete items from the list, perhaps to bring your "favorite" shooting settings back to the top of the list. Highlight any item in the list and press to delete. To confirm, press again. Deleting items simply makes the list shorter—older items do not reappear. If you regularly find yourself editing the Recent Settings list in this way, it's worth considering reverting to My Menu.

4 FLASH

The D810 has a built-in flash. This sets it apart from top pro models like the D4s, but should not be taken as an indication that the D810 is not a professional camera.

True, a small pop-up flash is not much use on its own as a main light—its range is limited and the quality of the light is ugly. But it still has the ability to play a serious, even professional, role as a source of fill-in light. Furthermore, the built-in flash can act as a "commander" unit for a multiflash wireless setup, potentially making it a powerful professional tool.

Few serious photographers can really say they never use flash. Even in landscape photography, it often has a role to play for foreground fill. Yet there are many for whom flash remains something of a dark art. It mystifies many people, for instance, that professionals seem to use flash on bright days but not when the light levels drop—exactly the opposite of what might be expected.

Whether you use the built-in flash or a compatible accessory flashgun, the D810 is very capable at managing flash exposure automatically. Still, to get the best out of flash, and to make informed decisions about when to use it and when to do without, we need to understand a few basic principles.

NIGHT RIDER

>>

Here, flash is the dominant light on the rider, though there is a blurred secondary image from the ambient light. I exposed to keep the background dark to emphasize the rider. 180mm, 1/40 sec., f/6.3, ISO 1000.

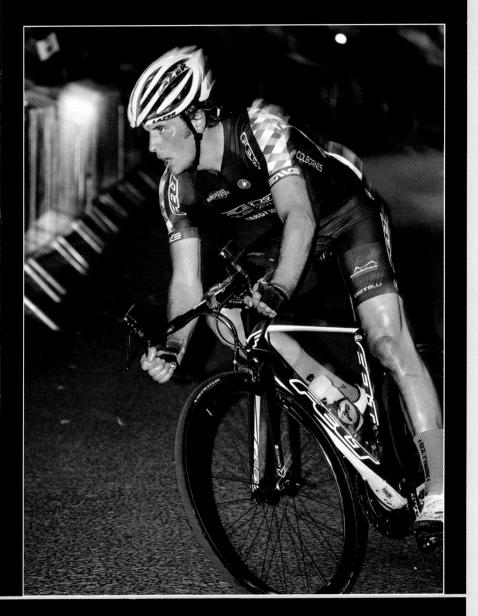

» PRINCIPLES

All flashguns are small; all flashguns are weak. These two statements are the key to understanding flash photography. They are especially true for built-in units like that on the D810 and most other DSLRs—and even more so for compact cameras, where the flash is typically even smaller and weaker. Because it's small, the flash produces very hard light. It's similar to direct sunlight, but even the strongest sunlight is slightly softened by scattering and reflection; we can use the same principles to soften the flash, too

The weakness of flash is even more fundamental. Above all, it means that all flashguns have a limited range. Accessory flashguns are generally more powerful than built-in units, which extend their range somewhat—but only somewhat.

Built-in flash units raise a third issue, too: namely, their fixed position close to the lens, which makes the light one-dimensional and the same for every shot—which would be boring! Accessory flashguns give us a range of additional options.

Finally, there's an important distinction between using the flash as the main (or only) light source and using it as a supplementary light. The commonest supplementary use is for fill light (see page 150) but flash can also be used as an accent, to add extra definition, or to give a sharper image of a fast-moving subject.

» BUILT-IN FLASH

The D810's built-in flash, like all such units, is small, low-powered, and fixed in position close to the lens axis. Together, these factors mean it has a limited range, and produces a flat and harsh light which is unpleasant for, say, portraits. It's certainly better than nothing at times, but its real value is for fill-in light. Its other great asset is that it can be used to trigger remote flashquns.

Activating the built-in flash

1) Select a metering method: matrix- or center-weighted metering is appropriate

D810 WITH FLASH RAISED

FLASH POP-UP BUTTON \$

Tip

The built-in flash covers the field of lenses up to 24mm (16mm if using DX-crop). With wider lenses, the corners of the frame will not be covered by the flash.

for fill-in flash. Spot metering is appropriate when flash is the main or only light.

- 2) Press 5 and the flash will pop up and begin charging. When it is charged the ready indicator 3 is displayed in the viewfinder.
- 3) Choose a flash mode by pressing and rotating the Main Command Dial

until the appropriate icon appears in the control panel. See page 155 for explanation of the different flash modes.

- **4)** Half-press the shutter-release button to meter and focus. Fully depress the shutter-release button to take the photo.
- **5)** When finished, close the flash by pressing down until it clicks into place.

SHADOW

>>

The built-in flash can throw a very obvious shadow.

» NIKON CREATIVE LIGHTING SYSTEM

Nikon's Creative Lighting System (CLS) came into being in 2003. It embodied a number of innovations to make the use of flash not just easier but, equally importantly, more flexible. These include i-TTL flash metering, FV (flash value) lock, advanced wireless control, and auto FP high-speed sync, all of which we'll look at later in this chapter.

CLS requires both a compatible camera body (like the D810) and one or more compatible flashguns. These include all current Nikon Speedlights plus several models which are now officially discontinued (but may still be available as new). These are listed on page 165 and the current models are described in detail on pages 165–167.

Many older Nikon flashguns can also be used with the D810 but advanced CLS functions such as wireless flash control will not be available. The Nikon manual gives a list of such units.

> Fill-in flash

A key application for flash is for "fill-in" light, giving a lift to dark shadows like those cast by direct sunlight. This is the answer to the "mystery" of why pros regularly use flash in bright sunlight. Fill-in flash doesn't need to illuminate the shadows fully, only to lighten them a little. This means the flash can be used at a smaller aperture, or greater distance, than when it's the main light (averaging around 2 Ev smaller, or four times the distance).

LIGHT ROCK

~

The background exposure is the same for both shots, but the fill-in flash lightens the shadows (right) while scarcely affecting the sunlit areas. 14mm, 1/100 sec., f/11, ISO 64, tripod.

i-TTL balanced fill-flash for DSLR

i-TTL balanced fill-flash is part of Nikon's Creative Lighting System (CLS). It helps achieve natural-looking results when using fill-in flash, provided that matrix or centerweighted metering is selected and a CPU lens is attached. It is activated automatically and the flash (either the built-in unit or a compatible accessory flash) emits several near-invisible pre-flashes immediately before exposure. The reflected light from these is analyzed by the D810's metering sensor, together with the ambient light, to produce the optimum exposure. If Type D or G lenses are used, distance information is also taken into account for even greater exposure accuracy.

Standard i-TTL flash for DSLR

When spot metering is selected, this mode is activated instead of i-TTL balanced fill-flash. The flash output is still controlled to illuminate the subject correctly, but the background illumination is not taken into consideration. This mode is more appropriate when a compatible flash is being used as the main light source, rather than a fill-in light.

FLASH CYCLE

¥ Iy

i-TTL balanced fill-flash for DSLR gives a fairly natural result; it's not overly obvious that flash has been used at all, but without it the contrast would be much harsher.

30mm, 1/200 sec., f/9, ISO 200.

» FLASH EXPOSURE

Whether the shutter speed is 1/200 sec. or 20 sec., the flash normally fires just once and therefore delivers the same amount of light to the subject. If there's no other light, the subject will look the same whatever the shutter speed. However, in most cases, even in the studio, there is at least a little other light around, which we

call ambient light. As soon as there is some ambient light, shutter speed becomes relevant, as slower shutter speeds give ambient light more chance to register.

Aperture, however, is relevant to both flash and ambient exposure. If you use a smaller aperture, but don't change the flash output or ISO, the image will look

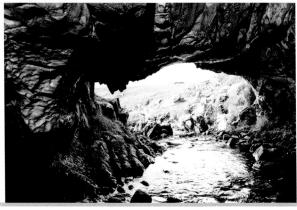

CAVING IN

Both shots use the same aperture setting, giving identical results in the interior of the cave, which is lit only by the flash. However, varying the shutter speed makes a difference in the areas lit by daylight.

24mm, 1/250 sec. and 1/15 sec., f/9, ISO 100. darker. The camera's flash metering takes this into account but it is useful to understand this distinction for a clearer sense of what's going on, especially with slow-sync shots.

The combinations of shutter speed and aperture that are available when using flash depend on the exposure mode in use.

Note:

Under some circumstances, flash can be used with shutter speeds faster than 1/250 sec. See High-speed flash sync (page 164).

Exposure mode	Shutter speed	Aperture Set by camera.	
P	Set by camera. The normal range is between 1/250 and 1/60 sec., but in certain flash modes all settings up to 30 sec. are available.		
A	Selected by user. All settings between 1/250 sec. and 30 sec. are available. If user sets a faster shutter speed, the shutter will fire at 1/250 sec. while the flash is active.	Set by camera.	
S	Set by camera. The normal range is between 1/250 and 1/60sec., but in certain flash modes all settings up to 30 sec. are available.	Selected by user.	
М	Selected by user. All settings between 1/250 sec. and 30 sec. are available. If user sets a faster shutter speed, the shutter will fire at 1/250 sec. while the flash is active.	Selected by user.	

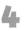

» FLASH RANGE

The usable range of any flash depends on its power, and on the ISO sensitivity setting and the aperture selected. If the flash does not reach as far as you want, you can increase its effective range, within limits, by using a higher ISO rating and/or a wider aperture—but check first that flash compensation (page 158) is not in effect. The following table shows the approximate maximum range of a Nikon SB-700 for selected distances, apertures, and ISO settings, assuming a 50mm lens. These figures are based on Nikon's published figures, verified by practical tests. It's not necessary to memorize all these figures, but it is helpful to have a general sense of the range limitations that apply when using flash. In any given situation, a few quick test shots will soon establish a workable shooting range.

LIGHT IN THE TUNNEL

×

The limited range of the flash is apparent, only really illuminating a few meters of the tunnel. 16mm, 1/50 sec., f/11, ISO 2500

		ISO setting				Maximum range		
64	100	200	400	800	1600	3200	meters	feet
	1.4	2	2.8	4	5.6	8	19.8	65′
1.6	2	2.8	4	5.6	8	11	14.2	47′
2.2	2.8	4	5.6	8	11	16	9.8	32'
3.2	4	5.6	8	11	16	22	7	23'
4.5	5.6	8	11	16	22	32	4.9	16′
6.3	8	11	16	22	32		3.5	11" 6"
9	11	16	22	32			2.6	8′
13	16	22	32				1.6	5′

» GUIDE NUMBERS

The Guide Number (GN) is a measure of the power of a flash. In the past, photographers used GNs constantly to calculate flash exposures and working range. With the Nikon CLS, such computations are rarely needed, but the GN does help us compare different flashguns. For instance, the GN for the built-in flash is 12 (meters, at ISO 100); for the Nikon SB-910 it is 34, indicating almost three times the power. This allows shooting at three times the distance, at a lower ISO, or with a smaller aperture.

Tip

GNs are specified in feet and/ or meters and usually—but not always—for an ISO rating of 100. When comparing different units, be sure that both GNs are stated in the same terms.

» FLASH SYNCHRONIZATION AND FLASH MODES

In order to cover the whole image frame, the flash must be fired when the shutter is completely open. However, at faster shutter speeds DSLRs do not expose the whole frame at once—for the D810, the fastest shutter speed where this applies is (normally) 1/250 sec. This is known as the sync (short for synchronization) speed.

Flash modes are distinguished by how they regulate synchronization and shutter speed. To choose flash mode, press 22 and rotate the Main Command Dial.

Standard flash mode (Front-curtain sync)

Front-curtain sync is the default mode. In this mode, the flash fires as soon as the shutter is fully open, i.e. as soon as possible after the shutter-release button is pressed. In P and A exposure modes, the camera will automatically set a shutter speed between 1/60–1/250 sec. The "opposite" of front-curtain sync is, naturally enough, rear-curtain sync (see next page).

Note:

Nikon brands this basic flash mode as "Fill-flash". This is accurate when using matrix or center-weighted metering, but not when spot metering is active (see page 44).

Red-eye reduction

On-camera flash, especially from built-in units, often creates "red-eye", when light reflects off the subject's retina. In animals you may see other colors.

Red-eye reduction works by shining a light (the AF-assist illuminator) at the subject just before the exposure, causing the subject's pupils to contract. This delay makes it inappropriate with moving subjects, and kills spontaneity. Most of the time, it's far better to remove red-eve using the Red-eye correction facility in the Retouch menu (see page 138) or on the computer. Better still, use a separate flash. away from the lens axis, or no flash at all, perhaps shooting at a high ISO rating.

Slow sync

This mode allows longer shutter speeds (up to 30 sec.) to be used in P and A exposure modes, so that backgrounds can be captured even in low ambient light. Movement of the subject or camera (or even both) can result in a partly blurred image combined with a sharp image where the subject is lit by the flash. This may be unwanted, but is often used for specific creative effect. This mode is unavailable when shooting in S and M exposure modes, because longer shutter speeds can then be set directly.

Red-eye reduction with slow sync

Self-evidently, this combines the two modes named, allowing backgrounds to register. This may give a more natural look to portraits than Red-eye reduction mode on its own, but is still subject to the same problematic delay. Like slow sync, this mode is only available when using P and A exposure modes.

Rear-curtain sync

Rear-curtain sync triggers the flash not at the first available moment (as with frontcurtain sync) but at the last possible instant. With moving subjects, this means that any image created by ambient light appears behind the subject. This usually looks more natural than the effect of front-curtain sync, when the blurred image extends ahead of the direction of movement. In P and A modes it also allows you to select slow shutter speeds (below 1/60 sec.), becoming slow rearcurtain sync.

When using longer exposure times, shooting with rear-curtain sync can be tricky, as you need to predict when your subject will be at the end of the exposure, rather than the instant after pressing the shutter-release button. It is often best suited to working with co-operative subjects—or naturally repeating action, like races over numerous laps of a circuit so you can fine-tune your timing after reviewing images on the monitor.

SYNC SHOTS

Slow sync combines a flash image with a motion-blurred image from the ambient light. Front-curtain sync (left) makes the blurred elements appear to run ahead of the flash image; rear-curtain sync (right) lets them trail behind it.

Left: 14mm, 1/100 sec., f/11, ISO 400; right: 140mm, 1/40 sec., f/6.3, ISO 1000.

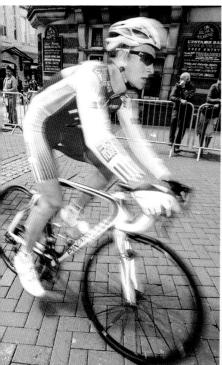

» FLASH COMPENSATION

Although Nikon's Creative Lighting System offers excellent flash metering, it's not completely infallible. You may also want to adjust flash output for creative effect. Image review and playback let you assess the effect of the flash, allowing compensation to be applied to further shots with confidence.

However, if the subject is already at the limit of flash range, positive compensation can't make it any brighter. In this case, if you want to brighten the flash image, use a wider aperture, set a higher ISO, or move closer to the subject.

After use, reset flash compensation to zero. Otherwise the camera will retain the setting next time you use flash.

FLASH COMPENSATION

The background exposure remains the same for these three shots, taken with flash compensation set to -1, 0, and +1 respectively. 34mm, 1/125 sec., f/11, ISO 100.

>>

Manual flash

If Custom Setting e3 Flash control for built-in flash is set to Manual (page 118), you can control flash output even more precisely, from full power to as low as 1/128. When using external Speedlights, you set manual power through the unit's own controls.

> FV lock

FV lock works like exposure lock, allowing flash output to be locked and the image reframed. It's useful when you want to use flash with an off-center subject, outside the area covered by the focusing sensors (and spot metering). Using FV lock requires assigning the FV lock function to a control button (Fn, Preview, or **AE-L/AF-L**). It's usually more convenient to use flash compensation, fine-tuning with the monitor screen.

- 1) To assign the Fn button to the FV lock function, navigate to Custom setting f4 Assign Fn button and select Fn button press. Select FV lock and press (OK). You can also assign this function to the PV button (Custom Setting f5) or AE-L/AF-L (Custom Setting f6).
- **2)** Raise the flash and wait for it to charge, or attach a CLS-compatible flashgun.
- **3)** Position the subject centrally in the frame; half-press the shutter-release button to activate focus and metering.
- **4)** Check the flash-ready indicator **3** is shown in the viewfinder. Press the assigned button. A pre-flash fires to set the flash level, then FV lock icons appear.
- **5)** Reframe the image and shoot. The flash level is locked for succeeding shots.

6) To release FV lock, press the assigned button again.

> Flash exposure bracketing

Flash exposure bracketing is another way to achieve the required level of flash illumination. It works just like exposure bracketing, and you can bracket both flash and the main exposure simultaneously; set Custom Setting e5 Auto bracketing set to Flash only (to vary flash level only) or AE & flash (to vary the main exposure as well).

- 1) While pressing **BKT**, rotate the Main Command Dial to select the number of shots (2, 3, 5, 7, or 9) for the burst.
- **2)** Still pressing **BKT**, rotate the Subcommand Dial to select the flash output increment between shots. Possible values run from 0.3 Ev to 3 Ev.
- **3)** Frame, focus, and shoot. The camera will vary the flash output (and overall exposure if **AE & flash** was selected) with each frame until the sequence is completed. A progress indicator appears in the control panel.
- **4)** To return to normal shooting, press **BKT** and rotate the Main Command Dial until **OF** appears in the control panel or information display.

» USING OPTIONAL SPEEDLIGHTS

If you're serious about portrait or close-up photography, in particular, you'll soon find the built-in flash inadequate. Accessory flashguns, which Nikon calls Speedlights, enormously extend the power and flexibility of flash with the D810.

As we've already observed, Nikon Speedlights integrate fully with Nikon's Creative Lighting System for outstanding results. There are currently four models, all highly sophisticated units mainly aimed at professional and advanced users, and priced accordingly.

The table below shows CLS-compatible Speedlights made by Nikon, both current and discontinued.

Independent makers such as Sigma offer alternatives, many of which are also

compatible with Nikon's i-TTL flash control. However, such dedicated units are also relatively expensive.

Using non-Nikon units

Nikon issues dire warnings about using other brands of flash with its cameras, and certainly doesn't want to let on that third-party units may be compatible with CLS control. However, independent makers do offer alternative flashguns which are fully compatible with i-TTL flash metering and, at least to a limited extent, with wireless flash control too.

On the other hand, some flashguns may use too high a trigger voltage or even the wrong polarity, which could damage the camera's circuitry. It's best to avoid

	Guide Number for ISO 100 (meters)	Use as commander unit?	Current or discontinued	
SB-910	34	Yes	Current	
SB-700	28	Yes	Current	
SB-300	18	No	Current	
SB-R200	10	No	Current	
SB-900	34	Yes	Discontinued	
SB-800	38	Yes	Discontinued	
SB-600	30	No	Discontinued	
SB-400	21	No	Discontinued	

mounting or connecting any non-Nikon flashgun unless it's from a reputable maker like Sigma or Metz, and their information clearly states that the unit is compatible.

Warning!

The risk of encountering excessive voltages is even more pronounced with studio flash units. When using Nikon DSLRs with studio flash—shooting images of the camera for this book, for example—I've never connected them directly but do use a Speedlight or built-in unit to trigger the studio flash in "slave" mode.

Even cheap, basic flashguns offer many possibilities. You may lose i-TTL metering, but great results are possible with a little trial and error. If you use certain setups regularly (as you may well do for portraits and close-ups), then you can easily record and replicate the flash settings. However, take note of the warning above: be wary of flashguns that are not certified compatible unless you can verify their trigger voltage.

There are still useful ways to employ such units but they should not be mounted in the hotshoe. You may have an old flashgun at the back of a cupboard somewhere, and it's also worth looking in the bargain bin at the local camera shop.

There is only space in this book to detail Nikon's own current units, but information about older units is included in the D810 Nikon Reference Manual. Information about Sigma units is available from www. sigmaphoto.com or www.sigma-imaging-uk.com/flash.

Mounting an external Speedlight

- 1) Check that the Speedlight is switched off. Slide the base of the Speedlight into the camera's hotshoe. If you feel resistance, check that the mounting lock on the Speedlight is released.
- **2)** Rotate the lock lever at the base of the Speedlight to secure it in position.
- 3) Switch on the Speedlight. Once it is charged and ready, a 3 Icon appears in the viewfinder

> Bounce flash and off-camera flash

The built-in flash can work well for fill-in but is limited as a main light. Its fixed position just above the lens throws shadows on close subjects and gives portraits a "police mugshot" look. It's also prone to red-eye.

Simply mounting a separate Speedlight in the hotshoe may only improve things marginally; the light is still harsh and still quite close to the lens axis, so red-eye remains a common issue.

You can dramatically alter the quality of light by either:

- **1)** Bouncing the flash light off a ceiling, wall, or reflector.
- 2) Taking the Speedlight off the camera.

> Bounce flash

Bouncing the flash light off a suitable surface both spreads the light, softening hard-edged shadows, and changes its direction, eliminating the flatness of direct on-camera flash.

USING FLASH

>>

The first shot (top) was taken using the built-in flash; there's an ugly shadow yet the subject itself looks a bit flat. The second (center) uses off-camera flash from the left, creating strong modeling. The third (bottom) uses bounce flash, giving a softer, more even light. 100mm macro, f/11, ISO 64, tripod.

Nikon's SB-910 and SB-700 Speedlights have heads which can be tilted and swiveled through a wide range, allowing light to be bounced off walls, ceilings, and other surfaces. The SB-300 has a basic tilt capability, allowing light to be bounced off the ceiling or a reflector.

Tip

Most surfaces absorb some light, and the light has to travel further to reach the subject: i-TTL metering will automatically adjust for this, but the working range is reduced. Bounce flash works better in domestic interiors with low ceilings (especially if they are white or light in color) than in larger spaces. Alternatively, you can use a reflector. Colored surfaces change the color of bounced light, which may help with creative effect—portrait photographers use gold reflectors for a warmer result—but choose a white or silvered surface for neutral results.

> Off-camera flash

Taking the flash off the camera gives complete control over the direction of its light. The flash can be fired wirelessly (see below) or using a flash cord. Nikon's dedicated cords preserve i-TTL metering.

> Wireless flash

Many external flash units can be fired wirelessly using a "slave" attachment, but with this there's no other communication between camera and flash, and no direct control over flash output. However, using

WIRELESS FLASH

Wireless flash was used to throw some extra light into this limestone grike. Apart from any other consideration, there physically wasn't room in the narrow space to mount the flash on the camera's hotshoe. I used the Phottix Odin radio system to control the flash, but very similar results are possible using the built-in flash in commander mode, or using a sync lead. 24mm, 1/100 sec., f/13, ISO 100.

» NIKON SPEEDLIGHTS

Nikon Speedlights like the SB-910 and SB-700 allow full flash control, integrated by the camera's powerful metering system. The D810's built-in flash can act as the "commander" unit, controlling multiple Speedlights in one or two separate groups. It's this ability, above all, which elevates the built-in flash from an "amateur" add-on to a powerful professional feature.

To enable Commander mode, and tune the output of one or more remote Speedlights, use Custom setting e3: Flash cntrl for built-in flash. To allow the camera to regulate flash output, set Mode to TTL for each unit or group. Comp settings are exactly like Flash Compensation (see page 158).

As an alternative to Nikon's own units, many professionals prefer a radio-controlled system. These generally have a greater range and also allow you to use third-party flashguns. The best-known name in this field is Pocket Wizard, while I've had excellent results using the less expensive Phottix Odin setup.

Using multiple flashes in a wireless system gives you virtually complete control over the strength and direction of light on your subject, but there's no doubt it takes a little time to get a feel for all the possible permutations. It's a very good idea to have a few dry-runs before using such a setup on an important shoot.

> High-speed flash sync

Nikon's SB-910, SB-700, and SB-R200 Speedlights all offer Auto FP High-Speed sync. This enables the flash output to be phased or pulsed, allowing flash to be used at all shutter speeds. Combining flash with fast shutter speeds is useful, for instance, when ambient light levels are high or you wish to use a wide aperture, or when using fill-in flash with fast-moving subjects.

Enable Auto FP High Speed sync using Custom setting e1: set either 1/320s (Auto FP) or 1/250s (Auto FP). If a suitable Speedlight is attached, flash can then be used at any shutter speed from 30 sec. to 1/8000 sec. You should, however, be aware that the effective power (and therefore working range) of the Speedlight will reduce as the shutter speed gets faster.

See the manual for the individual Speedlight for more details, and take test shots and review them on the monitor if at all possible.

> Speedlight SB-910

The SB-910 is the flagship of Nikon's Speedlight range. An obvious change over earlier models is a more intuitive control interface, in line with the SB-700. It offers multiple illumination patterns, an impressive 17-200mm zoom range (extendable to 14mm with the built-in diffuser) and automatic detection of sensor format—in other words, it knows whether it's attached to an FX-format or DX-format camera. The firmware is upgradeable when the flash is attached to a camera such as the D810. The Guide Number is quoted as 34 (ISO 100/meters), but the effective GN varies according to the zoom setting. The SB-910 can also be employed as the Commander unit for integrated fully auto flash control with multiple Speedlights.

Guide Number: 34 (meters) (ISO 100, set at 35mm zoom).

Flash coverage (lens focal length range): 17–200mm with Nikon D810; can be widened to 14mm with built-in adapter or separate diffusion dome.

Tilt/swivel: Yes

Recycling time: 2.3 sec. with Ni-MH batteries: 4 sec. with alkaline batteries

Approximate number of flashes per set of batteries: 190 with Ni-MH batteries; 110 with alkaline batteries
Dimensions (width x height x depth): 78.5 x 145 x 113mm
Weight (without batteries): 420g

Included accessories: Diffusion Dome SW-13H, Speedlight Stand AS-21, Fluorescent Filter SZ-2FL, Incandescent Filter SZ-2TN, Soft Case SS-910

> Speedlight SB-700

The SB-700 is a highly featured unit with several innovative aspects including intuitive operation and a choice of illumination patterns. Though lacking a few of the high-end features of the SB-910, and

slightly less powerful, it still has everything most users will ever need. It's also smaller, lighter, and significantly cheaper.

Guide Number: GN 28 (meters) (ISO 100, set at 35mm zoom)

Flash coverage (lens focal length

range): Equivalent to 24–120mm on D810

Tilt/swivel: Yes

Recycling time: 2.5 sec.

Approximate number of flashes per set

of batteries: 200

Dimensions (width x height x depth): 71

 \times 126 \times 104.5

Weight: 360g (without batteries)

Included accessories: Speedlight Stand AS-22, Nikon Diffusion Dome SW-14H, Incandescent Filter SZ-3TN, Fluorescent

Filter SZ-3FL, Soft Case SS-700

> Speedlight SB-300

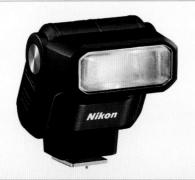

A compact, light, and simple flash.

Guide Number: 18 (meters) (ISO 100, set

at 35mm zoom)
Tilt/swivel: Tilt only

Dimensions (width x height x depth):

57.4 x 65.4 x 62.3mm

Weight: 97g (without batteries)

> Speedlight SB-R200

Designed principally to work as part of a close-up lighting system (see page 172); can't be attached to the camera's hotshoe. Can be triggered by an SU-800 Commander, or SB-910/SB-700 Speedlight.

Wireless Speedlight Commander SU-800 The SU-800 allows complete control over a complex setup of up to three groups of Speedlights.

Speedlight Commander Kit R1C1 and Speedlight Remote Kit R1 Dedicated kits for close-up photography (see page 172 for more detail).

> Flash accessories

Flash accessories such as diffusers, reflecters, and remote leads allow yet more flexibility and control over lighting effects, while power packs increase flash capacity.

Speedlight Stand AS-19 Allows Speedlights to stand on flat surfaces or to be mounted on a tripod.

Flash diffusers Flash diffusers are a simple, economical way to spread and soften the hard light from a flash head. Both the SB-910 and SB-700 include a small dome-type diffuser. Larger third-party units give almost a "soft-box" effect.

Diffusers inevitably reduce the light reaching the subject; flash metering will compensate, but the effective range will be reduced.

> Flash brackets

Nikon's Speedlights can be mounted on a tripod or stand on any flat surface using the AS-19 stand, but for more portable support many photographers prefer a flexible arm or bracket attached to the camera; Novoflex produces a wide range.

WIRELESS FLASH

The bottom image resulted from using the setup with a HONL diffuser seen in the top picture. The light is clearly directional but much softer than using a "naked" Speedlight. 100mm macro, f/13, ISO 64, tripod.

CLOSE-UP

Most photography is about capturing what you can see with the naked eye. Close-up photography goes beyond this into a whole new world, or at least a new way of seeing the world. For many its fascination can last a lifetime.

A key issue in close-up and macro photography is depth of field (see page 41). As you move closer to the subject, depth of field becomes narrower. This often necessitates stopping down to small apertures, which can make long exposures essential. Narrow depth of field also means that the slightest movement of either subject or camera can ruin the focus. A tripod or other solid camera support is often required, and sometimes you'll want to immobilize the subject (within ethical limits, of course).

With minimal depth of field, focusing becomes critical. Merely focusing on "the subject" is no longer adequate and you must decide which part of the subject—an insect's eye, or the stamen of a flower, for instance—to focus on. The D810's 51 AF points cover much of the frame, but Live View has a lot to offer. In Live View AF (see page 78) you can set the focus point anywhere in the frame, and you can zoom in for greater precision. This also makes manual focus both easy and ultra-precise.

FLY'S-EYE VIEW This image exemplifies the minimal depth of field obtained in extreme close-up shooting. Only the ends of the bee's antennae and parts of its eyes are truly sharp. 100mm macro, 1/640 sec., f/8, ISO 640, tripod.

PRETTY IN PINK

Potential close-up subjects are everywhere, and close-up photography really encourages us to look and see.

100mm macro, 1 sec., f/11, ISO 64, tripod.

» MACRO PHOTOGRAPHY

"Close-up" is not an exact term, but "macro" does have an established and precise meaning. Macro photography means photographing objects at life-size or larger, i.e. with a reproduction ratio (see below) of 1:1 or larger. Many zoom lenses are badged "macro" when their reproduction ratio is around 1:4, or 1:2 at best. There's still plenty of close-up potential, but it isn't macro as classically defined.

There are several possible ways to explore true macro photography without the expense of a dedicated macro lens (see page 176).

> Reproduction ratio

The reproduction ratio (or image magnification) is the ratio between the actual size of the subject and the size of its image on the D810's imaging sensor. This measures 35.9 x 24mm. An object of this

size, captured at 1:1, will fill the image frame exactly. To take an example which you should have to hand, an SD memory card (32 x 24mm) will not quite span the long axis of the frame but will fill the short axis. Of course, when the image is printed, or displayed on a computer screen, it may appear many times larger than "life", but that's another story.

> Working distance

The working distance is the distance required for a desired reproduction ratio with any given lens. It is directly related to the focal length of the lens: a 200mm

TACK SHARP

The left-hand shot shows the closest view achieved with a "normal" 24-85mm zoom lens (about 1:4). The second, taken with a 100mm macro lens at the closest possible distance, gives approximately life-size (1:1) reproduction. 85mm and 100mm macro, 1/15 sec., f/16, ISO 64.

macro lens doubles the working distance for 1:1 reproduction when compared to a 100mm lens. Extra distance can be a big help when photographing living subjects, especially mobile ones, and with delicate subjects, living or not, which might be damaged by accidental contact.

For any given lens, to fill the frame with a subject, working distance will be shorter with an FX-format camera like the D810 than with a DX-format camera such as the D7100. To increase working distance, when no alternative lens is available, consider switching Image area to DX (see page 65); the resulting images—of about 15 megapixels—are still more than adequate for most purposes.

Working distance, and the minimum focus distance of a lens, are normally measured from the subject to the focal

plane, i.e. the position of the sensor. A 25cm working distance may mean that the subject, or the bit of the subject you're focusing on, is less than 10cm from the front of the lens. Other paraphernalia like lens hoods or ring-flash can narrow this gap even more.

Tip

To get as close as possible to your subject, try this: use manual focus and set the lens to its minimum focusing distance. Don't touch the focus control again; instead move either camera or subject until the image is sharp. This isn't fast, but does guarantee that you're as close as the lens allows.

BUTTERFLY

Longer working distances
can be particularly helpful
with subjects that may be
easily disturbed.

» MACRO LIGHTING

Of course, many fine close-up and macro shots can be taken using available light. However, you'll often find that your own shadow, or the camera's, can intrude. Many subjects (like the interiors of flowers) can create their own shadows too. For these and other reasons, you'll soon start to want more controlled lighting. This usually means flash, but regular Speedlights are not designed for ultra-close work, and when mounted in the hotshoe may not light the subject at all.

Specialist macro flash units usually take the form of either ring-flash or twin flash. At these operating distances they do not need high power and can be relatively light and compact.

Ring-flash units encircle the lens, giving even illumination even on ultra-close subjects (they're also favored by some portrait photographers). Nikon no longer makes a ring-flash, but alternatives come from Sigma and Nissin.

Nikon itself favors a twin-flash approach with its Speedlight Commander Kit R1C1

BRIGHT AND BEAUTIFUL

The bottom image resulted from the setup in the top picture, with the D810 and Sunpak LED Macro Ring Light (this is an older version, not the DSLR67). It gives even, almost shadowless illumination on the subject, but doesn't reach very far, so the background is dark. 100mm macro, 1/6 sec., f/11, ISO 64, tripod.

and Speedlight Remote Kit R1. Both use two Speedlight SB-R200 flashguns, mounted either side of the lens. The R1C1 uses a Wireless Speedlight Commander SU-800 unit which fits into the camera's

hotshoe, while the R1 needs a separate Speedlight to act as commander. These kits are expensive but give very flexible and precisely controllable light on macro subjects.

> LED light

An alternative is to use LED lights, like the very cheap Sunpak DSLR67 LED Macro Ring Light. Its continuous output allows you to preview the image in a way not possible with flash. Its low power limits it to very close subjects, but that of course is all you need in a macro light. You may need to use quite high ISO ratings to get short enough shutter speeds for mobile subjects. There is also a distinct color cast and you

STRANGE FRUIT

The first of these shots (left) simply used an SB-700 Speedlight, to the left. For the second, the only difference was that a sheet of white card was placed just out of shot on the right. 100mm macro, f/13, ISO 64.

may need to experiment with white balance settings (and/or shoot RAW).

> Improvization

Dedicated macro-flash units aren't cheap, and may be unaffordable or unjustifiable when you just want a taste of macro work. Fortunately, you can do lots with a standard flashgun, plus a flash cord. With basic units, you'll lose the D810's advanced flash control, but it only takes a few test shots to establish settings that you can use repeatedly (remember to keep notes). Also essential is a small reflector, like a piece of white card; place it really close to the subject for maximum benefit. This system can be very flexible and can deliver very polished results.

I've also found that a flash diffuser, like the HONL I use (see page 167), can give excellent results; on small subjects it gives a really good spread of light.

» EQUIPMENT FOR MACRO PHOTOGRAPHY

> Close-up attachment lenses

Close-up attachment lenses are simple magnifying lenses that screw into the filter thread of the lens. They are light, convenient, inexpensive, and fully compatible with the camera's exposure and focusing systems. For best results, it's recommended to use them with prime lenses (see page 192).

Nikon produces six close-up attachment lenses—see the table below.

Warning!

Some recent lenses are not compatible with accessories such as extension tubes, bellows (see below and opposite), and teleconverters (see page 202). Check the lens manual beforehand.

Product number	Attaches to filter thread	Recommended for use with
0, 1	52mm	Standard lenses
3T, 4T	52mm	Short telephoto lenses
5T, 6T	62mm	Telephoto lenses

> Extension tubes

Extension tubes are another simple, relatively inexpensive, way of extending the close-focusing capabilities of a lens. An extension tube is essentially a simple tube fitting between the lens and the camera. This decreases the minimum focusing distance and thereby increases the magnification factor. Again they are light, compact, and easy to carry and attach.

The Nikon system includes four extension tubes—PK-11A, PK-12, PK-13, and PN-11—which extend the lens by

Tip

Nikon's own extension tubes are no longer listed, but compatible extension tubes are produced by other manufacturers. Some support exposure metering, but they do not allow autofocus with the D810.

8mm, 14mm, 27.5mm, and 52.5mm respectively. The PK-11 incorporates a tripod mount. The basic design of these tubes has not changed for many years, which means that many of the camera's functions are not available. In particular, there's no autofocus.

Kenko also produces compatible extension tubes, which do support autofocus. They're also far more reasonably priced than Nikon's own offerings.

> Bellows

Like extension tubes, bellows extend the spacing between the lens and the camera body, but they are not restricted to a few set lengths. Again, there's no extra glass to impair optical quality. However, bellows are expensive, heavy, and take time to set up. They are usually employed in a studio or other controlled setting.

Nikon's PB-6 bellows offers extensions from 48mm to 208mm, giving a maximum reproduction ratio of about 11:1. Focusing and exposure are manual only.

> Reversing rings

Also known as reverse adapters or inversion rings, these allow lenses to be mounted in reverse; the adapter screws into the filter thread. This allows much closer focusing than when the lens is used normally. They are ideally used with a prime lens, such as the classic 50mm f/1.8: Nikon's Inversion ring BR-2A fits its 52mm filter thread.

› Light reduction

Because accessories like extension tubes and bellows increase the effective physical length of the lens, they also increase the effective focal length. However, the physical size of the aperture does not change. The result is to make the lens "slower"; i.e. a lens with a maximum aperture of f/2.8 behaves like an f/4 or f/5.6 lens. This makes the viewfinder image dimmer than normal, and affects the exposure required. The camera's metering will accommodate this, but you may need a longer shutter speed or more light. Reversing rings do not have this effect.

» MACRO LENSES

True macro lenses achieve reproduction ratios of 1:1 or better and are optically optimized for close-up work, though normally very capable for general photography too. This is certainly true of Nikon's Micro Nikkor lenses, of which there are currently five. Two of them are DX lenses but they should not automatically be ruled out on this score.

Having said all that, the lens used for all the close-up illustrations in this book is a 100mm Tokina.

60MM F/2.8G ED AF-S MICRO NIKKOR

The 60mm f/2.8G ED AF-S Micro Nikkor is an upgrade to the previous 60mm f/2.8D: advances include ED glass for superior optical quality and Silent Wave Motor for ultra-quiet autofocus.

105MM F/2.8G AF-S VR MICRO NIKKOR

The 105mm f/2.8G AF-S VR Micro

Nikkor also features internal focusing, ED glass, and Silent Wave Motor, but its main claim to fame is as the world's first macro lens with VR (Vibration Reduction).

As the slightest camera shake is magnified at high reproduction ratios, technology designed to combat its effects is extremely welcome, allowing you to employ shutter speeds up to four stops slower than otherwise possible. However, it can't compensate for movement of the subject. Remember, too, that at close range the slightest change in subject-to-camera distance can completely ruin the focus, so a tripod is still invaluable.

The 200mm f/4D ED-IF AF Micro

Nikkor is an older design, but is particularly suited to photographing the animal kingdom, as its longer working distance means there is much less chance of frightening your subject away.

If you're happy using DX-crop mode, there are also two Micro Nikkor lenses specifically engineered for the DX format.

GREEN FINGERS

For serious close-up work, a good macro lens combines quality and convenience. 100mm macro, 1/100 sec., f/11, ISO 200, tripod.

If you're just dipping your toe in the waters, the **40mm f/2.8G AF-S DX Micro Nikkor** has the attraction of being Nikon's lightest, and least expensive, macro lens. Be aware, however, that its working distance at 1:1 reproduction ratio is just 16cm, leaving very little room between the subject and the front of the lens.

The **85mm f/3.5G ED VR AF-S DX Micro Nikkor** is a more versatile focal length and has internal focusing, ED glass, and Silent Wave Motor.

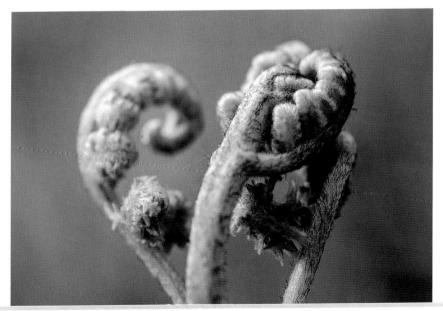

many, the true purpose of the SLR is to shoot stills and its ergonomics are still best for this, but it has become ever clearer that the addition of video is no mere sideshow.

Dedicated movie makers have embraced DSLRs because their large sensors deliver image quality that's superior—and just plain different—to standard camcorders, while photojournalists welcome the ability to shoot high-quality stills and video on the same camera. However, still photography and movies are very different media, requiring distinctly different approaches for the best results.

(High Definition) quality with a frame size of 1920 x 1080 pixels. Full HD is still a general benchmark of video resolution, although the lower 720p standard (1280 x 720 pixels) is the norm on *Vimeo.com*, a key outlet for quality video online. 720p footage looks excellent on most computer screens and mobile devices, and gives much smaller files for up- and download.

The D810 can shoot movies in Full HD

However, Retina iPads have a 2048 x 1536 display—over 50% more pixels than Full HD. With displays like this becoming common, and with "4K" video (equivalent to around 8 megapixels) already available on a few cameras, footage shot in Full HD may be more "future-proof".

> Advantages

DSLRs in general, not least the D810, have some real advantages over standard camcorders. One is the large sensor's ability to give very shallow depth of field (see page 41); and movie-makers have eagerly embraced this "DSLR look". The large sensor also brings greater dynamic range (page 87) and better quality at high ISO ratings, extending the possibilities for shooting in low light. Another plus is the D810's ability to use the entire array of Nikon-fit lenses (see page 192). In particular, it can use wide-angle lenses which go well beyond the range of most camcorders.

Note:

Most digital video cameras claim zoom ranges of 800x or more, but these are only achieved by "digital zoom", a software function which enlarges the central area of the image, losing quality. "Optical zoom" range is what matters, and interchangeable lenses give a potential range of at least 80x (10mm–800mm). The widest range currently available in a single Nikon lens is 18–300mm.

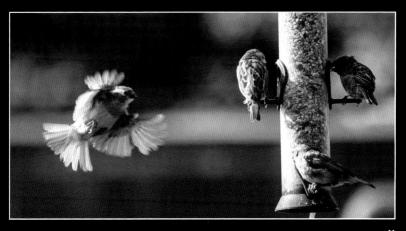

BIRD FEEDER

It's much easier to get really shallow depth of field than with most video cameras. 300mm, DX-crop (equivalent to 450mm), f/4, ISO 400.

WIDE VIEW

Here the focal length was 24mm—on a full-frame camera like the D810 that's still a genuine wide angle. Even so, by focusing really close, on the flowers, it's possible to soften the background.

» MAKING MOVIES

> Preparation

Before shooting, select key settings in the Movie settings section of the Shooting menu (see below). Much of this preparation can be done in Movie Live View, but before actually shooting a clip. Other settings such as Picture Controls should also be set in advance. If you're planning to adjust the look of the movie in post-processing ("grading") then the Flat Picture Control (page 90) gives most latitude for this, but if you're likely to use the footage more or less as is, then pick the Picture Control which will give the look you want. You can quickly set the Picture Control in Movie Live View by pressing **Q** ■ . Use ▲ / ▼ to scroll through the list and **OK**) to select a Picture Control. You can also press > to adjust the settings for the highlighted Picture Control (see page 89).

Tip

You can check the general look of a shot in Live View, but taking a still frame usually gives an even better indication. Best of all, shoot a short clip.

> Movie settings

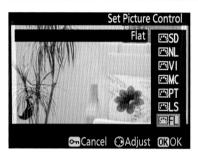

PICTURE CONTROL SELECTION IN MOVIE LIVE VIEW

\$

Movie settings has seven sub-menus. Frame size/frame rate sets the movie image size and frame rate. The size options are 1920 x 1080 pixels and 1280 x 720 pixels. The frame rate options vary according to the size chosen. (See also Image area, below.)

Movie quality sets the compression level (see Note below); options are **High** or **Normal**.

Microphone sensitivity determines the sensitivity of the built-in microphones (or an external microphone if attached). The options are: Auto, Manual Sensitivity (in steps from 1-20), and Off. You can see an audio-level display while in this menu, which makes it easy to do a "soundcheck".

Note:

Footage recorded to card is always compressed to some degree, though High quality is fine for most purposes (akin to JPEG Fine for stills). For professional applications, the D810 can also export uncompressed footage when a compatible recorder is connected to the camera's HDMI port, while still recording compressed footage to the memory card(s).

Frequency response again applies both to the built-in microphones or an external one. Wide range (the default) picks up a broad frequency range which may capture all kinds of ambient sound. Vocal range is tailored more narrowly to the normal frequencies of human speech and can give cleaner sound when recording dialog.

Wind noise reduction applies only to the built-in microphones. Enabling it can indeed reduce the level of wind noise but may also impair the quality of other sound.

Destination determines which card slot is used for recording movies. It makes sense to use one card for stills and one for movies. The settings screen shows available recording time for each card at current settings.

Movie ISO sensitivity settings In P, S, and A modes, ISO control is always

automatic, but if you shoot in mode M you can set the ISO yourself using ISO sensitivity (mode M). It is often necessary to do so, as the available shutter speed range is narrower than when shooting stills (see page 184). You can also opt for Auto ISO control (mode M). Finally, Maximum sensitivity allows you to set an upper limit to the ISO which auto control can set—options run anywhere from 200 to Hi2.

All of the above options, except for Movie ISO sensitivity settings, can also be accessed while in Movie Live View options (but not while actually shooting a clip) by pressing 4 . In addition you can access options for Monitor brightness, Highlight display, and Headphone volume.

- 1) In Movie Live View, make sure that the screen is showing information indicators (if not, press info to cycle through the screens, as in normal Live View).
- 2) Press \P and use \triangle / ∇ to highlight one of the items on the right of the screen.
- 3) Press to see options for that item; select from available options with the Multi-selector.
- **4)** Press **OK** to confirm and return to the screen of step 2.
- 5) Press ♣ again to exit.

> Image area

The D810 records movies with a "widescreen" aspect ratio of 16:9; normally these use almost the full width of the sensor (see diagram on page 64). However, if Image area (page 65) is set to DX, or Auto DX Crop is On and a DX lens attached, the camera will employ a smaller area. This does not affect the output size of the footage; you can still record in Full HD as well as smaller frame sizes. This not only allows the use of DX lenses—which can be light, inexpensive, and have very wide zoom ranges—but also gives a "teleconverter" effect (see page 202).

You can set Image area through the Shooting menu in the normal way, but remember that at settings of 5:4 or 1.2x the camera will use the FX movie area (see page 189). You can also access Image area by pressing •• in Movie Live View; it's the first option on the list.

> Focus options

The focus modes and AF-area options for movie shooting are the same as for Live View (page 78). If **Full-time servo AF (AF-F)** is selected, the D810 will automatically maintain focus while movie recording is in progress, though it can lag behind rapid camera/subject movements. If **Single-servo AF (AF-S)** is selected, the camera will only refocus when you half-press the shutter. In both cases, shifts in focus are often all too obvious in the final clip.

Manual focusing is also possible, but can be yet another recipe for wobbly pictures. Yet again, this indicates the use of a tripod, especially with longer lenses, where focusing is more critical and wobbles are magnified. Some lenses have a smoother manual focus action than others. The physical design of older lenses often makes them more suitable, with large and well-placed focus rings.

MOVIE VIEWMovie image areas superimposed on the full screen FX image area.

Study the credits for major movies and TV shows and you'll often see someone called a "focus puller". This is an assistant camera operator, whose sole task is to adjust the focus, normally between predetermined points (for instance, shifting from one character's face to another). This leaves the lead camera operator free to concentrate on framing, panning, and/or zooming.

Executing this kind of deliberate and controlled focus shift is not easy, especially when you're the sole camera operator—and if it's not right, it will be very obvious in the final footage.

This all underlines that changing focus during the shooting of a clip is tricky. If not done smoothly and accurately it can also be very disconcerting when viewing the footage. There are accessories which allow you to control focus more smoothly and precisely, but they are a big investment.

Fortunately, changing focus during shooting is often not necessary anyway. Using a fixed focus for each shot is often perfectly viable, especially when depth of field is good. To use a fixed focus for a shot, use AF-S (Single-servo AF), set focus in Live View before move shooting starts, and avoid pressing the shutter-release button while shooting. By all means experiment with AF for movies, but this will often underline its limitations.

FIXED FOCUS

×

Like many shots, this one did not require any shift in focus as the walkers progressed through the frame. 24mm, f/11, ISO 250

> Exposure

Exposure control depends on the exposure mode selected before shooting begins.

In Program or Shutter-priority modes, exposure levels can be adjusted by ±3 Ev using and the Main Command Dial. Shutter speed, aperture, and ISO are set automatically. In fact, for movies there is no functional difference between P and S modes.

In Aperture-priority mode, aperture can be manually adjusted during shooting. Shutter speed and ISO are set automatically. Aperture control is obviously vital if you're seeking to create "DSLR-look" footage with slender depth of field.

Manual mode gives you direct control over aperture, shutter speed, and ISO sensitivity. The shutter speed does affect how moving subjects are recorded, so this can be very important. However, the available shutter speed range is limited (see below).

While all these adjustment options are welcome, actually doing it while shooting is fiddly. It's difficult to avoid jogging the camera unless it's on a very solid tripod, and the built-in microphones may also capture the sounds of these operations. Another consequence can be obtrusive changes in brightness level in the resulting footage. Just as with focusing, it is often best to get these things right beforehand and use a fixed exposure, but of course changes in brightness levels (e.g. panning

from a shadowy area towards a brighter one) sometimes mean that you don't have the option.

Shutter speed

You can (if the light's good) set shutter speeds right up to 1/4000 sec., but there are inevitable limits to the slowest speed you can select. For instance, if frame rate is 24, 25, or 30, the slowest possible speed is 1/30 sec. After all, if you're shooting 25 frames a second you can't expect each frame to have a ½-sec. exposure. Similarly, if your frame rate is 50p the slowest possible shutter speed is 1/50 sec., and 1/60 sec. for 60p.

Based on still photography experience, you'll probably expect faster shutter speeds to give sharper pictures. In movies it doesn't work that way. If you shoot at, say, 1/500 sec., you will find that each frame of the movie might appear sharp when examined individually, but the motion appears jerky when you play the movie. This is because you have recorded 25 tiny slices of the continuous action (assuming a 25p frame rate)—25 times 1/500 sec. is just 5% of the action. The nearer the shutter speed is to 1/25 sec., the nearer you get to capturing 100%, and the smoother the motion appears.

However, in bright conditions, you can't shoot at 1/30 sec. and at the same time

use a really wide aperture for shallow depth of field, even at ISO 64. Sometimes you need to compromise, although a Neutral Density filter (see page 212) could come in very handy.

Exposure metering

Most of the usual methods of judging exposure are available in Movie Live View but Live View Exposure Preview (see page 75) is not among them. Shooting a test shot or short test clip is a recommended alternative.

However, the D810 has an extra trick up its sleeve, specifically to indicate possible overexposure. If you press In Movie Live View and select Highlight display>On, the camera will display diagonal "zebra stripes" in areas which may be blown out or "clipped" (see page 90). As there's no RAW file option when shooting movies,

the scope for highlight recovery is very limited, so this display can be a godsend.

THE MOVIE HIGHLIGHTS DISPLAY

Power aperture

You can use the Fn and Pv buttons to govern aperture. Use Custom setting g1 and select **Power aperture (open)**. This also automatically sets g2 to **Power aperture (close)**. Once these are enabled, each press on the Fn button widens the aperture, while the Preview button makes

it smaller. This is quieter and smoother than using the Sub-command Dial. Power aperture is only available in A and M modes.

SMOOTH SAILING

"

A slow shutter speed helps to render movement more smoothly. 72mm, 1/50 sec., f/11, ISO 100.

> Sound

Often, one of the easiest ways to identify skilled or professional video footage is not with your eyes but with your ears. Good sound quality and the absence of extraneous background noise are vital for movies that are enjoyable to "watch".

The D810's built-in microphones give reasonable quality stereo output. Though front-aiming, they readily pick up any sounds you make operating the camera (focusing, zooming, even breathing). If you want to include dialog or "talking heads", keep subjects close to the camera and ensure that background noise is minimized.

Fortunately the D810 allows you to attach an external microphone, which connects to a 3.5mm socket under the cover on the camera's left side. This overrides the internal microphones.

The D810 allows you to monitor sound during shooting by plugging headphones into the appropriate socket. However, you can't manually adjust recording level while shooting, so check and set sound levels beforehand in Live View, or leave on Auto.

Index marking

Adding index marks at key points during a take can facilitate editing. Use Custom Setting g1 or g2 and select **Index marking**. Now, pressing the Preview button during recording adds an index mark—a maximum of 20 for each movie clip.

> Shooting

- **1)** Choose exposure mode, AF mode and AF-area mode as for Live View shooting. Set aperture if using A or M mode.
- 2) Set **v** to the **p** position. Activate Live View by pressing its center button.
- **3)** Select shooting options, such as Picture Control, as above.
- **4)** Check sound levels. Check framing and exposure. Initialize focus by half-pressing the shutter release or with **AF-ON** (or focus manually).
- **5)** Press to start recording the movie. **REC** flashes red at the top of the screen while recording, and an indicator shows the maximum remaining shooting time.
- **6)** To stop recording, press **⊙** again.
- 7) Exit Live View by pressing Lv.

Tip

You can also use the shutter-release button to start and end movie recording: see Custom Setting g4

Assign shutter button. This removes the option to shoot a still frame directly during movie recording.

» SHOOTING MOVIES

The golden rule is: think ahead. If a still frame isn't quite right, you can review it, change position or settings, and be ready to reshoot within seconds. To shoot and review even a short movie clip eats up much more time, and you may not get a second chance anyway. It's doubly important to get shooting position, framing, and camera settings right before you start. It's easy to check the general look of the shot by shooting a still frame beforehand, but this does not allow for movement of subject, the camera, or both. You can also do a dry run in Live View before shooting for real.

If you're new to the complexities of movies, start with simple shots. Don't try zooming, panning, and focusing simultaneously; do one thing at a time. Many subjects can be filmed with a fixed camera: waterfalls, birds at a feeder, musicians playing, and loads more. Equally, you can become familiar with camera movements shooting static subjects: try panning across a wide landscape or zooming in from a broad cityscape to a detail of a single building.

Handheld or tripod shooting

It's impossible to over-stress the importance of a tripod for shooting decent movies. Shooting handheld is a good way to reveal just how wobbly you

CAMERA SUPPORT

\$

really are—especially as you can't use the viewfinder. Vibration Reduction (VR) lens technology can counteract short-frequency shake, but does nothing to eliminate slower (and often larger) wobbles. Of course, even "real" movie directors sometimes use handheld cameras to create a specific feel, but there's a huge difference between controlled wobble for deliberate effect, and incessant, uncontrolled, shakiness. Using a tripod, or other suitable camera support, is the simplest way to give movie clips a polished, professional look.

In the last few years, we've also seen lots of new devices intended to stabilize the camera when you have to shoot handheld, from simple brackets to smaller versions of the legendary Steadicam. If none of these are available, look for other alternatives, for instance, by sitting with elbows braced on knees. Whatever you do, "think steady".

> Panning

The panning shot is a movie-maker's staple. Often essential for following moving subjects, it can also be used with static subjects—for instance, sweeping across a vast panorama. Of course. landscapes aren't always static, and a panning shot combined with breaking waves, running water, or grass blowing in the breeze can produce beautiful results.

Handheld panning is very problematic; it may be acceptable when following a moving subject, but a wobbly pan across a grand landscape will definitely grate. You really, really need a tripod for this and it needs to be properly leveled, or you may start panning with the camera aimed at the horizon but finish by seeing nothing but ground or sky. Do a "dry-run" before shooting.

Keep panning movements slow and steady. Panning too rapidly can make the shot hard to "read" and even nauseate the viewer. Smooth panning is easiest with video tripods, but perfectly possible with a standard model: leave the pan adjustment slightly slack. Hold the tripod head, not the camera, and use the front of the lens as a reference to track steadily across the scene.

With moving subjects, the speed and direction of panning is dictated by the need to keep the subject in frame. Accurate tracking of fast-moving subjects is very challenging and takes a lot of practice.

OUICK THINKING

This looked like an opportunity for a classic panning shot but it would have been tricky to follow neatly when handholding. I also had the choice of zooming out as the riders swept past, or simply holding still and letting them pass through frame. With no chance to reshoot, these decisions really need to be taken in advance.

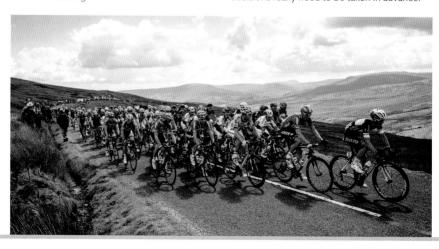

> Zooming

The zoom is another fundamental technique. Moving from a wide view to a tighter one is called zooming in, the converse zooming out. Again, a little forethought makes all the difference to using the zoom effectively—consider the framing of the shot at both start and finish. If you're zooming in on a specific subject, double-check it's central in the frame.

No current lenses for the D810 are designed specifically for shooting movies, and this is most obvious in relation to zooming. Firstly, none of them have the extreme zoom range of some camcorder lenses. More seriously, it's hard to achieve a really smooth, even-paced zoom action. Practice does help; firmly mounting the camera on a solid tripod helps even more.

Zooming while handholding virtually guarantees jerky zoom and overall wobbliness. It's also worth experimenting to see which lens has the smoothest zoom action. There's definitely a gap in the market for a lens with wide focal length range and powered zoom. Nikon already

makes power-zoom lenses for its Nikon 1 mirrorless cameras, so watch this space.

When zooming, remember that depth of field (see page 41) decreases towards the telephoto end of the range. Your subject may appear perfectly sharp in a wide-angle view but end up looking soft when you zoom in. Pre-set focus at the telephoto end, whether your planned shot involves zooming out or zooming in.

Still frame capture

To capture a still frame during movie shooting, simply press the shutter-release button. This will end movie recording, take the shot, and return you to Live View. The resulting image will use the 16:9 aspect ratio; quality and size are determined by your still-image settings (see page 64). For image sizes see the table below.

Lighting

For obvious reasons, you can't use flash. There are LED light units specifically designed for DSLR-movie shooting now readily available, and the D810's ability to shoot at high ISO ratings is invaluable.

lmage area	Image size setting	Size in pixels
FX movie	Large (or RAW)	6720 x 3776
	Medium	5040 x 2832
	Small	3360 x 1888
DX movie	Large (or RAW)	4800 x 2704
	Medium	3600 x 2024
	Small	2400 x 1352

6

» EDITING MOVIES

We've referred to the D810 shooting movies, but actually it doesn't. Like all movie cameras, it shoots movie clips. A clip, or even a collection of clips, is not a movie, only the raw material.

Turning a collection of clips into a movie requires editing, and specifically Non-Linear Editing (NLE). This simply means that clips in the final movie don't have to appear in the same order in which they were shot. Digital editing is also non-destructive; this means that it does not affect your original clips (unlike cutting and splicing bits of film in the "old days"). During editing, you manipulate preview versions of these clips and the software merely keeps "notes" on the edit. At the end, you export the result as a new movie; this can take a long time to "render".

> Software

Nikon now provides movie editing software for Mac and Windows as part of the View NX2 suite provided with the camera. Nikon Movie Editor is a basic, simple editing package but it handles all the key tasks.

Other, more sophisticated options are also available at no cost. Mac users have iMovie, part of the iLife suite, included with all new Macs. The Windows equivalent is Windows Movie Maker, pre-installed with Windows Vista; for Windows 7 or 8 it's a

free download from *windowslive.com*. A more advanced (but not free) option, for either platform, is Adobe Premiere Elements

All these apps make it easy to trim and reorder your original clips. Instead of simply cutting instantaneously between shots, you can apply various transitions such as dissolves, wipes, and fades. You can also adjust the look of any clip or segment of the movie; as well as basic controls for brightness or color, a range of special

NIKON MOVIE EDITOR

×

iMOVIE

.

Tip

If you haven't created them yourself, still photos, music, and other media are someone else's copyright. Even if you've legitimately purchased a song and downloaded it online, this does not give you the right to use it in a public performance (showing your movie). Using unlicensed music is a great way to get your video banned by YouTube. Look for open-source material or get the copyright owner's permission to use their work.

effects can be added—you can, for instance, make your movie look scratched and faded, as if shot on film 50 years ago, rather than yesterday with a DSLR.

> Taking it further

There's far more to movie-making than we can cover in a single chapter. A useful next step would be *Understanding HD Video* by Chiz Dakin, from this publisher.

WATER LEVEL

•

A natural subject for a panning shot, but the tripod needs to be properly leveled or Stockholm harbor could develop a pronounced slope.

7 LENSES

There are many reasons for preferring a DSLR like the D810 over a compact. One of the most important is the ability to use a vast range of lenses, including Nikon's own legendary system as well as lenses from other makers. Nikon's "F" lens mount is now—in its basic form—50 years old. A philosophy of continuity of design means that most Nikkor lenses will work on the D810 (although sometimes with major limitations).

However, there are still sound reasons why the best lenses for the camera are among the more recent range. One obvious one is that many older lenses lack a CPU and therefore many automatic functions are unavailable. Most obviously, pre-Al and Al lenses are manual focus only. They can also only be used in Aperture-priority and Manual exposure modes.

It's refreshing, and probably educational, to go back to older and perhaps more considered ways of working, but lens design has not stood still in the half-century lifespan of the F-mount. Classic prime lenses often stand up well in terms of sharpness and distortion, but modern lens coatings are better at containing flare. Older zoom lenses are rarely great optical performers and often feel heavy and unwieldy too.

Another reason for preferring lenses designed specifically for digital cameras

relates to the way light reaches the minute individual photodiodes or "photosites" on the camera's sensor. Because these are slightly recessed, there can be some cutoff if light hits them at an angle. This is less critical with 35mm film, for which older Nikkor lenses were designed. Newer lenses are specifically designed to ensure that light hits the sensor as nearly perpendicular as possible, maintaining illumination and image quality right across the frame.

Many older lenses can still be used, and will often give very good results, but critical examination may show some loss of brightness towards the edges of the frame, and perhaps a hint of chromatic aberration shortcomings can to some extent be corrected in post-processing (especially if you shoot RAW files).

The exceptional resolution of the D810 naturally exposes any shortcomings in

GATE

A subject brimming with fine detail (including cobwebs) which can show up any lack of resolution from the lens—or any shortcomings in technique.

100mm macro, 1/8 sec., f/8, ISO 200, tripod.

» FOCAL LENGTH

lenses, which may become all too obvious if you make huge prints or simply "pixelpeep" at 100% magnification on the computer screen. Limitations are usually most obvious at the edges of the frame, and many will be mitigated when shooting at apertures 2–3 stops smaller than the maximum. The "sweet spot" for most lenses is usually between f/5.6 and f/11, before diffraction really kicks in, but if you are a really critical user you may want to conduct your own tests.

When they launched the D800E, the first Nikon DSLR with no anti-aliasing filter, Nikon took the unusual step of producing a list of suggested lenses which were most suitable for its ultimate demands. As the D810 has, if anything, better resolution than even the D800E, these lenses are highlighted in green in the table at the end of this chapter. In the book covering the D800E, I remarked that it would be "interesting to see how independent lens makers like Sigma respond to this initiative". It appears that part of their response has been the launch of lenses like the Sigma 35mm F1.4 DG HSM A.

Though familiar, the term "focal length" is often misapplied. The focal length of any lens is a basic optical characteristic, and it is not changed by fitting the lens to a different camera. A 20mm lens is a 20mm lens, no matter what.

However, what is often called the "effective focal length" can and does change. I can fit the same lenses to the D810 or to my DX-format D7000, but the results are different because the D810's larger sensor "sees" more of the image that the lens projects.

The FX format has the same image area (give or take 0.1 of a millimeter) as a standard frame of 35mm film. On both FX and on 35mm cameras, the true focal length and the "effective" focal length are the same because 35mm is taken as the norm. On DSLRs with smaller sensors, like the DX-format sensor of the D7000, the effective focal length is longer but, by convention, we still use the true focal length to describe the lenses we use. Therefore, if someone tells you they took a particular shot with, say, a 200mm lens, you also need to know the format of the camera they used.

Just to confuse everyone, this convention is rarely followed when talking or writing about digital compact cameras. Most of these have much smaller sensors and the true focal lengths of their lenses are very much shorter, but they are nearly

always described by their effective focal length. It's even, still, sometimes called the "35mm equivalent".

Crop factor

As we've just seen, the D7000 has a smaller sensor than the FX or 35mm standard. This creates a crop factor, also referred to as focal length magnification factor, of 1.5. The same applies to using the **DX-crop** function of the D810 (page 65). This normally applies automatically when a DX lens is fitted but can also be activated manually (set **Image area** to **DX**). This still yields very usable 15-megapixel images. If you use DX-crop with a 200mm lens, the field of view is the same as using a 300mm lens on full-frame. Of course, you can also crop full-frame images later, with greater

CROP CONTROL

The area covered by a Nikkor 35mm DX lens compared to the DX-crop area. I can comfortably use the 1.2x image area with this lens, and even use 5:4 with very slight vignetting, which is fixable in post-processing.

flexibility, but the DX-crop method is handy if you want to use the images right away. It also allows long-range shooting with light and inexpensive lenses, handy for sports and wildlife, and reduces file size.

It's also worth noting that the focus points cover most of the DX image area, which improves the chances of keeping a moving subject in focus even when it is close to the edge of the frame.

Field of view

The field of view, or angle of view, is the area covered by the image frame. While the focal length of a lens remains the same on any camera, the angle of view seen in the image is different for different sensor formats. The angle of view is usually measured on the diagonal of the frame (as in the table on pages 207–209).

Tip

Some DX lenses actually cover a wider area than the strict DX-crop, and this gives you the option to obtain larger images with them: set Auto DX crop to Off, then crop the images afterwards to get rid of the darkened corners. You can do this using Trim in the Retouch menu, or in any image-editing app. Using DX-crop can make framing more intuitive, and is handy if you want to use the images right away.

RIBBLEHEAD, YORKSHIRE DALES

The images below were taken with a D810, from a fixed position with a range of lenses. 1/100 sec., f/11, ISO 100, tripod.

Focal length: 12mm

Focal length: 24mm

Focal length: 50mm

Focal length: 100mm

Focal length: 200mm

Focal length: 300mm

» LENS ISSUES

Flare

Lens flare is usually seen when shooting towards the sun or other bright light sources. Caused by reflections within the lens, it may produce a string of colored blobs or a more general "veiling" effect.

FLARE

The flare in the first shot (top) is pretty disastrous. In the second, with a very slight shift of position to mask the sun behind some foliage, there's no flare at all. 24mm, 1/60 sec., f/11, ISO 100, tripod.

Advanced lens coatings help reduce flare, as does keeping lenses and filters clean. Even so, when the sun's directly in shot, some flare may be inescapable. You can sometimes mask the sun, perhaps behind a tree.

If the sun isn't actually in shot, you can shield the lens. A good lens hood is essential, but may need to be supplemented with a piece of card, a map, or your hand. This is easier when using a tripod; otherwise it requires assistance, or one-handed shooting. Check carefully to see if the flare has gone—and that the shading object hasn't crept into shot.

> Lens hoods

A lens hood serves two main functions: it shields the lens against knocks, rain, and other hazards. It also helps to exclude stray light which does not contribute to the image but may degrade it by causing flare. Most Nikkor lenses come with a dedicated lens hood. Where they don't, hoods are available separately but Nikon's own tend to be disproportionately expensive while third-party offerings may be less than half the price. However, do check that the hood in question is compatible with the lens—try before you buy, if possible, and take test shots to check there's no vignetting (see page 198).

Distortion

Distortion makes lines which are really straight appear curved in the image. Distortion is usually worst with zoom lenses, especially at the extremes of the zoom range. When straight lines bow outwards, it's called barrel distortion; when they bend inwards it's pincushion distortion. Distortion often goes unnoticed when shooting natural subjects with no straight lines, but it can still rear its ugly head when level horizons appear in landscape or seascape images.

Distortion can be corrected using **Auto Distortion Control** in the Shooting menu (for compatible lenses) or rectified later, using **Distortion Control** in the Retouch menu, or in post-processing. However, all these methods crop the image.

Chromatic abberation

Chromatic aberration occurs when light of different colors is focused in slightly different places on the sensor, and appears as colored fringing when images are examined closely. The D810 has built-in correction for chromatic aberration during processing, but this applies only to JPEG and TIFF images. Aberration can also be corrected in post-processing—with RAW images, this is the only option.

Vignetting

Vignetting is a darkening towards the corners of the image, most conspicuous in even-toned areas like clear skies. Most lenses show slight vignetting at maximum aperture, but it should reduce on stopping down. The D810 has built-in Vignette control (see page 104), but this applies only to JPEG and TIFF images. It can also be tackled in post-processing. Severe vignetting can arise if you use unsuitable lens hoods and filter holders, or "stack" multiple filters on the lens.

> Lens care

Lenses require special care. Glass elements and coatings are easily scratched and this will degrade your images. Remove dust and dirt with a blower. Remove fingerprints and other marks using a dedicated lens cleaner and optical grade cloth.

> Standard lenses

Nikkor 50mm f/1.8

Traditionally, a 50mm lens was called standard, as its field of view was held to approximate that of the human eye. Standard lenses are typically light, simple, and have wide maximum apertures. Zoom lenses whose range includes the 50mm focal length are often referred to as "standard zooms".

SUMMIT CROSS

×

Standard lenses are thought to give a "normal" or "natural" view. 50mm, 1/160 sec., f/11, ISO 400.

> Wide-angle lenses

Nikkor 14-24mm f/2.8G ED AF-S

A wide-angle lens is really any lens wider than a standard lens; for the D810, this means any lens with a focal length shorter than 50mm. Wide-angle lenses are valuable for working close to subjects or bringing foregrounds into greater prominence. They lend themselves both to photographing expansive scenic views and to working in cramped spaces where it simply isn't possible to step back to "qet more in".

In the 35mm film era, anything wider than about 24mm was regarded as "superwide". The advent of DX-format cameras has spurred the development of a new breed of lenses, such as Nikon's widely praised 14-24mm f/2.8G ED AF-S, yet these come into their own even more with "full-frame" cameras like the D810. Sigma's 12-24mm F4.5-5.6 II DG HSM has even wider range and is less than half the price.

LANDSCAPE

Wide-angle lenses can help you capture strong foregrounds. 50mm, 1/160 sec., f/11, ISO 400.

> Telephoto lenses

Nikkor 300mm F/2.8G ED VR II AF-S

Telephoto lenses, often simply called long lenses, give a narrow angle of view. They are mostly employed when working distances need to be longer, as in wildlife and sports photography, but have many other uses, such as singling out small or distant elements in a landscape. Moderate telephoto lenses are favored for portrait photography, because the greater working distance gives a natural-looking result and is more comfortable for nervous subjects. The traditional "portrait" range is

The laws of optics, combined with greater working distances, mean depth of field is limited. This is often beneficial in portraiture, wildlife, and sport, as it concentrates attention on the subject by throwing backgrounds out of focus. It can be less welcome in landscape shooting.

Tip

Switch VR OFF when using the camera on a tripod. Otherwise, it will sometimes add shake instead of removing it. A few of the latest VR lenses have a "Tripod" setting—try that.

The size and weight of longer lenses make them harder to handhold comfortably, and their narrow angle of view also magnifies any movement—high shutter speeds and/ or the use of a tripod or other camera support are therefore the order of the day. Nikon's Vibration Reduction (VR) technology also mitigates the effects of camera shake, but it can slow down the maximum frame rate, a factor sports shooters in particular need to recognize.

> Teleconverters

AF-S Teleconverter TC-20E III

Teleconverters are supplementary units, which fit between the main lens and the camera body, and magnify the focal length of the main lens. Nikon currently offers the TC-14E III (1.4x magnification), TC-17E II (1.7x), and TC-20E III (2x). The advantages are obvious, allowing you to extend the focal length range with minimal additional weight (the TC-14E III, for example, weighs just 200 grams).

However, teleconverters can degrade image quality—as you might expect, the higher the magnification factor, the more noticeable this is. The TC-20E III, in particular, produces a significant loss of sharpness, especially if you try and shoot at maximum aperture. Results improve when the lens is stopped down to f/8 or f/11; beyond this, sharpness tails off again due to diffraction.

Converters also cause a loss of light. Fitting a 2x converter to an f/4 lens turns it into an effective f/8. One consequence is that the camera's autofocus may become sluggish or will only work with the central focus points.

Warning!

Some lenses are incompatible with these teleconverters. Check carefully before buying or using one.

GETTING CLOSER

>>

Attaching a teleconverter to your lens is a quick and lightweight way to get closer to the action. 200mm, 1/1600 sec., f/5.6, ISO 400.

> Zoom lenses

Nikkor 24-85mm f/3.5-4.5G ED AF-S

The term "zoom" covers lenses with variable focal length, like the AF-S Nikkor 24-85mm f/3.5-4.5G ED VR. A zoom lens can replace a bagful of prime lenses and cover the gaps in-between, scoring highly for weight, convenience, and economy.

Flexible focal length also allows very precise framing.

While once considered inferior in optical quality, there is now little to choose between a good zoom and a good prime lens, at least in terms of general sharpness and contrast. Most zoom lenses will have a "sweet spot" somewhere in the zoom range where distortion is minimal, but many show discernible barrel distortion at wide settings and, conversely, pincushion distortion at the long end.

Cheaper or older zooms, and those with a very wide range (e.g. 18-200mm or 28-300mm), may still be optically compromised, and usually have a relatively small ("slow") maximum aperture. Besides, most such lenses are DX-only.

STREETLIGHT

<<

Zooms are useful travel or street lenses, giving you lots of framing options in a compact package. *ISO 200, 60mm, 3 sec., f/11, tripod.*

> Macro lenses

Nikkor 24mm f/3.5D ED PC-E

For specialist close-up work there is little to beat a true macro lens. For more on these see pages 176–177.

> Perspective-control lenses

Perspective-control (or "tilt-and-shift") lenses give unique flexibility in viewing and controlling the image. Their most obvious application is in photographing architecture, where with a "normal" lens it often becomes necessary to tilt the camera upwards, resulting in converging verticals (buildings appear to lean back or even to one side). The shift function allows the camera back to be kept vertical, so that vertical lines in the subject remain vertical in the image. Tilt movements also allow extra control over depth of field, such as whether to extend or to minimize it.

The current Nikon range features three PC lenses, with focal lengths of 24mm, 45mm, and 85mm. They retain many automatic functions, but require manual focusing.

LEANING TOWERS

A perspective-control lens (left) straightens the vertical lines of tall buildings, which would otherwise be distorted. 24mm, 1/100 sec., f/11, ISO 200.

» NIKON LENS TECHNOLOGY

Nikon lenses have a high reputation, and many incorporate special features or materials. As these are referred to extensively in the table on page 207, brief explanations of the main terms and acronyms are given in the table below...

Abbreviation	Term	Explanation
AF	Autofocus	Lens focuses automatically. The majority of
		current Nikkor lenses are AF but a
		substantial manual focus range remains.
ASP	Aspherical Lens	Precisely configured lens elements that
	Elements	reduce the incidence of certain aberrations.
		Especially useful in reducing distortion with wide-angle lenses.
CRC	Close-range	Advanced lens design that improves picture
	Correction	quality at close focusing distances.
D	Distance	D-type and G-type lenses communicate
	information	information to the camera about the
		distance at which they are focusing,
		supporting functions like 3D Matrix Metering
DC	Defocus-image	Found in a few lenses aimed mostly at
	Control	portrait photographers; allows control of
		aberrations and thereby the appearance of
		out-of-focus areas in the image.
DX	DX lens	Lenses specifically designed for DX-format
		digital cameras. They will not give full-
		frame coverage on 35mm cameras or FX-
		format DSLRs like the D810.
DE or PC-E	E-type lens	Lens without mechanical aperture linkage;
		aperture control is implemented
		electromagnetically within the lens. So far,
		only seen in PC-E perspective-control
		lenses, and a couple of long telephotos.

Abbreviation	Term	Explanation
G	G-type lens	Modern Nikkor lenses with no aperture ring;
		aperture must be set on the camera.
ED	Extra-low	ED glass minimizes chromatic aberration (the
	Dispersion	tendency for light of different colors to be
		focused at slightly different points).
IFR	Internal	Only internal elements of the lens move
	Focusing	during focusing; the front element does not extend or rotate.
M/A	Manual/Auto	Most Nikkor AF lenses offer M/A mode, which
		allows seamless transition from automatic to
		manual focusing if required.
N	Nano Crystal	Said to virtually eliminate internal reflections
	Coat	within lenses, guaranteeing minimal flare.
PC	Perspective	See page 204.
	Control	
RF	Rear Focusing	Lens design where only the rearmost element
		move during focusing; makes AF operation
		faster.
SIC	Super Integrated	Nikon-developed lens coating that minimizes
	Coating	flare and "ghosting".
SWM	Silent Wave	Special in-lens motors which deliver very fast
	Motor	and very quiet autofocus operation.
VR	Vibration	System which compensates for camera shake.
	Reduction	VR is said to allow handheld shooting up to
		three stops slower than would otherwise be
		possible (i.e. 1/15th instead of 1/125th sec.).
		New lenses now feature VRII, said to offer a
		gain of an extra stop over VR (1/8th instead of 1/125th sec.).

» NIKKOR LENS CHART

This table lists currently available Nikkor autofocus lenses. DX-series lenses, which do not cover the full sensor area of the D810, are listed last. The angle of view quoted for these lenses is the effective

angle of view on the DX frame area. For an explanation of abbreviations, see the table on pages 205–206. Lenses specifically recommended by Nikon for optimal quality (see page 192) are highlighted in green.

_			_		-		
						ES	

	Optical features/ notes	Angle of view on FX format	Minimum focus distance (m)	Filter size (mm)	Dimensions (diameter/ length) (mm)	Weight (g)
14mm f/2.8D ED AF	ED, RF	114	0.2	Rear	87 x 86.5	670
16mm f/2.8D AF Fisheye	IF	180	0.25	Rear	63 x 57	290
20mm f/2.8D AF	CRC	94	0.25	62	69 x 42.5	270
24mm f/1.4G ED	ED, SWM,NC	84	0.25	77	83 x 88.5	620
24mm f/2.8D AF		84	0.3	52	64.5 x 46	270
28mm f/1.8G AF-S	NC, SWM	74	0.25	67	73 x 80.5	330
28mm f/2.8D AF	·	74	0.25	52	65 x 44.5	205
35mm f/2D AF		63	0.25	52	64.5 x 43.5	205
35mm f/1.8G AF-S	RF, SWM	63	0.25	58	72 x 71.5	305
35mm f/1.4G AF-S	NC, SWM	63	0.3	67	83 x 89.5	600
50mm f/1.8G AF-S	SWM	46	0.45	58	72 x 52.5	185
50mm f/1.8D AF		46	0.45	52	63 x 39	160
50mm f/1.4D AF		46	0.45	52	64.5 x 42.5	230
50mm f/1.4G AF-S	IF, SWM	46	0.45	58	73.5 x 54	280
58mm f/1.4G AF-S	NC, SWM	40.5	0.58	72	85 x 70	385
85mm f/1.4G AF	IF, SWM, NC	28.5	0.85	77	86.5 x 84	595
85mm f/1.8D AF	RF	28.5	0.85	62	71.5 x 58.5	380
85mm f/1.8G AF-S	IF, SWM	28.5	0.8	67	80 x 73	350
105mm f/2D AF DC	DC	23.3	0.9	72	79 x 111	640
135mm f/2D AF DC	DC	18	1.1	72	79 x 120	815
180mm f/2.8D ED-IF AF	ED, IF	13.6	1.5	72	78.5 x 144	760
200mm f/2G ED-IF AF-S VRII	ED, VRII, SWM	12.3	1.9	52	124 x 203	2900
300mm f/4D ED-IF AF-S	ED, IF	8.1	1.45	77	90 x 222.5	1440
300mm f/2.8G ED VR II AF-S	ED, VRII, NC, SWM	8.1	2.2	52	124 x 267.5	2900
400mm f/2.8G ED VR AF-S	ED, IF, VRII, NC	6.1	2.9	52	159.5 x 368	4620

AF PRIME LENSES

	Optical features/ notes	Angle of view on FX format	Minimum focus distance (m)	Filter size (mm)	Dimensions (diameter/ length) (mm)	Weight (g)
400mm f2.8E	ED, SPORT	6.1	2.6	40.5	159.5 x 358	3800
FL ED VR AF-S	VR, NC, SWM			(internal)		
400mm f/2.8D	ED, SWM	6.1	3.8	52	160 x 352	4800
ED-IF AF-S II						
500mm f/4G	IF, ED, VRII,	5	4	52	139.5 x 391	3880
ED VR AF-S	NC					
600mm f/4G	ED, IF, VRII,	4.1	5	52	166 x 445	5060
ED VR AF-S	NC					
800mm f/5.6E	ED, NC,	3.1	5.9	52	160 x 461	4590
FL ED VR AF-S	SWM, FL					
		AF ZOOM	LENSES			
14-24mm f/2.8G	IF, ED, SWM,	114-84	0.28	None	98 x 131.5	970
ED AF-S	NC					
16-35mm f/4G	NC, ED, VR	107-63	0.29	77	82.5 x 125	680
ED VR						
17-35mm f/2.8D	IF, ED, SWM	104-63	0.28	77	82.5 x 106	745
ED-IF AF-S						
18-35mm f/3.5-	ED, SWM	100-63	0.28	77	83 x 95	385
4 .5G ED AF-S						
24-70mm f/2.8G	IF, ED, SWM,	84-34.3	0.38	77	83 x 133	900
ED AF-S	NC					
24-85mm f/2.8-4D	IF	84-28.5	0.5	72	78.5 x 82.5	545
IF AF						
24-85mm f/3.5-4.5G	ED, VRII, SWM	84-28.5	0.38	72	78 x 82	465
ED VR AF-S						
24-120mm f/4G	ED, SWM, NC,	84-20.5	0.45	77	84 x 103.5	710
ED-IF AF-S VR	VRII					
28-300mm f/3.5-5.6G	ED, SWM	75-8.1	0.5	77	83 x 114.5	800
ED VR						
70-200mm f/2.8G	ED, SWM, VRII	34.3-12.3	1.4	77	87 x 209	1540
ED-IF AF-S VRII						
70-200mm f/4G	ED, IF, SWM,	34.3-12.3	1	67	78 x 178.5	850
ED AF-S VRIII	NC, VRIII					
70-300mm f/4.5-5.6G		34.3-8.1		67	80 x 143.5	745
AF-S VR	VRII					-
80-400mm f/4.5-5.6D ED VR AF-S	ED, VR, NC	30.1-6.1	2.3	77	95.5 x 203	1570
200-400mm f/4G	ED, NC, VRII,	12.3-6.1	2	52	124 x 365.5	3360
ED-IF AF-S VRII	SWM					
		MACRO L	ENSES			
14-24mm f/2.8G ED AF-S	ED, SWM, NC	39.6	0.185	62	73 x 89	425
16-35mm f/4G ED VR	ED, IF, VRII, NC, SWM	23.5	0.31	62	83 x 116	720
17-35mm f/2.8D ED-IF AF-S	ED. CRC	12.3	0.5	62	76 x 104.5	1190

	PERSPECTIVE-CONTROL LENSES								
	Optical features/ notes	Angle of view on FX format	Minimum focus distance (m)	Filter size (mm)	Dimensions (diameter/ length) (mm)	Weight (g)			
24mm f/3.5D ED PC-E	ED, NC	84	0.21	77	82.5 x 108	730			
(manual focus)									
45mm f/2.8D ED PC-E	ED, NC	51	0.25	77 x 94	83.5 x 112	780			
(manual focus)									
85mm f/2.8D ED PC-E	ED, NC	28.4	0.39	77	82.7 x 107	650			
(manual focus)									
DX LE	NSES (ANGLE	OF VIEW AS	SUMES DX-CF	ROP IN EF	FECT)				
10.5mm f/2.8G	CRC	180	0.14	Rear	63 x 62.5	300			
DX Fisheye				TTO GI		300			
10-24mm f/3.5-4.5G	ED, IF, SWM	109-61	0.24	77	82.5 x 87	460			
ED AF-S DX	,,		0.21		02.0 X 01	400			
12-24mm f/4G	SWM	99-61	0.3	77	82.5 x 90	485			
ED-IF AF-S DX			0.0		0210 X 3 0	403			
16-85mm f/3.5-5.6G	VRII, SWM	83-18.5	0.38	67	72 x 85	485			
ED VR AF-S DX	71111, 0 77111	00 1010	0.30	01	72 X 03	403			
17-55mm f/2.8G	ED, IF, SWM	79-28.50	0.36	77	85.5 x 11.5	755			
ED-IF AF-S DX	20,11,011111	20100	0.30		03.3 X 11.3	133			
18-55mm f/3.5-5.6G	VRII, SWM	76-28.5	0.28	52	66 x 59.5	195			
VR II AF-S DX	***************************************	70 20.5	0.20	JL	(retracted)	193			
(Retractable)					(retracted)				
18-55mm f/3.5-5.6G	VR, SWM	76-28.50	0.28	52	73 x 79.5	265			
AF-S VR DX	111, 5 1111	70 20.50	0.20	JL	13 × 13.5	203			
18-70mm f3.5-4.5G	ED, SWM	76-22.50	0.38	67	73 x 75.5	420			
ED-IF AF-S DX	20,01111	70 22.50	0.50	01	13 × 13.5	420			
18-105mm F/3.5-5.6G	ED, IF, VRII,	76-15.3	0.45	67	76 x 89	420			
ED VR AF-S DX	NC, SWM	.0 13.3	0.43	01	10 x 03	420			
18-140mm F/3.5-5.6G	ED, IF, VRII,	76-11.5	0.45	67	78 x 97	490			
ED VR AF-S DX	SWM	10 11.5	0.43	01	10 x 31	430			
18-200mm f/3.5-5.6G	ED, SWM, VRII	76-8	0.5	72	77 x 96.5	560			
ED AF-S VRII DX	25,51111,1111	, , ,	0.5	12	77 X 30.5	300			
18-300mm f/3.5-5.6G	ED, IF, SWM,	76-5.3	0.45	77	83 x 120	830			
ED VR AF-S DX	VRII	10 0.5	0.45	1.1	03 X 120	030			
35mm f/1.8G AF-S	SWM	44	0.3	52	70 x 52.5	210			
40mm f/2.8G AF-S DX	SWM	38.5	0.163	52	68.5 x 64.5	235			
Micro NIKKOR	3 77 77	30.3	0.105	32	00.5 × 04.5	233			
55-200mm t/4-5.6	ED, SWM, VR	28.5-8	1.1	52	73 x 99.5	335			
AF-S VR DX	EB, SWINI, VIC	20.5	1.1	JL	73 × 33.3	333			
55-200mm f/4-5.6G	ED, SWM	28.5-8	0.95	52	68 x 79	255			
ED AF-S DX	25,577111	20.5 0	0.55	JL	00 1 1 3	233			
55-300mm f/4.5-5.6G	ED, SWM	28.5-5.2	1.4	58	76.5 x 123	530			
ED VR	LD, JVVIVI	20.5 5.2	1.7	20	10.3 X 123	550			
85mm f/3.5G ED VR	ED, IF, SWM,	18.5	0.28	52	73 x 98.5	355			
AF-S DX Micro	VRII	10.0	0.20	JL	13 × 30.3	555			

Nikkor

8 ACCESSORIES & CARE

DSLRs are system cameras: as well as lenses and flashguns, there are many other accessories which can extend the capabilities of the camera. Nikon's system is huge, and third-party suppliers offer even more options.

» FILTERS

Some types of filter are almost redundant with digital cameras. For instance, variable white balance (see page 68) has virtually eliminated the need for color-correction filters, once essential for accurate color on film.

As a general principle, avoid using filters unnecessarily. Adding extra layers of glass in front of the lens can increase flare or otherwise degrade the image. "Stacking" of multiple filters increases this risk, as well as the chance of vignetting (see page 198).

There is one (debatable) exception to this rule: many people keep a UV or skylight filter (see below) attached to each lens as a first line of defence against knocks and scratches—filters are much cheaper to replace than lenses. However, many working pros don't do this, relying instead on lens hoods for protection.

> Types of filter

Filters can attach to the lens in several ways. The most familiar type is the circular filter which screws to the front of the lens. The filter-thread diameter (in mm) of

Nikon lenses is specified in the table on page 207-209, and usually marked around the front of the lens next to a Ø symbol. Nikon produces high-quality filters in sizes matching the range of Nikkor lenses. Larger ranges come from Hoya and B+W.

If you use filters extensively, you'll probably find slot-in filters more economical and convenient. The square or rectangular filters fit into a slotted holder. One holder and one set of filters can serve many lenses, each of which just needs a simple adapter ring. The best known name in this area is Cokin, which has several systems, while Lee Filters have a very high reputation.

A few specialist lenses, including supertelephotos, extreme wide-angle, and fisheye lenses, require equally specialist filters, fitting either at the rear of the lens or by a slot in the lens barrel.

POLARIZED POOL

s

Using my polarizing filter for its neutral density value enabled me to achieve a slow shutter speed, even in bright sunlight.

70mm, 1/2 sec., f/16, ISO 32, tripod.

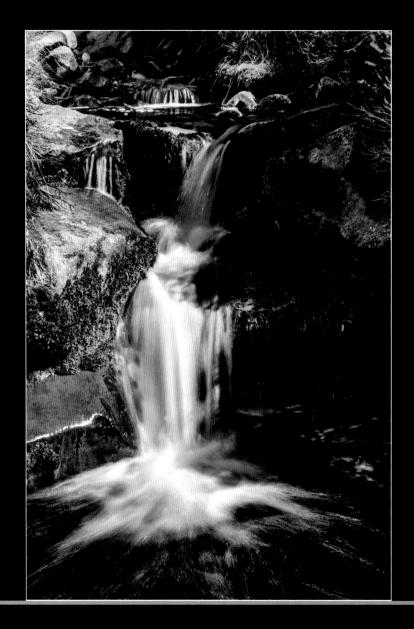

UV and skylight filters

Both of these filters cut down ultraviolet light, which can make images appear excessively blue. The skylight filter also has a slight warming effect. As already suggested, a major benefit is in protecting the front element of the lens.

Polarizing filters

The polarizing filter cuts down reflections from most surfaces, intensifying colors in rocks and vegetation, for instance. It can make reflections on water and glass virtually disappear, restoring transparency. Rotating the filter strengthens or weakens its effect.

The polarizer can also cut through atmospheric haze (though not mist or fog) like nothing else, and can make blue skies appear more intense. These effects are strongest when shooting at right angles to the sunlight, vanishing when the sun is directly behind or in front. When used with

wide-angle lenses, the effect can vary conspicuously across the field of view. You might only use it occasionally, but some of its effects are virtually impossible to reproduce by any other means, even in post-processing. Sometimes it can be priceless.

Neutral density filters

Neutral density (ND) filters reduce the amount of light reaching the lens, without shifting its color—hence "neutral". ND filters can be either plain or graduated. A plain ND filter allows you to set slower shutter speeds and/or wider apertures than otherwise possible. A classic example is shooting waterfalls, where you may want a long shutter speed to create a silky blur.

POLAR EXPLORATION

•

The same view taken with (left) and without a polarizing filter. See how the colors and definition of the clouds are affected. 24mm, 1/30 sec./1/160 sec., f/13, ISO 100.

Graduated ND filters have neutral density over half their area, with the other half being clear, and a gradual transition in the center. They are widely used in landscape photography to compensate for wide differences in brightness between sky and land. However, the effect of the straight-line transition can be unpleasantly obvious, especially when the skyline is irregular, as in a mountain view or cityscape. The immense dynamic range of cameras like the D810, especially when shooting RAW, makes it much more likely that you'll capture a full range of detail in both highlights and shadows. There are

RING THE CHANGES

There was a big difference in brightness levels here, but a graduated filter wasn't a good solution (right) as its straight transition cut across the skyline. For a more natural result two separate RAW conversions were combined using Photoshop Layer Masks (left).

also several alternative ways to deal with wide ranges of brightness, including Active D-Lighting (page 87) and HDR imaging (page 91).

Special effects filters

Soft-focus filters are still used in portrait photography, but have been widely supplanted by digital post-processing. Much the same is true of the "starburst". Both of these can be replicated in-camera, using **Soft** and **Cross Screen** respectively in the **Filter effects** section of the Retouch menu (page 139).

"Effects" images were all the rage in the 1970s, when the Cokin system became available to stills photographers. The appeal soon palled, although there's been a revival with the likes of Instagram. Just remember, if you capture the image "straight", and apply effects through the Retouch menu or in post-processing, you can always change your mind.

» ESSENTIAL ACCESSORIES

Nikon includes several items in the box with the camera, but these are really essentials, not extras.

EN-EL14 battery

Without a battery, your fabulous D810 is useless deadweight. While the camera's battery life is good, it never hurts to have a fully charged spare on hand. This is especially true in cold conditions, when using the monitor extensively, or when shooting movies.

MH-23 charger

Vital to keep the EN-EL15 battery charged and ready. MH-25 chargers are also compatible.

BM-12 LCD monitor cover

It's wise to keep the monitor cover permanently attached. If it becomes scratched, it's easily and inexpensively replaced, whereas replacing the monitor itself is a complex and very expensive business.

BF-1A/1B body cap

Keeps the interior of the camera free of dust and dirt when no lens is attached.

BACKPACK

Backpacks (this one's by f-stop) are a good way to carry heavy equipment, and best for the spine.

> Camera cases

Nikon doesn't supply a case, but unless the camera lives permanently indoors, one should be seen as essential. The most practical is a simple drop-in pouch which can be worn on a waist-belt. Excellent examples come from makers like Think Tank, Camera Care Systems, and LowePro.

PADDED POUCH

>>

2

This pouch by Think Tank Photo combines good protection and easy access.

If you want to carry a larger system, perhaps including several lenses, a flash, and a tripod, then a backpack-type bag is kindest on your spine.

> Optional accessories

A very extensive range of accessories to improve or modify the performance of the D810 is available both from Nikon and from third-party suppliers: a small selection is listed here.

Like other camera-makers, Nikon is often criticized for the high price of its accessories and it is often worth looking for third-party alternatives, but take care that they are reputable products and fully compatible.

Multi-Power Battery Pack MB-D12

The MB-D12 has two main functions, providing extra power and improving the camera's handling in portrait orientation. It provides an extra shutter-release button, command dials, Multi-selector, and **AF-ON** button. It can be loaded with a second EN-EL15 battery or with AA cells.

Hahnel make an alternative battery grip for around half the price of the Nikon MB-D12, which includes an infrared remote control. It is listed for the D800/ D800E but there's no reason why it should not be fully compatible with the D810.

AC Adapter EH-5/EH-5a/EH-5b

Used to power the camera directly from the AC mains, allowing uninterrupted shooting in, for example, long studio sessions (a power connector is also required).

Wireless transmitter WT-5

Coupled with a UT-1 communications unit, this enables the camera to connect to Wi-Fi networks (see page 226). Photographs can be viewed on any computer on the network (e.g. using Nikon View NX2) and also saved immediately to a computer (e.g. using Nikon Transfer). Nikon Camera Control Pro 2 software (available separately) allows camera functions to be controlled directly from any Mac or PC (see page 228).

Wireless Remote Controller WR-R10/WR-T10/Wireless Remote Controller WR-1

The combination of WR-R10/WR-T10, or a pair of WR-1s, can be used to control the camera remotely—you'll also need a WR-A10 adapter.

Tip

For simple transfer of images over a Wi-Fi network, an EyeFi card is an inexpensive alternative (see page 227). Third-party units like Hahnel's Giga T Pro II can give you much of this power at a lower cost. However, none of these let you see what the camera is seeing, or transfer images; this requires the WT-5 (above), or a physical connection to the computer.

GP-1 and GP-1A GPS units

Dedicated Global Positioning System devices (see page 230).

Diopter adjustment

The D810's viewfinder has built-in dioptric adjustment, between -3 and +1 m⁻¹. If your eyesight is outside this range, Nikon produces a series of viewfinder lenses between -3 and +2 m⁻¹, with the designation DK-17C.

Tip

It's normally easier to wear contact lenses or glasses. Set the built-in dioptric adjustment (page 24) while wearing your usual glasses/lenses.

PETAL POWER

Tripods are ideal for all manner of subjects. 100mm, 1/100 sec., f/4, ISO 3200.

>>

Remote cords

To release the shutter from a distance, a variety of cords can be attached to the D810's 10-pin terminal, from simple triggers like the basic MC-30 to sophisticated cords which link to remote triggering devices.

Screen shades

Camera LCD screens can be impossible to see properly in bright sunlight. The viewfinder is much better for shooting in bright light, but you can still need the screen for Live View, movie shooting, and image review. Third-party companies produce accessory screen shades—probably the best-known name is Hoodman. However, if you only need one occasionally, you can improvize; you could even revert to the classic black cloth hood of the traditional view-camera user.

» CAMERA SUPPORT

There's much more to camera support than tripods, although these remain a staple—arguably, even more so with the D810 than with most cameras.

> Tripods

The D810 (like the D800/800E) creates a bit of a paradox. On the one hand, its fine image quality at high ISO settings does make handholding easier. On the other, if you are really trying to exploit its immense resolution, there's no point in cutting corners, and you should use a tripod habitually. This is even more true if, as already noted, you also want to exploit its excellent dynamic range, which is best at low ISO ratings.

A good tripod is also an investment, and should last for many years. Tripods come in all manner of sizes, weights, and materials.

ALIVIOI CO

Titanium and carbon fiber give the best combination of low weight and good rigidity—at a price. Carbon-fiber tripods are made by Manfrotto and Gitzo, among others. My first Manfrotto carbon tripod outlived several cameras and indeed took me from shooting film to well into the digital age.

When shooting movies, a tripod is essential, and many tripods are designed specifically for this purpose (see page 187).

Monopods

Monopods can't equal the ultimate stability of a tripod, but they are light, easy to carry, and quick to set up. They are favored by sports photographers, who often need to react quickly while using hefty, long telephoto lenses.

Other camera supports

There are many other solutions for camera support, both proprietary products and improvised alternatives. It's still hard to beat the humble beanbag; these can be homemade, or bought from various suppliers.

BEANBAG

<<

A simple homemade beanbag that has served me well for many years.

» STORAGE

Memory cards

The D810 stores images on Type 1 Compact Flash cards and/or Secure Digital (SD) cards, including SDHC and SDXC. In view of the huge file sizes generated by the D810, large-capacity cards with fast write speeds are recommended. Even these are now remarkably cheap, so it's advisable to carry a spare or two.

Memory card performance is measured in two ways: Speed rating or rated speed (e.g. 30MB/s) is the key measure when shooting stills, especially RAW files. Class or speed class rating is more important when shooting video—the higher the better—Nikon recommend a minimum of Class 6.

Backing up on the move

Memory cards rarely fail, but it's always worth backing up valuable images as soon as possible. The D810's second card slot, of course, allows instant in-camera backup (see page 102). On longer trips, with no regular access to a computer, many photographers use some sort of mobile device for further backup. Dedicated photo storage devices like the Vosonic VP8870 and Epson P7000 are increasingly hard to find, as most people (if they back up at all) now use a laptop, smartphone, or tablet (see page 227).

Card care

If a memory card is lost or damaged before downloading or backing up, your images are lost too. Blank cards are cheap but cards full of images are irreplaceable—unlike the camera itself. As SD and CF cards use solid-state memory, they are pretty robust but it's still wise to treat them with care. Keep them in their original plastic cases, or something more substantial, and avoid exposure to extremes of temperature, direct sunlight, liquids, and strong electromagnetic fields.

Note:

There seems to be no evidence that modern airport X-ray machines have any harmful effect on either digital cameras or memory cards.

Tip

If, despite your best efforts, dust spots do appear on the image, they can be removed in most image-editing programs with a Cloning tool or similar. In Nikon Capture NX-D this process can be automated by creating a Dust-off reference image in-camera, while spot-removal can be applied across batches of images in Adobe Lightroom.

» CARE

The D810 is a very rugged camera, but it's also packed with complex and delicate technology. A few simple and commonsense precautions should ensure that it keeps functioning perfectly for many years.

Basic care

The camera body can be cleaned by removing dust and dirt with a blower, then wiping with a soft, dry cloth. After exposure to salt spray, wipe off carefully with a cloth dampened with clean, fresh water (ideally distilled water), then dry thoroughly. As prevention is better than cure, keep the camera in a case when not in use.

The playback monitor is best protected by keeping the monitor cover in place. If the monitor itself needs cleaning, use a blower as above, then wipe the surface with a soft cloth or a swab designed for the purpose. Do not apply pressure and never use household cleaning fluids.

Cleaning the sensor

While the D810 dispenses with the optical low-pass filter over the sensor (page 9), there is still a protective filter in front of the sensor itself. Although everyone refers to "sensor cleaning", it's this filter, not the sensor itself, which can actually attract dust and need cleaning. Dust on the filter will appear as dark spots in your images.

Warning!

Astonishingly, the Nikon manual (page 444) implies that the reflex mirror can be cleaned with a cloth and lens cleaning fluid. This goes against all normal advice: never touch the reflex mirror in any way, as it is extremely delicate. Remove dust from the mirror with gentle use of an air-blower, and nothing else. The advice about use of a cloth and fluid should apply only to lenses (see page 198).

Prevention is better than cure, but however careful you are—unless you never change lenses at all—some dust will eventually find its way in. Fortunately, the D810 has a self-cleaning facility. This can

CLEANING THE SENSOR

Cleaning the sensor requires confidence—and also very great care!

×

be activated manually at any time or set to occur automatically when the camera is switched on and/or off—select options using **Clean Image Sensor** in the Setup menu.

Occasionally, however, stubborn spots may remain and it may become necessary to clean the filter manually. This is best done in a clean, draught-free, and well-lit area, preferably using a lamp which can be aimed into the camera's interior.

Ensure the battery is fully charged: use a mains adapter if available. Remove the lens, switch the camera on and select **Lock mirror up for cleaning** from the Setup menu. Press the shutter-release button to lock up the mirror. First, attempt to remove dust using a hand air-blower (**do not use** compressed air or any other aerosol). If this appears

ineffective, consider using a dedicated sensorcleaning swab, carefully following its supplied instructions. **Do not use** other brushes or cloths and **never** touch the sensor with your finger—the result could be far worse than a few dust spots! When cleaning is complete, turn the camera off, and the mirror will reset.

> Braving the elements

Cold

Nikon specify an operating temperature range of $0-40^{\circ}\text{C}$ ($32-104^{\circ}\text{F}$). When ambient temperatures fall below freezing, the camera can still be used, but aim to keep it within the specified range as far as possible. Keeping the camera in an insulated case or under outer layers of clothing between shots will help keep it warmer than the

SNOW PROBLEM >> A dramatic location, but potentially hazardous for camera and photographer. 100mm, 1/400 sec., f/11, ISO 100.

surroundings. If it does become chilled, battery life can be severely reduced (remember to carry a spare battery). In extreme cold, the LCD displays may become erratic or disappear completely and ultimately the camera may cease to function. If allowed to warm up gently, no permanent harm should result.

Heat and humidity

Extremes of heat and humidity (Nikon stipulate over 85%) can be even more problematic, as they are more likely to lead to long-term damage. In particular, rapid transfers from cool environments to hot and humid ones (for instance, from airconditioned hotel to sultry streets) can cause internal condensation. If such transitions may occur, pack the camera and lens(es) in airtight containers with sachets of silica gel, which will absorb any moisture. Allow equipment to reach ambient temperature before unpacking, let alone using, it.

Water

The D810 is reasonably weatherproof, so can be used with reasonable confidence in light rain. Keep exposure to a necessary minimum, and wipe regularly with a microfiber cloth (always handy to deal with accidental splashes). Avoid using the built-in flash and keep the hotshoe cover in place. Double-check that all access covers on the camera are properly closed.

Take extra care to avoid contact with salt water. If this does occur, clean carefully and immediately with a cloth, lightly dampened with fresh or, preferably distilled, water. Ideally, protect the camera with a waterproof cover..

Dust

As we've noted, any dust on the sensor can cause unwelcome spots on images. Though the D810 has a self-cleaning function, it still makes sense to take every precaution against dust getting into the camera in the first place. Mostly this means taking care when changing lenses. Aim the camera downward and stand with your back to any wind. In really bad conditions (such as sandstorms) it's best not to change lenses at all, and better still to protect the camera with a waterproof, and therefore also dust-proof, case. Dust that settles on the outside of the camera is relatively easy to remove; the safest way is with a handoperated or compressed air-blower. Do this before changing lenses, memory cards, or batteries, keeping all covers closed until the camera is clean.

Warning!

Any damage caused by heavyhanded manual cleaning or the use of inappropriate products could void your warranty. If in doubt, consult a professional dealer or camera repairer.

9 CONNECTION

Connecting to external devices is an essential element of digital photography, enabling you to store, organize, view, and print your images. The D810 is designed to facilitate these operations, and a couple of useful cables are included with the camera.

> Connecting to a computer

Connecting to a Mac or PC allows you to store, organize, and backup your images. It also helps you exploit the full power of the D810, including the ability to optimize image quality from RAW files. Some software packages allow "tethered" shooting, where images appear on the computer straight after capture; Nikon Camera Control Pro 2 (optional purchase) goes further, allowing the camera to be controlled directly from the Mac or PC.

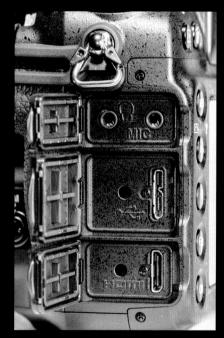

CONNECTING THE CAMERAConnection ports on the left side of the D810.

DOWNLOADING IMAGESD810 connected to a computer.

3

Computer requirements

The massive file sizes produced by the D810 place extra demands on computer systems, stressing processor speed, hard disk capacity, and—above all—memory (RAM). Systems with less than 4GB of RAM may run slowly when dealing with RAW, TIFF, and even full-size JPEG images from the camera. Fortunately, for most systems adding extra RAM is relatively easy and inexpensive. Extra hard disk space can also be helpful, as the system will slow significantly when the hard disk becomes filled, close to capacity—and again, those large files eat up hard drive space.

The D810 supports USB3 for connecting the camera; this is backwards-compatible with USB2 but transfer speeds over USB2 will be slower. A CD drive is useful but not essential for installing the supplied software, as it can also be downloaded from the Nikon website.

If you already own a Nikon DSLR, you will almost certainly have Nikon View NX2 installed already, but it must be updated to the latest version (2.10.0) to support fles from the D810. This version requires one of the following operating systems: Mac OS X (Version 10.9.2, 10.8.5, or 10.7.5); Windows 8.1; Windows 7 (Service Pack 1); Windows Vista (Service Pack 2). Windows XP and older versions of Mac OS X are no longer supported.

> Backing up

Until they are backed up, your precious images exist only as data on the camera's memory card (or cards, if you use the **Backup** option for the D810's second card slot). Memory cards are robust but they are not indestructible, and in any case you will surely wish to format and reuse them. However, when images are transferred to the computer and you format the card(s), those images again exist in just one location, the computer's hard drive. If anything happens to that hard drive, whether fire, theft, or hardware failure, you could lose thousands of irreplaceable images.

The simplest form of backup is to a second hard drive; the "gold standard" requires multiple drives, with one always kept off site. Online backup is also an option, but unless you shoot very sparingly

APPLE BACKUP

Apple's Time Machine maintains backups automatically.

you'll find free services offer nowhere near enough space. Flickr gives you an impressive 1TB completely free, but some commentators have questioned how secure it is against both data loss and image theft. Paid services give higher levels of security but at a price—however, Google Drive and now Dropbox Pro have made them much more affordable.

> Color calibration

A major headache for digital camera users is that images look one way on the camera monitor, different on the computer screen, different when you email them to your friends, and different again when printed. To achieve consistency across different devices, it's vital above all that your main

CALIBRATING

Screen calibration in progress with a Datacolor Spyder4Express.

computer screen is correctly set up and calibrated. This may seem complex and time-consuming, but ultimately it saves much time and frustration. Detailed advice is beyond the scope of this book, but try searching System Help for "monitor calibration". There's more detail in the DSLR Handbook (from this author and publisher) and there's some useful advice at http://www.cambridgeincolor.com/color-management-printing.htm.

> Connecting the camera

The supplied USB cable allows direct connection to a computer. This description is based on Nikon Transfer, part of the supplied View NX2 package. The procedure with other software will be similar in outline but different in detail.

CARD READER

Built-in SD card slot on a modern iMac.

- 9
- 1) Start the computer and let it boot up. Open the cover (the middle one of three) on the camera's left side and insert the smaller end of the supplied USB cable into the slot; insert the other end into a USB port on the computer (not an unpowered hub or port on the keyboard).
- **2)** Switch on the camera. Nikon Transfer starts automatically (unless you have configured its Preferences not to do so).

Tip

It's often more convenient to transfer photos using a card-reader. The procedure is broadly similar. Many PCs have built-in card slots but separate card-readers are cheap and widely available. Older readers may not support SDHC or SDXC cards.

- **3)** The Nikon Transfer window offers various options. The following are particularly important.
- **4)** To transfer selected images only, use the check box below each thumbnail to select or deselect as required.
- 5) Click the Primary Destination tab to choose where photos will be stored. You can create a new subfolder for each transfer, rename images as they are transferred, and so on.
- **6)** Click the **Backup Destination** tab if you want Nikon Transfer to create backup copies automatically during transfer.
- **7)** When transfer is complete, switch off the camera and disconnect the cable.

> Wireless connection

With a Nikon Wireless transmitter WT-5 and UT-1 communications unit (sold together as UT-1WK), the camera can connect to Wi-Fi networks. Photographs can then be viewed and saved on any computer on the network. You can also use Nikon Camera Control Pro 2 software (see below) for full control of the camera. However, this solution is expensive.

TRANSFER

Nikon Transfer 2.

<<

There's another limitation in that Nikon Camera Control Pro 2 will only work on Mac or Windows computers, not on mobile devices. An alternative solution is the CamRanger—see http://camranger.com—which provides Live View and control of all the main camera settings and can link to iOS and Android devices as well as Macs and PCs, for less than a third of the combined cost of the UT-1WK and Nikon Camera Control Pro 2. If you just want to transfer images to a computer over a wireless network, there's a much cheaper option: use an Eye-Fi card.

> Eye-Fi

Eye-Fi looks and operates like a conventional SD memory card, but includes an antenna which allows it to connect to Wi-Fi networks, enabling you to transfer images wirelessly. Eye-Fi cards also support ad-hoc networks, allowing

ENABLING EYE-FI

Eye-Fi connection screen.

images to be transferred to a laptop or iPad when out of the range of regular Wi-Fi. For leisurely-paced work like landscape, this can be a good way of backing up while out in the field, but transfer speeds are too slow for prolific (e.g. sports) shooters. Use Eye-Fi Upload in the Setup menu to enable transfers. When not needed, turn Eye-Fi off to save battery power. The card still functions as a regular memory card.

> Software and image processing

Most of us want to do more with our images than simply store them. Backing up, printing, organizing, and making them look their best: all these require the right software.

Software choice depends partly on how you shoot. If you always shoot JPEG images, you may feel little need to tinker with them later, and organizing and cataloging will be your main priorities. If you shoot RAW files, on the other hand, some image processing is essential—and you have great freedom to adjust tone, color, and so on to your liking.

> Nikon software

The D810 is buildled with Nikon View NX2 software. This includes Nikon Transfer, a simple application that does a simple job competently. Nikon View NX2 itself covers most of the main processes in digital photography: you can view and browse images, save them in other formats, and

print. However, editing and enhancing images (including RAW files) is neither fast nor intuitive, when compared to iPhoto or Lightroom. Using Nikon's own software should give the best results, but getting there might try your patience. View NX2 also doesn't support organizing or cataloging.

Nikon Capture NX-D

At the time of writing, it is hard to deliver a verdict on Nikon Capture NX-D, which has recently supplanted Nikon Capture NX2. Version 1 of Capture NX-D has recently been launched, but so far is available for Windows only, so I haven't been able to evaluate it.

Capture NX2 offered a wide range of editing options, especially for RAW files, including a "control point" system for tailored local adjustments. Some loved its quirky interface, others (myself included) couldn't get on with it. It took some acclimatization, it was undoubtedly slow, and it made no provison for organizing or cataloging.

Nikon Capture NX-D is very different.

For a start, it is a free download—Capture NX2 was quite expensive. Unfortunately, reviewers almost unanimously rate it as a major downgrade, with many advanced tools, including the control point system, removed. On the plus side, editing is now non-destructive, and batch processing has been improved, but it is still no help with organizing or cataloging.

Nikon Camera Control Pro 2

In suitable settings, Camera Control Pro 2 allows the functions and settings of the D810 to be operated directly from a Mac or PC (tethered shooting). As soon as images are captured they can be scrutinized on the computer screen; Live View integration allows real-time viewing. Of course, it's a professional product at a professional price. Lightroom and several other apps also support tethered shooting.

DIRECT CONTROL

Using Nikon Camera Control Pro 2 to shoot.

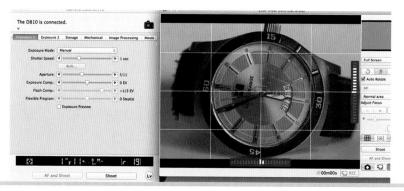

> Third-party software

The undisputed market leader is Adobe Photoshop. Its power far exceeds most users' needs. Adobe recently changed to a subscription model under the Creative Cloud label, which means that the software is continuously updated—but it will stop working if you don't keep up the payments.

Many users, including some pros, find that the more affordable Photoshop Elements does all they need. It has sophisticated editing features, including the ability to open RAW files from the D810. It is not (so far) part of Creative Cloud—you pay once for a perpetual license to use the software, in the familiar way.

Photoshop Elements includes an Organizer module, which allows you to "tag" photos, assign them to "Albums", or add keywords.

FDITING SOFTWARE

Editing an image in Adobe Photoshop CC.

The first of the state of the s

Mac users have another ready choice in the form of iPhoto, pre-installed on new Macs, which also combines organizing and editing abilities. However, Apple has recently announced that iPhoto will soon be discontinued (along with Aperture), giving way to a single Photos app. It's not yet clear whether this will offer advanced features such as RAW support: comparisons with the existing Photos app for iOS devices are not particularly encouraging.

Complete integration of organizing and editing functions was pioneered by Apple's Aperture (Mac only) and Adobe Lightroom (Mac and PC). However, Apple has already ceased development work on Aperture and it will soon be discontinued, leaving Lightroom in a near-monopoly position. There is a "new kid on the block" in Corel's reasonably-priced AfterShot Pro.

Highly recommended if you regularly shoot RAW, Lightroom offers powerful

organizing and cataloging, with advanced image editing for seamless workflow. Editing is "non-destructive": edit settings such as color balance, exposure, cropping, and so on are recorded alongside the original RAW (or DNG) file without creating a new TIFF or JPEG file. TIFF or JPEG versions, embodying all your edits, can be exported as needed.

> GPS

Nikon's GP-1 or GP-1a GPS (Global Positioning System) units can be mounted on the hotshoe or clipped to the camera strap. They link to the camera's accessory terminal using a supplied cable. Certain other third-party GPS units can also be connected.

GPS units add information on latitude, longitude, altitude, heading, and time to the image metadata. This is displayed as an extra page of photo info on playback and can be read by many imaging apps.

When the camera has established a connection and is receiving data from the GPS, GPS will be displayed in the information display. If this flashes, the GPS is searching for a signal, and data will not be recorded.

The **Location data** item in the Setup menu has three sections as follows.

Standby timer If set to **Disable**, this stops the meters turning off and returning the

camera to standby. This ensures that the GPS receiver is always able to connect to the satellite network (unless the signal is blocked). If you select **Enable**, the meters will turn off after one minute. This saves battery power, but next time you take a picture, the GPS receiver may not have time to get a fix, in which case no location data will be recorded.

Position This displays the current information, as reported by the GPS device. Apart from other uses, this could be handy if you get lost!

Set clock from satellite As the GPS network embodies some of the most accurate timing in existence, enabling this should mean that your camera clock is always bang on.

Note:

Older versions of Adobe Photoshop, Elements, and Lightroom will not recognize the D810's RAW files. One possible workaround is to use the free Adobe DNG Converter to convert D810 files to the standard DNG format. However, this does add an extra step, possibly a time-consuming one, to your workflow.

LOCATION, LOCATION

4

GPS information allows you to see exactly where photos were taken.

» CONNECTING TO A PRINTER

The camera's memory card can be inserted into a compatible printer or taken to a photo printing store. Alternatively, the camera can be connected to any printer that supports the PictBridge standard, but only JPEG files can be printed. If you want prints from RAW files, create JPEG copies first (see page 136). Printing from TIFF files is not an option.

For maximum flexibity and power when printing, and to print from TIFF files, transfer photographs to a computer first. The procedure for printing will then depend on your operating system, imaging software and the printer you are using. The following is a brief guide to printing your images directly from the camera to a compatible printer.

To connect to a printer

- 1) Turn the camera off.
- 2) Turn the printer on and connect the supplied USB cable. Insert the the smaller end of the cable into the USB slot, under the middle cover on the left side of the camera.
- **3)** Turn the camera on. You should now see a welcome screen, followed by a

PRINTING

Connecting to a printer.

PictBridge playback display. There's now a choice between **Printing pictures one at a time** or **Printing multiple pictures**.

Printing pictures one at a time

- 1) Select the photo you wish to print, then press (K). This reveals a menu of printing options (see the table on the next page). Use the Multi-selector to navigate the menu and highlight specific options; press (K) to select.
- **2)** When the required options have been set, select **Start printing** and press**OK**). To cancel at any time, press**OK**) again.

Printing multiple pictures

You can print several pictures at once. You can also create an index print of all JPEG images (up to a maximum of 256) currently stored on the memory card. NEF (RAW) images cannot be printed. With the PictBridge menu displayed, press (K). The options in the table overleaf are displayed.

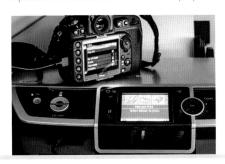

Options name	Options available	Notes	
Page size	Dependent on printer	Options depend on paper sizes the printer can support.	
No. of copies	1-99	Use \triangle / ∇ to choose the number of prints and press \bigcirc to select.	
Border	Printer default Print with border No border	If Print with border is selected, the border will be white.	
Time stamp	Printer default Print time stamp No time stamp	Prints time and date when image was taken.	
Сгор	Crop No cropping	Crop prints selected area only to size selected under Page size. Screen shows image with border delineating crop area. Use ▲ / ▼ to change size of this area; use the Multi-selector to reposition it. When satisfied, press ()	
Print Select	card. To choose cur?/O¬¬ and press ♠. prints set to "1". Hol Repeat to select fur from each. Finally, p	tor to scroll through pictures on the memory rently selected image for printing, hold The picture is marked and number of d?/Om and use to print more copies. ther images and choose number of prints ress (K) to display PictBridge menu and ons, as in table above. Select Start printing	
Select Date	Prints one copy of each picture taken on selected date(s).		
Printing (DPOF)	Prints images already selected using Print set (DPOF) option in Playback menu (see page 99).		
Index Print	Prints all JPEG images on the memory card, up to maximum of 256. If more images exist, only the first 256 will be printed.		

» CONNECTING TO A TV

You can playback photographs and movie clips through an HDMI (High Definition Multimedia Interface) TV or set-top box. The Nikon D810 does not support non-HDMI systems.

Printing pictures one at a time

- **1)** Check the settings in the HDMI item in the Setup menu.
- **2)** Turn the camera off (always do this before connecting or disconnecting the cable).
- **3)** Open the HDMI cover halfway down the left side of the camera and insert the cable into the slot. Connect the other end to the TV.
- **4)** Tune the TV to an HDMI channel.

5) Turn the camera on and press the playback button. Images remain visible on the camera monitor as well as on the TV and you navigate using the Multiselector in the usual way. The D810's Slide show setting (see Playback menu, page 99) can be used to automate playback.

Note:

Use of a mains adapter is recommended for lengthy playback sessions. No harm should result if the camera's battery expires during playback, but it is annoying.

SHARING MEMORIES

×

Connection to a TV makes it easy to share your pictures and movies with family and friends.

» GLOSSARY

- 8-bit, 14-bit, 16-bit See Bit depth.
- **Aperture** The lens opening which admits light. Relative aperture sizes are expressed in f-numbers.
- **Artifact** Occurs when data or data produced by the sensor are interpreted incorrectly, resulting in visible flaws in the image.
- Bit depth The amount of information recorded for each color channel.
 8-bit, for example, means that the data distinguishes 28 or 256 levels of brightness for each channel. 16-bit images recognize over 65,000 levels per channel, which allows greater freedom in editing. The D810 records RAW images in 12- or 14-bit depth and they are converted to 16-bit on import to the computer.
- **Bracketing** Taking a number of otherwise identical shots in which just one parameter (e.g. exposure) is varied.
- **Buffer** On-board memory that holds images until they can be written to the memory card.
- **Burst** A number of frames shot in quick succession; the maximum burst size is limited by buffer capacity.
- **CCD (Charge-Coupled Device)** A type of image sensor that is used in many digital SLR cameras.
- **Channel** The D810, like other digital devices, records data for three separate color channels (see RGB).

- **Clipping** Complete loss of detail in highlight or shadow areas (or both), leaving them pure white or black.
- CMOS (Complementary Metal Oxide Semiconductor) A type of image sensor used in many digital cameras, including the D810.
- Color temperature The color of light, expressed in degrees Kelvin (K). Confusingly, "cool" (bluer) light has a higher color temperature than "warm" (red) light.
- CPU (Central Processing Unit) A small computer in the camera (also found in many lenses) that controls most or all of the unit's functions.
- **Crop factor** *See Focal length multiplication factor.*
- **Diopter** Unit expressing the power of a lens.
- **dpi (dots per inch)** A measure of resolution: should strictly be applied only to printers (see ppi).
- **Dynamic range** The range of brightness from shadows to highlights within which the camera can record detail.
- **Exposure** Used in several senses. For instance, "an exposure" is virtually synonymous with "an image" or "a photo': to make an exposure = to take a picture. Exposure also refers to the amount of light hitting the image sensor, and to systems of measuring this. See also Overexposure, Underexposure.
- **EV (Exposure Value)** A standardized unit of exposure. 1 Ev is equivalent to 1 "stop" in traditional photographic parlance.

- Extension rings/Extension tubes Hollow tubes which fit between the camera tube and lens, used to allow greater magnifications.
- **f-number** Lens aperture expressed as a fraction of focal length; f/2 is a wide aperture and f/16 is narrow.
- **Fast** Lens with a wide maximum aperture, such as f/1.8; f/4 is relatively fast for long telephotos.
- Fill-in flash Flash used in combination with daylight. Used with naturally backlit or harshly side-lit subjects to prevent dark shadows.
- **Filter** A piece of glass or plastic placed in front of, within, or behind the lens to modify light.
- **Firmware** Software which controls the camera. Upgrades are issued by Nikon from time to time and can be transfered to the camera via a memory card.
- **Focal length** The distance (in mm) from the optical center of a lens to the point at which light is focused.
- Focal length multiplication factor In DXcrop mode, the image area is smaller than a 35mm film frame, so the effective focal length of all lenses is multiplied by 1.5.
- **(ps** The number of exposures (photographs) that can be taken in a second. The D810's maximum rate is 5–7fps (depending on Image size and power source).
- **Highlights** The brightest areas of the scene and/or the image.

- **Histogram** A graph representing the distribution of tones in an image, ranging from pure black to pure white.
- ISO (International Standards
 Organisation) ISO ratings express film
 speed and the sensitivity of digital sensors
 is guoted as ISO-equivalent.

JPEG (from Joint Photographic Experts Group) A compressed image file standard. High levels of JPEG compression can reduce files to about 5% of their

standard. High levels of JPEG compression can reduce files to about 5% of their original size, but not without some loss of quality.

- **LCD Liquid Crystal Display** Flat screen, such as the D810's rear monitor.
- **Macro** A term used to describe close focusing and close-focusing ability of a lens. A true macro lens has a reproduction ratio of 1:1 or better.
- Megapixel See Pixel.
- **Memory card** A removable storage device for digital cameras.
- **Noise** Image interference manifested as random variations in pixel brightness and/or color.
- Overexposure When too much light reaches the sensor, resulting in a too-bright image, often with clipped highlights.
- Pixel (picture element) The individual colored dots (usually square) which make up a digital image. One million pixels = 1 megapixel.

- **Post-processing** Adjustment to images on computer after shooting. Can cover anything from minor tweaks of brightness or color to extensive editing.
- **ppi (pixels per inch)** Should be applied to digital files rather than the commonly used dpi (See dpi).
- **Reproduction ratio** The ratio between the physical size of an object and the size of its image on the sensor.
- **Resolution** The number of pixels for a given dimension, for example, 300 pixels per inch. Resolution is often confused with image size. The native size of an image from the D810 is 7,360 x 4,912 pixels; this could make a large but coarse print at 100 dpi or a smaller but finer one at 300 dpi.
- **RGB (Red, Green, Blue)** Digital devices, including the D810, record color in terms of brightness levels of the three primary colors.
- **Sensor** The light-sensitive chip at the heart of every digital camera.
- **Shutter** The mechanism that controls the amount of light reaching the sensor by opening and closing when the shutter-release button is pushed.
- **Speedlight** Nikon's range of dedicated external flashguns.
- **Spot metering** A metering system which takes its reading from the light reflected by a small portion of the scene.
- **Telephoto lens** A lens with a long focal length and a narrow angle of view.

TIFF (Tagged Image File Format)

A universal file format supported by virtually all image-editing applications.

- **TTL (through the lens)** The viewing and metering systems in SLR cameras such as the D810.
- **Underexposure** When insufficient light reaches the sensor, resulting in a toodark image, often with clipped shadows.
- **USB (Universal Serial Bus)** A data transfer standard, used to connect to a computer.
- Viewfinder An optical system used for framing the image. On an SLR camera, such as the D810, it shows the view as seen through the lens.
- White balance A function which compensates for different color temperatures so that images may be recorded with correct color balance.
- Wide-angle lens A lens with a short focal length and a wide angle of view.
- Zoom A lens with variable focal length, giving a range of viewing angles. To zoom in is to change focal length to give a narrower view and zoom out is the converse. Optical zoom refers to the genuine zoom ability of a lens; digital zoom is the cropping of part of an image to produce an illusion of the same effect.

» USEFUL WEBSITES

NIKON-RELATED SITES

Nikon Worldwide

Home page for the Nikon Corporation www.nikon.com

Nikon UK

Home page for Nikon UK www.nikon.co.uk

Nikon USA

Home page for Nikon USA www.nikonusa.com

Nikon User Support

European Technical Support Gateway www.europe-nikon.com

Nikon Info

User forum, gallery, news, and reviews www.nikoninfo.com

Nikon Historical Society

Worldwide site for study of Nikon products www.nikonhs.org

Grays of Westminster

Revered Nikon-only London dealer www.graysofwestminster.co.uk

GENERAL SITES

Digital Photography Review

Independent news and reviews www.dpreview.com

Thom Hogan

Real-world reviews and advice www.bythom.com/nikon.htm

Jon Sparks

Landscape and outdoor pursuits photography www.jon-sparks.co.uk

EQUIPMENT

Adobe

Photoshop, Photoshop Elements, Lightroom www.adobe.com/uk

Aquapac

Waterproof cases www.aquapac.net

f-stop

Backpacks and accessories http://fstopgear.com

Sigma

Independent lenses and flash units www.sigma-imaging-uk.com

PHOTOGRAPHY PUBLICATIONS

Black & White Photography magazine, Outdoor Photography magazine www.ammonitepress.com/camera-guides. html www.theamcgroup.com

» INDEX

A accessories and care 210–221, 214 action, freezing 40 Active D-Lighting 86, 87, 104 Active Information Display 30, 69 AF-area modes 56 AF-C Continuous-servo AF 54 AF frime tune 134 AF prime lenses 207, 208 AF-S Single-servo AF mode 54 AF zoom lenses 208 anti-aliasing filters 9 aperture 39 and depth of field 41 in Live View 80 Aperture-priority (A) auto mode 31, 36, 39, 40–41 artefacts 9 Aspherical Lens Elements (ASP) 205 Auto -area AF mode 57 distortion control 104 image rotation 131 modes 36 Autofocus (AF) 205	Clean image sensor/Lock mirror up for cleaning 130, 219 Close-range Correction (CRC) 205 close-up 168-177 cold, effects of 220 color balance 139 calibration 225 outline 142 sketch 142 space 72, 104 command dials 31, 32, 37 Compact Flash cards 25 computer connecting to a 222 requirements 224 connecting the camera 225 to a computer 222 to a printer 231 to a TV 233 connections 222-233 contrast 90 control panel 30 copyright information 132 crop factor 64, 65, 195	E electronic rangefinder 56 elements, braving the 220 E-type (DE or PC-E) lens 205 evolution of Nikon D810 6 exposure 10 bracketing 46, 48-49 compensation 46-47 lock 50 metering (movies) 183 modes 36-43 in movies 184 preview 75 extension tubes 174 Extra-low Dispersion (ED) glass 206 Eye-Fi 227 upload 135 eyesight, adjusting for 24 F Face-piority AF mode 80 field of view 195 file formats 11, 65, 66 naming 102 fill-in flash 150
back-button autofocus 55, 59 backing up images 224	custom functions 11 Custom setting	filter effects 139 filters 210–213
backlighting 92 battery	banks 108 menu 108–128	anti-aliasing 9 low-pass 9
charging 27 info 131	D	neutral density (ND) 212 polarizing 212
inserting the 27	default setting, restoring 73, 108	special effects 213
life 28 beanbag 217	Defocus-image Control (DC) 205 deleting images 82	UV or skylight 210, 212 firmware version 135
bellows 175	depth of field 39	fisheye 142
bounce flash 162	diopter adjustment 24, 216	flare 197
buffer 10, 35 built-in flash 148-149	Distance information (D) 205	flash 11, 146-167
Bulb (B) mode 42	distortion 198 control 142	accessories 167 bounce 162
	Digital Print Order Format (DPOF)	brackets 167
C camera	99	built-in 148-149
care 210, 219	D-Lighting 138 dust, effects of 221	compensation 158-159 exposure 152-153
cases 214	DX	fill-in 150
preparation 24-29	format 64, 65, 194	i-TTL balanced fill- 151
support 217 switching on the 28	lens (DX) 205, 209	modes 155-157
chromatic aberration 198	Dynamic-area AF mode 56 dynamic range 90	off-camera 162 range 154
	,	ange 134

synchronization 155-157 wireless 163 Flat Picture Control 90 flexible program 37 flicker reduction 130 focal length 39, 194, 196 focus 10 lock 59 modes 54 options (movies) 182	size 64-67 Image Dust Off Ref Photo 130 images backing up 224 deleting 82 hidden 98 protecting 82 resize 141 straighten 142 viewing as thumbnails 81	telephoto 201 wide-angle 200 zoom 203 light and exposure 92-93 LED 173 reductions 175 Live View 10, 74-80 location data 135 Long exposure NR 105
points 33, 58–61 point selections 58 focusing 54–57	information display 30 Internal Focusing (IFR) 206 Interval timer shooting 106	low-light focusing 60 low-pass filters 9
in Live View 78 low-light 60	ISO 10 Auto 52	M macro
freezing action 40 full features & camera layout 12-15	choices 53 sensitivity settings 51–53, 105 iTTL balanced fill-flash 151	lenses 176–177, 204, 208 lighting 172–173 photography 170–171
functions 22-93		equipment for 174-175
FV lock 159 FX format 8, 64, 65, 194	J JPEG 65 /TIFF recording 103	Main Command Dial 31, 37 main features 10-11 Manage Picture Control 104
G	,	Manual
GPS 230	L	focus 56, 80
Group-area AF mode 57	language 131	mode 31, 36, 42-43
G-type lens 206	LCD	Matrix (3D Color Matrix Metering
Guide Numbers (GN) 155	control panel 17	III) 44
	monitor 11	memory card 218
Н	screen 28, 81	formatting a 26, 129
HDMI (High Definition Multimedia Interface) 135	LED light 173 lens	inserting and removing 25 selection 81
HDR (high dynamic range) 90-91, 104	care 198 chart 207-209	Custom Setting 108-128
heat and humidity, effects of 221	CPU 45	displays 18-21 My 144-145
High ISO NR 105	DX 205 E-type (DE or PC-E) 205	Playback 96-99
highlights 85	G-type (DE 01 PC-E) 203	Recent Settings 144-145
highlight-weighted metering 45 high-speed flash sync 164	hoods 197	Retouch menu 136-143
histogram displays 84	issues 197-198	Setup 129-135
hyperfocal distance 41	release button 24	Shooting 100-107
hyperrocal distance 41	technology 205-206	menus 94-145
T	lenses 192-209	metering
image	AF prime 207, 208	center-weighted 44
area 64-67, 103, 182	AF zoom 208	highlight-weighted 45
enhancement 86-91	DX 64, 65, 209	Matrix (3D Color Matrix
overlay 140	macro 176-177, 204, 208	Metering III) 44
processor 10	Manual/Auto (M/A) 206	modes 44-45
quality 62, 63, 103	mounting 24	spot 45
playback 81-85	perspective-control 204, 209	miniature effect 143
review 98	standard 199	mode

AF-C Continuous-servo AF 54	Non-CPU lens data 134	Shutter-priority (S) auto mode 31,
AF-S Single-servo AF mode 54		38, 40-41
Aperture-priority (A) 31, 36, 37,	0	sidelighting 93
38	off-camera flash 162	Silent Wave Motor (SWM) 206
Auto-area AF 57		slide show 99, 233
Bulb (B) 42	P	slow sync mode 156
Dynamic-area AF 56	panning 188	software 11
Face-priority AF 80	perspective-control 142	and image processing 227
Group-area AF 57	lenses 204, 206, 209	Speedlights, using optional 160-161
Manual 31, 36, 42-43	photo information, viewing 83	split-screen display zoom 77
Program 36	Playback menu 96-99	spot metering 45
Shutter-priority (S) 31, 36, 37, 38	playback	sRAW images 66
Single-area AF 56	folder 97	standard lenses 199
Subject-tracking AF 80 modes	zoom 82	storage 218
AF-area 56	pre-shoot controls 86	straighten images 142
Auto 36	primary slot function 102	strap, attaching the 24
focus 54	printer, connecting to a 231	Sub-command Dial 31
metering 44-45	Program mode 36 Programmed Auto (P) Mode 36	Subject-tracking AF mode 80
Scene 36	protecting images 82	Super Integrated Coating (SIC) 206
monitor	protecting images 62	Т
brightness 129	Q	Third-party software 229
color balance 129	Quick retouch 142	TIFF 65, 103
monochrome 138	2.2	time-lapse photography 107
monopods 217	R	time zone and date 131
movie	RAW 66, 68	teleconverters 202
mode 10	rear-curtain sync 156	telephoto lenses 201
settings 107	Rear Focusing (RF) 206	tonal range 90
movies 178-191	Recent Settings menu 144-145	tripods 217
editing 143, 190–191	red-eye	TV, connecting to a 233
making 180–185	correction 138	two-button reset 73
shooting 187–189	reduction 156	
multiple exposure 105	Release mode 34-35	V
Multi-selector 33	remote cords 216	Vibration Reduction (VR) 206
My Menu 144-145	reproduction ratio 170	viewing
N	resize images 141	images as thumbnails 81
Nano Crystal Coat (N) 206	Retouch menu 136–143	photo information 83
NEF (RAW)	reversing rings 175	viewfinder 10, 16, 57
bit depth 103	S	vignetting 104, 198
file compression 103	Scene modes 36	virtual horizon 134
images 66	Secure Digital (SD) memory	W
processing 140	cards 25	water, effects of 221
recording 103	sensor 10	white balance 68-72, 104
Nikkor lens chart 207-209	cleaning the 219	wide-angle lenses 200
Nikon	Nikon FX-format 8, 64, 65, 194	wireless
Camera Control Pro 2 229	Set Picture Control 104	connection 226
Capture NX-D 228	Setup menu 129-135	flash 163
Creative Lighting System (CLS)	Shooting menu 100-107	working distance 170
150-151	shooting movies 187-189	-
FX-format sensor 8	shutter 10	Z
lens technology 205-206	operating the 29	zooming 189
Picture Controls 87, 88, 89	speed 38, 39, 40	zoom lenses 203
	/	